The Royal Portrait
Image and Impact

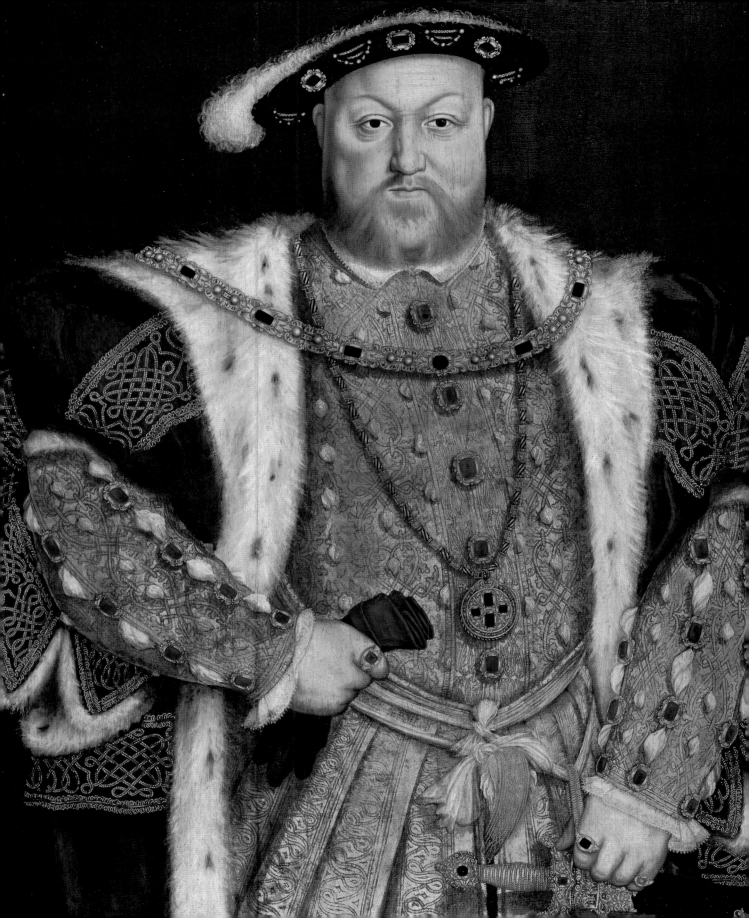

The Royal Portrait
Image and Impact

Jennifer Scott

ROYAL COLLECTION PUBLICATIONS

First published by
Royal Collection Enterprises Ltd
St James's Palace, London SW1A 1JR

For a complete catalogue of current publications,
please write to the address above, or visit our website
at www.royalcollection.org.uk

© 2010 Royal Collection Enterprises Ltd
Text by Jennifer Scott and reproductions of all items
in the Royal Collection © 2010 HM Queen Elizabeth II.

011925

ISBN 978–1–905686–13–1
British Library Cataloguing in Publication Data:
A catalogue record for this book is available from
the British Library.

Design: Nigel Soper
Production: Debbie Wayment
Printed and bound by Graphicom srl, Vicenza
Typeset in Walbaum and printed on Gardamatt

FRONT COVER: Sir Anthony Van Dyck,
Charles I with M. de St Antoine (fig. 63, detail)

INSIDE FRONT COVER: Mathias Kauage, *Missis Kwin* (fig. 1)

FRONTISPIECE: After Hans Holbein the Younger,
Henry VIII (fig. 39, detail)

PAGES 10-11: Flemish School, *The Meeting of Henry VIII
and the Emperor Maximilian* (fig. 27, detail)

INSIDE BACK COVER: Marcus Adams, *Princess Elizabeth* (fig. 134)

BACK COVER: British School, *The Field of the Cloth of Gold*
(fig. 34, detail) and details from figs 25, 46, 92, 95, 133 and 147

SPINE: fig. 42, detail

Mixed Sources
Product group from well-managed
forests, controlled sources and
recycled wood or fibre
www.fsc.org Cert no. CQ-COC-000015
©1996 Forest Stewardship Council
FSC

Contents

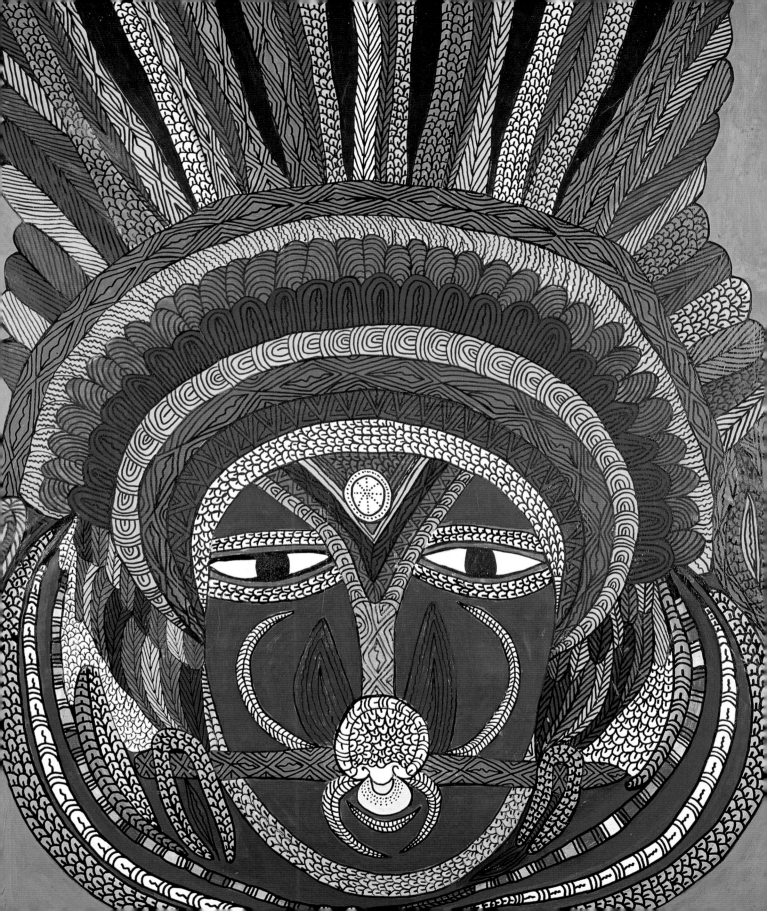

Introduction

'A painter of portraits … cannot make his hero talk like a great man; he must make him look like one.'

SIR JOSHUA REYNOLDS (1723–92)

A Discourse Delivered to the Students of the Royal Academy,
10 DECEMBER, 1771

THERE IS, in the Royal Collection, a portrait of Queen Elizabeth II that looks nothing like her. The Queen possesses a face that is globally familiar, and yet in 1996 an artist who had not met her painted her 'likeness'. The artist was Mathias Kauage from Papua New Guinea and the Tok Pisin title *Missis Kwin* translates as 'Mrs Queen' (fig. 1). This painting encapsulates the essential question that will be addressed in this book: what constitutes a royal portrait?

A portrait functions on various levels in order to create a visual representation of a person. Three main factors shape the making of royal portraits, and therefore should be borne in mind by the viewer when considering them:

1. Accuracy in capturing the sitter's appearance and the symbols that define his or her role.
2. The personal aspirations of the artist which affect his or her decision-making.
3. The intended location and audience and (if applicable) the terms of the commission.

It is immediately evident that Mathias Kauage was not concerned with accurately recording the physical appearance of the Queen. Instead he placed importance on defining her role as a leader by employing his own indigenous symbolism. Kauage's picture is bright and imposing. The face dominates the composition, giving the impression of a close-up view with an arresting expression of authority, while simultaneously smiling to show benevolence. The strong black outlines and vivid green background increase the resonance of the purples, blues, reds, yellows and whites. The sitter is presented in traditional Simbu *bilas* (body decoration constructed through face-paint, feathers, elaborate headdresses, tattooing and pig-tusk ornamentation). This is typical of Kauage's portraits, and of Papua New Guinean art in general, where figures within a portrait are frequently adorned with appropriate symbols of the artist's tribe.

Mathias Kauage was a native of Gembogl No. 2 Village in the Simbu Province of Papua New Guinea. As a young man he worked as a labourer before becoming a cleaner in the capital city of Port Moresby. He was inspired by artists working in the city, and taught himself how to paint. He quickly became established as an artist, gained a position at the National Art School and, when this ended in 1989, moved to a squatter settlement nearby where he trained students to emulate his style and

FIG. 1 Mathias Kauage (1944–2003), *Missis Kwin*, 1996. Acrylic on canvas, 151.3 x 114 cm. Royal Collection (RCIN 407778)

earned a reputation as an artist of significance. Kauage received support and renown through his mentor, the British artist Georgina Beier, who promoted his work worldwide. Kauage travelled often to Australia, Germany and Britain and he met the Queen on 3 July 1996 at the opening of the Modern Art Museum in Glasgow. *Missis Kwin* was painted shortly before this meeting, but Kauage included her image in other paintings (such as his *I met with the Queen in Scotland*, 1996, private collection) where she is depicted in a combination of British and Papua New Guinean clothing and accessories.

Kauage's personal aspirations seem to have been to uphold his idiosyncratic world view – one where his own background and experiences directly influenced his artistic choices. He had been encouraged by Beier not to emulate Western art, but instead to remain true to local customs and to practise self-expression. This may explain his approach to painting the Queen. As Susan Cochrane explains, 'when Kauage depicts important personages such as Captain Cook or the Queen, he portrays them as Simbu, signifying that they have been drawn into and have become part of Simbu culture'.[1] Since its independence from Australia on 16 September 1975 Papua New Guinea has retained the Queen as Sovereign. Kauage's unique portrayal, therefore, can be interpreted as a gesture of respect to the Queen as Head of the Commonwealth. The honour was returned in 1998 when the artist was awarded an OBE for 'services to art'.

Missis Kwin was not a royal commission. It was presented to the Queen by the people of Papua New Guinea in 1996. The intended location for the image, therefore, was within the royal household, and the audience, first and foremost, was the Queen herself. The painting adds to the diversity and richness of the Royal Collection. But the question remains, can it be called a royal portrait? If we compare it with a more conventional image, such as *Queen Elizabeth II* by Michael Leonard, where the Queen wears a yellow dress and pearls, sitting with a corgi next to her (fig. 2), the two paintings seem worlds apart. Leonard's portrait conforms to the established persona of the Queen, but does not include the traditional symbols of monarchy. In conventional British state portraiture from the Middle Ages until today, a monarch is frequently identifiable by certain symbols such as the crown, orb and sceptre and is represented wearing state robes and seated on a throne. It is perhaps when an artist deviates from these conventions that royal portraiture becomes particularly interesting.

Artists begin a royal portrait with a metaphorical, as well as a literal, blank canvas. What a royal portraitist constructs is an interpretation of the monarch which can be decoded to give insights into the political climate in which the image was made. The following pages include some of the most celebrated names in the history of art: Holbein, Hilliard, Van Dyck, Rubens, Gainsborough, Zoffany, Lawrence, Landseer, Winterhalter, Beaton and Freud. These artists chose to make themselves available to portray the monarch and to subject their careers, or parts of their careers, to the 'slavery' of portraiture.[2] Although a challenging task, it was not necessarily a hardship, as each artist knew that if the finished image was deemed a success, fame was guaranteed: good royal portraits are much sought after to provide an illustrated version of history.

This book focuses on portraits produced during six key periods of British history. The majority of works assessed are still part of the Royal Collection and housed, often on the public routes, in the royal residences – Windsor Castle, Buckingham Palace, The Palace of

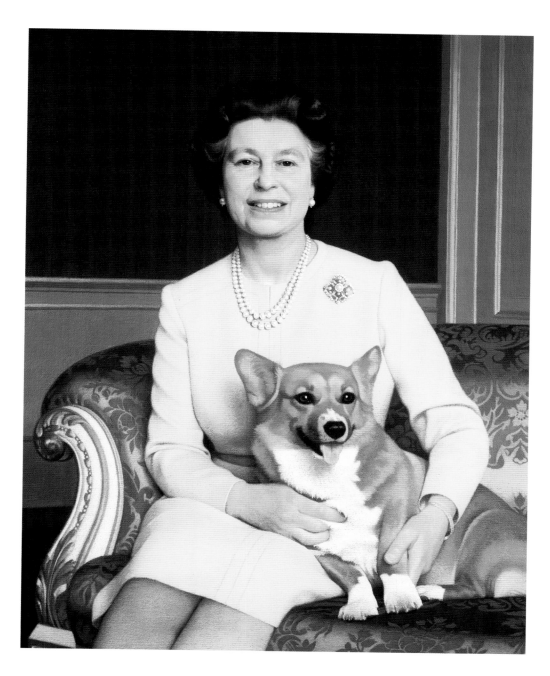

FIG. 2 Michael Leonard (b.1933), *Queen Elizabeth II*, 1985–6. Acrylic on cotton duck, 76.2 x 61.6 cm. London, National Portrait Gallery

Holyroodhouse, St James's Palace, Balmoral Castle, Sandringham House, Highgrove House, Osborne House, Hampton Court Palace, Kensington Palace, Kew Palace and the Banqueting House Whitehall – or included in changing exhibitions at the Queen's Galleries in London and Edinburgh. The fact that many of these royal portraits remain in or close to their intended historic locations enriches our understanding of them, for there is no better way to appreciate a work of art than within the context for which it was originally created.

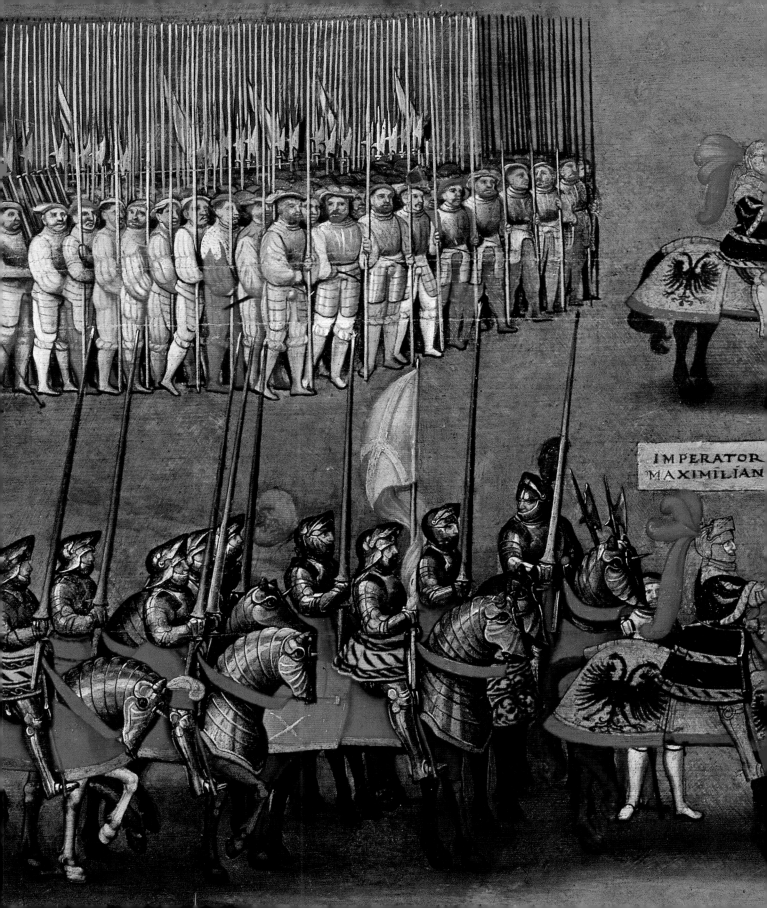

IMPERATOR
MAXIMILIAN

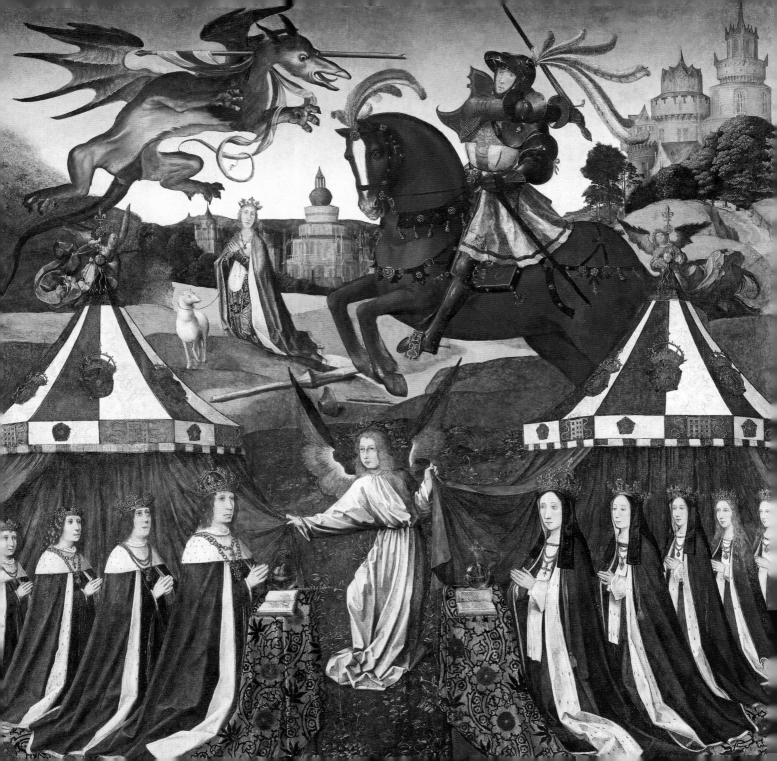

1
The Early English Royal Portraits

'The game's afoot: Follow your spirit; and upon this charge
Cry, "God for Harry, England, and Saint George!"'

WILLIAM SHAKESPEARE, *Henry V* ACT III SCENE I

AROUND 1503 HENRY VII appears to have commissioned an artist to paint a group representation of the royal family combined with an image of St George slaying the dragon (fig. 3). The painting encompassed numerous elements of royal portraiture: a representation of the king with his wife and their children, a political statement and a fascinatingly ambiguous image. The likeness in itself was not intended to be specific enough to identify this king as Henry VII (1457–1509). In the eighteenth century the painting was thought to depict Henry V (1387–1422) and Catherine of Valois, an error probably made because of the well-known links (immortalised by Shakespeare) between Henry V and St George. But when this painting was created, the identity of the family group in the lower section of the panel was expected to be immediately clear. *The Family of Henry VII with St George and the Dragon* is indicative of Henry VII's myth-making, which was essential to the formation of the Tudor dynasty. The painting bears witness today to both his self-perception and his self-presentation.

When looking at royal imagery we must question where paintings hung and who was at liberty to see them. As has often been noted, palaces were the first royal portrait galleries.

Images of royalty within palaces served to enhance interior displays and to imbue visitors with a sense of the monarch's presence. *The Family of Henry VII with St George and the Dragon* seems most likely to have been created as an altarpiece, and Horace Walpole – who acquired the painting in 1773 – noted that it had originally been an altarpiece at the royal palace at Sheen.[3] Walpole's source for this comment is unclear, but it is feasible that the painting was intended for the chapel at Henry VII's rebuilt (and renamed) Richmond Palace following the fire that destroyed Sheen Palace in 1497.[4]

Records indicate that images were used extensively to decorate the interior of Richmond Palace.[5] In the hall there were representations of the famous rulers of England, both real and mythical, including the legendary King Arthur, Richard I and one of the king Edwards – probably Edward III – along with an image of Henry VII himself. Similarly, within the chapel at Richmond Palace there were representations of the kings of England who had achieved sanctity. Most prominent of those would probably have been Edward the Confessor, and also Henry VI (1421–71), since Henry VII had been negotiating with Pope Alexander VI for his Lancastrian forebear to be canonised. The panel painting of *The Family of Henry VII with St George and the*

Dragon would have been suitable within this chapel setting, and the presentation of the King and his family might therefore have been intended as a continuation of the genealogical sequences in the hall and chapel, as well as functioning as a devotional altarpiece, with the donor presenting himself and his family humbly before God, and St George acting as intercessor. Perhaps the painting itself functioned as a prayer, appealing to God's mercy to approve and protect the Tudor line created by Henry VII.

This type of devotional portrait asks for God's blessing in exactly the same way that a church service asks God to bless a marriage, christening or coronation. It is a distinctive species of royal image because it depicts the ruler submitting to a higher rule.

It is no dishonour to serve a noble master. Just as a king loses nothing by stressing his devotion to God, so a nobleman loses nothing by stressing his devotion to his king. This devotion sometimes results in commissions for royal portraits. Particularly in the last hundred years many more portraits have been commissioned by loyal subjects or institutions than by the monarchs themselves. However, the very nature of this panel, the integration of the secular portraits with the religious image and the emphasis on Henry's strong lineage, certainly seem to point towards this being a royal commission.

The King is portrayed along with his wife and children, boys on the left and girls on the right. The children are not depicted realistically – the oldest boy, Prince Arthur, had died in 1502 aged 15, Prince Edmund died aged 1, Princess Elizabeth died at the age of 3 and Princess Catherine died with her mother at birth. However, the children are shown ranged in order of birth, presumably because it was easier (and neater) to line them up in this way to represent the idea of royal children.

The angel acts as a balance in the centre, unifying the two groups and symbolising the marriage of Henry VII and Elizabeth of York, which marked the end of the Wars of the Roses and the birth of the Tudor dynasty. Nonetheless the Lancastrian imagery dominates. The curtain from Elizabeth of York's side is being pulled further across by the uniting angel, demonstrating that the House of York had to submit to that of Lancaster. The viewer is led to see that it was only through Henry's peace-making tactics that harmony could be established.

The individual portraits cannot be read or intended as identifiable likenesses. If we compare the face of Henry VII in this painting with the King's effigy on his tomb at Westminster Abbey (fig. 4), commissioned by Henry VIII from the Florentine sculptor Pietro Torrigiano and based on the deceased King's death mask (fig. 5), it is evident that the painted representation is quite generic, with a symbolic, rather than realistic function. Unsurprisingly, Henry VII is presented with the attributes of kingship. A sceptre and orb, as well as an illuminated manuscript, are laid on a prie-dieu (prayer desk) in front of him. The King kneels before this and his pious gesture with hands closed in prayer is echoed by each of the male and female members of the royal family. The patterned brocade of the tables is continued to protect the knees of the figures and implies an interior, decorated

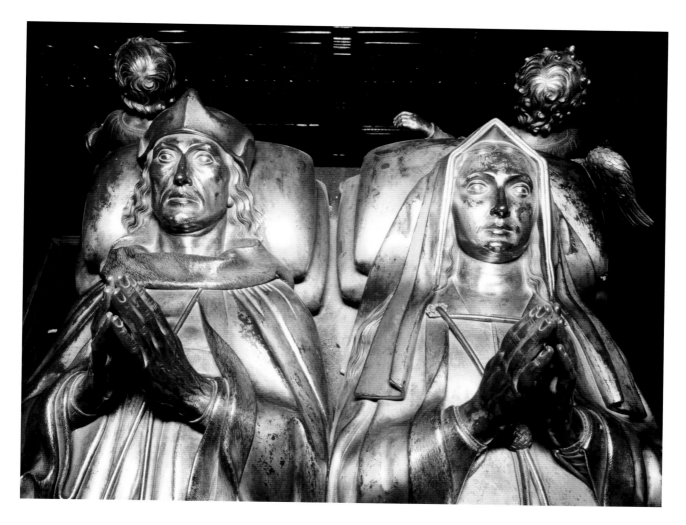

FIG. 4 Pietro Torrigiano
(1472–1528), *Tomb effigies
of Henry VII and Elizabeth of
York*, c.1518. Gilt bronze,
length 220 cm. London,
Westminster Abbey

space inside the two tents. The Tudor rose and the portcullis of the house of Beaufort (Henry VII's mother's heraldry) are emblazoned on the tents to reinforce the identity of the group. The central angel's attitude is more akin to a Coronation of the Virgin scene than to royal portraiture, strengthening the notion that this painting was intended to function primarily as an altarpiece, but with the added bonus of including a family group portrait.

The presentation of royal families in a group portrait was not without precedent. For example, the stained glass in the north window of the north-west transept at Canterbury Cathedral (completed in 1482) presents Edward IV (Elizabeth of York's father; 1442–83) and his family as donors (fig. 6). They are shown kneeling at prie-dieux wearing crowns, royal robes and chains. These depictions, like those in *The Family of Henry VII*, date from the lifetime of the King and the princes, and were intended to promote the notion of dynastic strength. Edward IV fully expected the existence of two sons to secure the Yorkist line (not anticipating the premature death of the princes in the Tower of London and the succession of his brother, the childless Richard III (1452–85), to the throne). Likewise, as we have seen, Henry VII hoped that

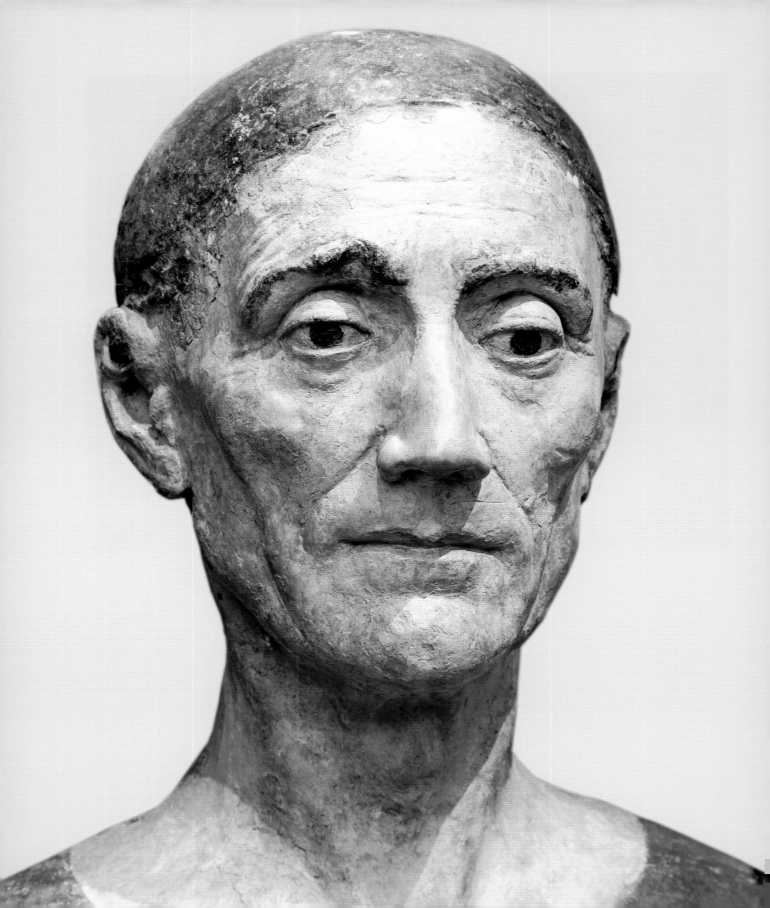

the presence of numerous heirs would show the strength of his line. Four of his children (Arthur, Edmund, Elizabeth and Catherine) and his Queen were dead by the time the painting was created, but all are shown as if alive.

Princess Margaret (the eldest of the daughters presented in *The Family of Henry VII with St George and the Dragon*) married James IV of Scotland in 1503. James IV had featured in a devotional portrait by the Flemish artist Hugo van der Goes in 1478–9 (fig. 7). The *Trinity Altarpiece* was a polyptych incorporating a portrait of James III of Scotland (1451–88), his son (the future James IV) and St Andrew in the left wing, and his Queen, Margaret of Denmark (*c*.1457–86), with St George in the right-hand panel. Although clearly politically charged images, the Van der Goes portraits serve as a reminder that religious devotion was at the core of such imagery. The Scottish panels originally flanked a now-lost religious image

(possibly a Virgin and Child enthroned) to which the figures portrayed showed reverence. The Scottish coat of arms with the lion presented directly above the young Prince James was purposefully reversed so that it did not 'turn its back' on the central religious figures.

Henry VII named his first-born son Arthur after the legendary King Arthur, and in art Henry likens himself to St George. Unlike a typical donor portrait where a patron saint presents the commissioner of a work of art to a religious group, or where the donor in small scale witnesses a religious scene, the Henry VII panel shows Henry on roughly the same scale as St George (the King is slightly smaller although he is in the foreground). The two elements of the painting overlap completely, so that the viewer immediately imagines that the Tudor family are *in situ* witnesses to St George's acts of heroism. The tents are reminiscent of those at a tournament or on a

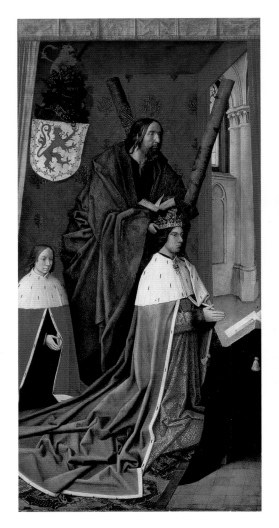

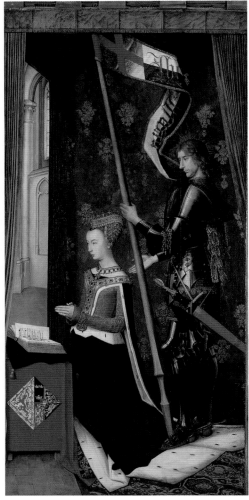

battlefield. St George is shown in full armour and, unusually, he has not yet killed the dragon (in contrast to the more popular format – see fig. 8, Raphael's *St George and the Dragon*, *c*.1506). Instead he is depicted mid-fight, with the dragon positioned higher up than the saint, who is compelled to inflict a deadly blow with his sword if he is to survive. Such a depiction of St George and the dragon eye to eye is rare, and intensifies the sense of drama. Beast and hero meet suspended in action, the horse's legs in a 'levade' position, ready to jump, the dragon with claws outstretched, poised to

attack, whilst the princess and the lamb serve as a gentle foil to the violence. In *The Golden Legend* by Jacobus de Voragine, written in Italy *c*.1260, we read that the entire sheep population of the terrorised town had been surrendered to the dragon before the humans were subsequently sacrificed at random.[6]

Why has the artist depicted the two pictorial elements on the same battlefield? Part of St George's lance lies broken on the ground, directly above King Henry's sceptre. The princess is shown wearing a robe and gown not dissimilar to that of the English royal

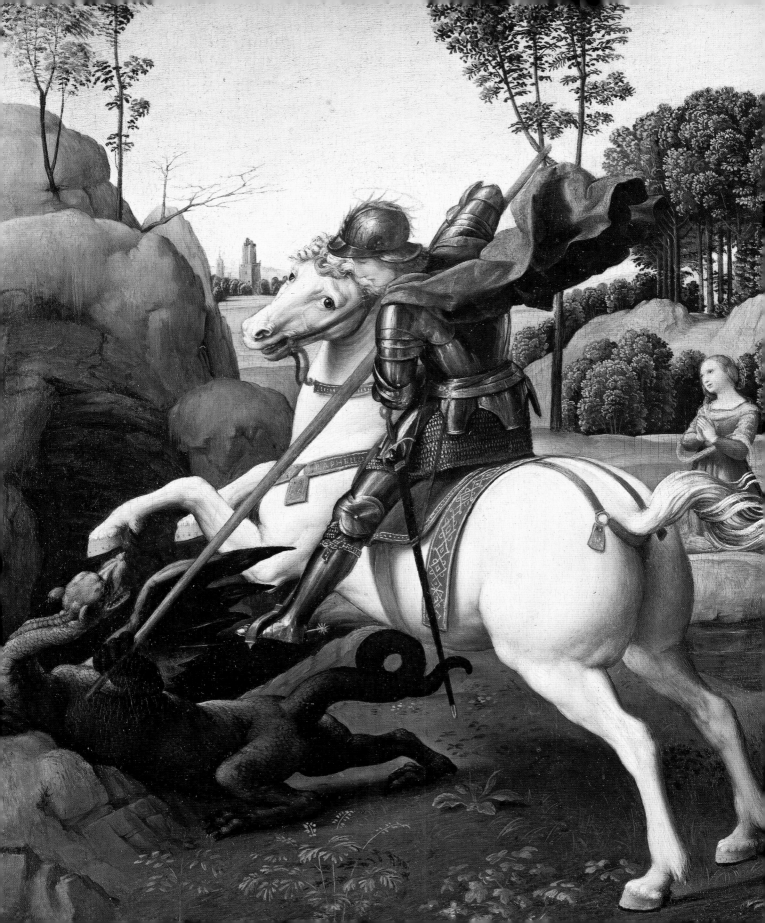

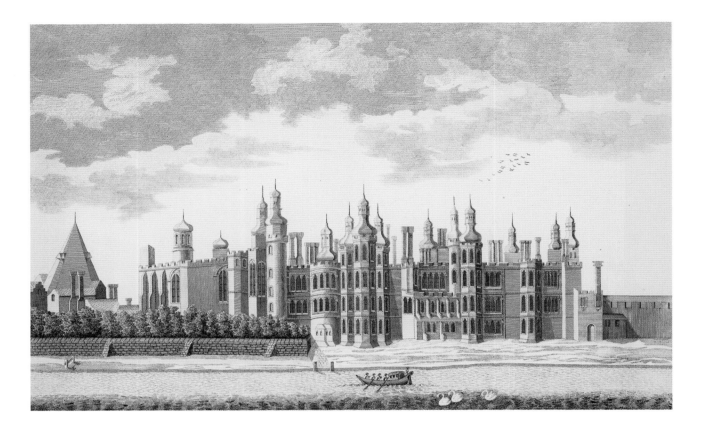

FIG. 9 James Basire (1730–1802), *View of Richmond Palace*, 1765. Engraving, 33.4 x 48.8 cm. Royal Collection (RCIN 703003)

princesses depicted below. She kneels with her hands in prayer, the attitude adopted by the royal family below, and the white lamb by her side is innocent and pure like the royal children. It would seem that in commissioning this painting, Henry wished to associate his dynasty with the glory of the heroic national saint. The backdrop of the scene is a town with fantastical-looking towers, symbolising the prosperity and civilisation which St George protects from danger. The onion-shaped dome of the tower between the horse and the dragon bears a slight resemblance to those at Richmond Palace (fig. 9). This may lend weight to the suggestion that the painting was intended for the chapel within the palace.

The aspiration to unite the symbolism of the new Tudor dynasty with that of St George signifies Henry VII's desire to emulate his great forebear Edward III (1312–77). Henry's claim to the throne came via his mother, who was the great-granddaughter of John of Gaunt, third son of Edward III. Edward's strong devotion to the saint led to the adoption of St George as patron saint of England. He also founded the chivalric Order of the Garter in 1348, for which St George was the third patron (after the Holy Trinity and the Virgin Mary), and the symbolic figure featuring on the Order's badge. According to *The Golden Legend*, St George was a heroic saint who defeated heresy (personified in the dragon) by spreading Christianity. Henry VII fought on the battlefield at Bosworth on 22 August 1485 in order to overcome the divisions of the Wars of the Roses. The 'religion' that he was spreading was of a new dynasty that could bring stability to the nation, and an end to the uncertainties surrounding the claim to the English throne.

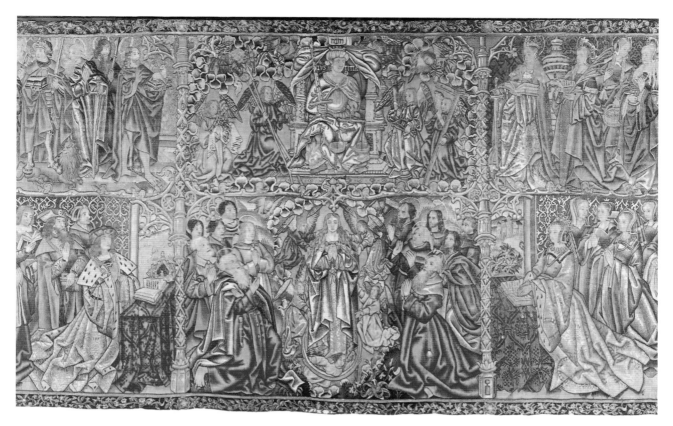

Henry VII was not only interested in establishing the future Tudor royal entitlement; he also wanted to create links with successful kings of the past, a desire that is evident in his mission to achieve sainthood for Henry VI (as mentioned above). In St Mary's Hall, Coventry, a tapestry panel survives depicting *The Glorification of the Virgin with attendant saints and the family and court of Henry VI* (fig. 10). It has been dated on stylistic grounds to the last decade of the fifteenth century and it appears to have been either made for Henry VII, who might have then presented it as a gift to the city, or commissioned by the civic authorities in Coventry to coincide with the 'cult' of Henry VI instigated by Henry VII.[7] In the tapestry the male and female figures are divided into groups, males on the left and females on the right, much as in the *Family of Henry VII* panel

(fig.3). The King and Queen kneel at prie-dieux and the focus of their attention is a scene of the Glorification of the Virgin in the centre.

The combination of secular and religious imagery was not a new phenomenon. An important precedent is the *Wilton Diptych*, painted for Richard II around 1395–9 (fig.11), and depicting the King on the left-hand panel kneeling on the hard ground of this world, being presented by his patron saints (two of whom are English kings) to the Virgin and attendant angels, who stand in the right-hand panel upon the flowery meadow of Heaven. The way in which the Christ Child blesses the kneeling King is reminiscent of the Adoration of the Magi. This may give a clue to Richard's chief source of influence: the painted decoration of St Stephen's Chapel, Westminster, commissioned by Edward III *c*.1355–63. The

FIG. 11 English or French School, *Richard II
presented to the Virgin and Child by his patron saints
John the Baptist, Edward and Edmund (The Wilton
Diptych)*, c.1395–9. Egg tempera on oak,
53 x 37 cm. London, National Gallery

east end of the chapel had a principal scene of the Adoration of the Magi, below which were depicted quarter life-size kneeling figures of St George, King Edward, Queen Philippa (1314–69) and their children. These frescoes were destroyed in the fire of 16 October 1834, but fortunately drawings were made by Richard Smirke in 1800 (figs 12 and 13). The King and his family would have appeared as though they were paying homage to the Christ Child, like the biblical kings or magi (wise men) depicted above them.

In the *Wilton Diptych*, the orb above the flag incorporates a minute depiction of England, represented by a green island and a white castle.[8] The King appears to have given England to Christ, who blesses and returns it. This takes the imagery one stage further than in the Edward III frescoes: there is no need for the magi to appear since Richard is interacting directly with the infant Christ Child. Some of the angels point to Richard as though in recognition and the King seems at home in this celestial company. This may also reflect the belief that the king was by divine right permitted to speak directly to God. The belief derived from the view that the act of anointing during the coronation ceremony conferred on the sovereign a status more elevated than that of the priesthood, an argument with the Church that would become essential to Henry VIII in the sixteenth century.[9]

The attendant angels in the *Wilton Diptych* wear badges with Richard's personal emblem,

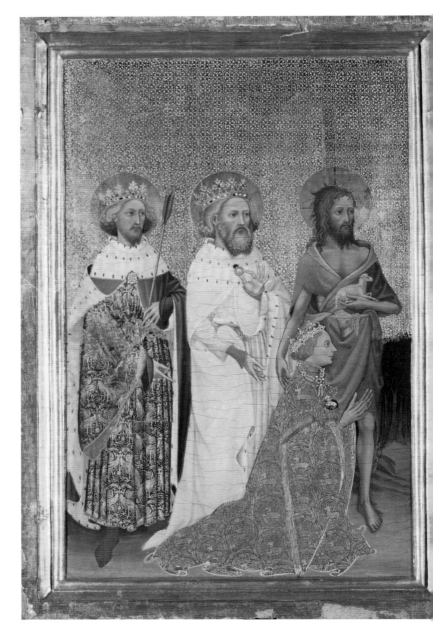

the white hart, and one of them holds the flag of St George – almost as though they were in the King's employ, just as St George's horse in *The Family of Henry VII with St George and the Dragon* sports the Tudor rose on its bridle buckle (see detail, fig. 14). There are other examples of such anachronistic 'ownership' of religious figures in art. In *St George and the Dragon* by Raphael, *c.*1506 (fig. 8), the saint is depicted wearing a garter emblazoned with the word *HONI*. This comes from the motto of the Order of the Garter, *Honi soit qui mal y pense*, meaning 'Disgraced be he who thinks ill of it'. The saint is portrayed as though he were a knight of the Order. He becomes the Garter Knights' ultimate symbol, epitomising, through his heroism, the organisation's aims as a chivalric order.

It seems certain that Raphael's *St George* was commissioned by Guidobaldo da Montefeltro, Duke of Urbino, to celebrate his investiture as a Knight of the Order of the Garter in 1504.[10] It was once believed that the Duke intended the painting as a gift to the English King, Henry VII, in acknowledgement of the honour bestowed upon him, which seemed to explain Charles I's ownership of the painting. In fact Charles I acquired it around 1625 from the 4th Earl of Pembroke in exchange for a book of Holbein drawings.[11] This suggests that the painting was commissioned by the Duke for his own collection as a token of his allegiance to the Order of the Garter and to its patron saint. Its subsequent acquisition by

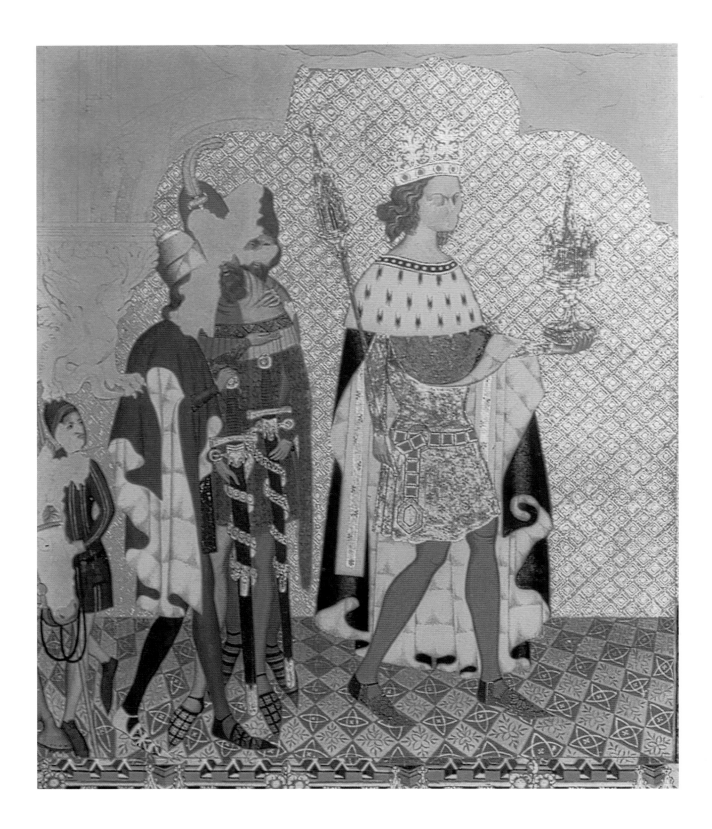

Charles I made it an important image for the iconography of the English royal family.

Occasionally portraits appear to have been used as substitutes for the monarch's presence. An early example of this is the portrait of Richard II, known as the *Westminster Portrait*, at Westminster Abbey, c.1395 (fig. 15). This unique, over-life-size, full-length and full-frontal portrait of the monarch enthroned is the earliest surviving image of its kind. Richard II is crowned and holds the sceptre and orb. He looks squarely out of the painting with an impassive expression. Here is an image of a king as he would have been expected to appear, resplendent in glory and filled with an unearthly confidence. It has been suggested that this painting was devised for the specific purpose of representing Richard II at any occasion that he could not physically attend –

possibly it was attached to a choir stall, and the viewer was intended to genuflect before it.[12] Certainly this panel with its iconography related to the enthroned full-frontal figure of Christ in Majesty was invested with the power to stand in place of the King.[13]

Great aristocratic collections of the sixteenth century, such as those formed by Bess of Hardwick, Lord Lumley and Lord Leicester, contained groups of royal portraits. The inventory of Charles I's collection, compiled in 1639 by Abraham Van der Doort, the surveyor of the King's pictures, lists 'Nyne old heads' hanging at Whitehall Palace.[14] These sets tended to comprise small-format images painted on panels with integrated frames. The style of these works appears to have derived from early compact (and therefore easy to transport) portraits used as diplomatic gifts or to advertise the

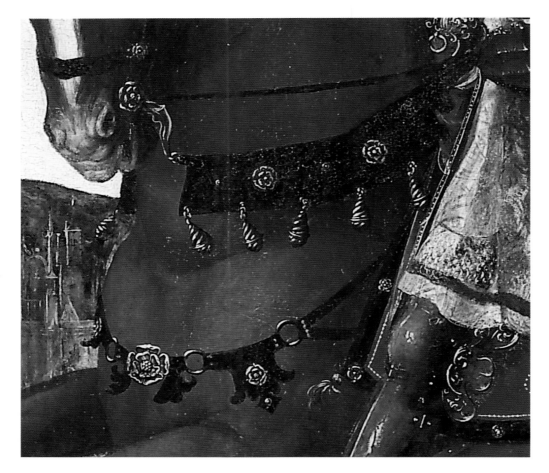

LEFT:
FIG. 14 Flemish School,
*The Family of Henry VII with
St George and the Dragon*
(detail of bridle buckle
embellished with Tudor
roses), *c.*1503–9. Oil on panel,
145.6 x 142.6 cm.
Royal Collection
(RCIN 401228)

beauty of prospective brides or grooms in dynastic marriage arrangements. Five early portraits in this fashion survive in the Royal Collection and would probably have been the core of the set identified in Charles I's picture-hang at Whitehall. These are Henry V, Henry VI, Edward IV, Elizabeth Woodville (wife of Edward IV; 1437–92) and Richard III (figs 16–20). They all (with the exception of *Elizabeth Woodville*, fig. 16) date to around 1500–1520.[15] The royal sitters were dead long before these portraits were made; the 'like-nesses' must therefore have been derived from previous images, some of which were presumably taken from life.

These five panels were first recorded in the inventory of 1542 and then again in the inventory of the works in Edward VI's collection recorded on his accession in 1547.

The portrait of *Elizabeth Woodville* has been

FIG. 15 Anon., *Portrait of
Richard II* (*The Westminster
Portrait*), *c.*1395. Oil on panel,
213.5 x 110 cm. London,
Westminster Abbey

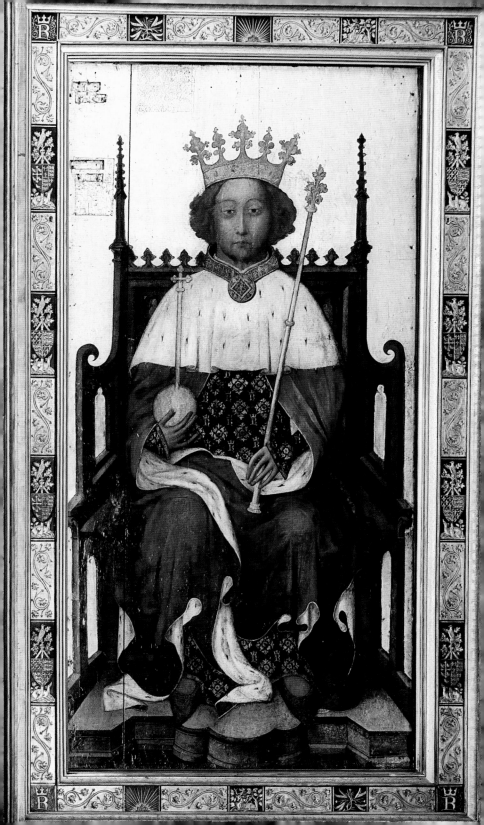

painted at some later point in its
h colours the view of it today. The
ctangular but originally had a
. Presumably it was squared off in
more readily with the other paint-
set. The rounded top is a slightly
ention (see figs 23a and b), which
it there is every possibility that the
rait dates from as early as c. 1471–80
the earliest surviving portrait of
Queen.[16]

fig.17), like Richard II in the *Wilton*
. 11), is shown in strict profile – a
the convention, dating from Clas-
that rulers are shown in this way
nd medals. The naked eye can
inges that the artist made to the
Henry VI (fig. 19), with creative
ng marking out the contours of eyes
id an easily discernible change to
of the hat to make it lower. The
ing indicates that the image was
ie artist on the panel itself, with the
that this was a prime painted ver-
copies of the same portrait (e.g. the
he National Portrait Gallery that is
40) must derive from the Royal Col-
l. The portrait of *Richard III* (fig. 20)
ar in format and style to the *Henry V*
I panels and all three share a sim-
terned background. This suggests
hree portraits may have been cre-
same workshop, most likely the
Northern European artist, since it
nable to employ artists from the
s at this date. The sophisticated

Fig. 16 British School,
Elizabeth Woodville,
c.1471–80. Oil on panel,
37.6 x 27 cm
(including additions).
Royal Collection
(RCIN 406785)

Fi
He
O
Rc
(R

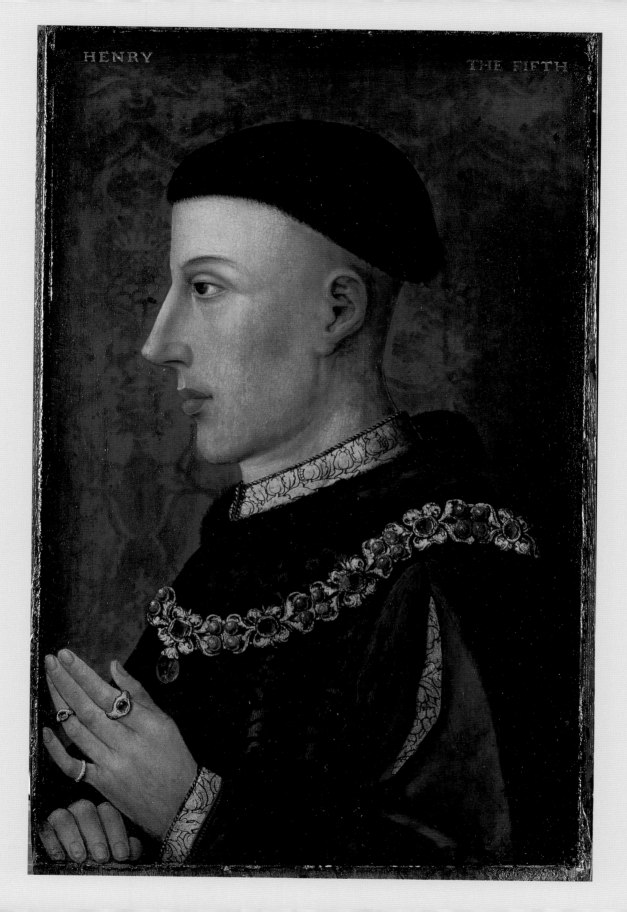
HENRY THE FIFTH

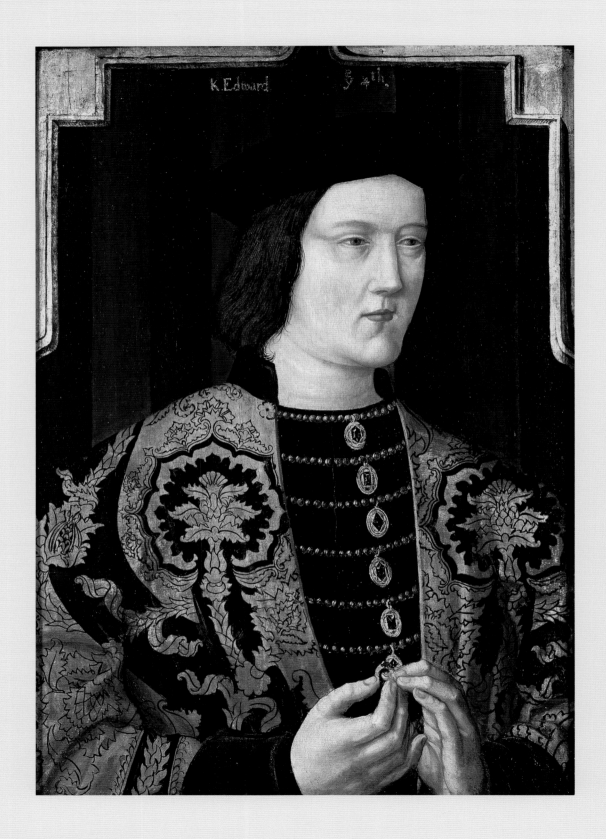

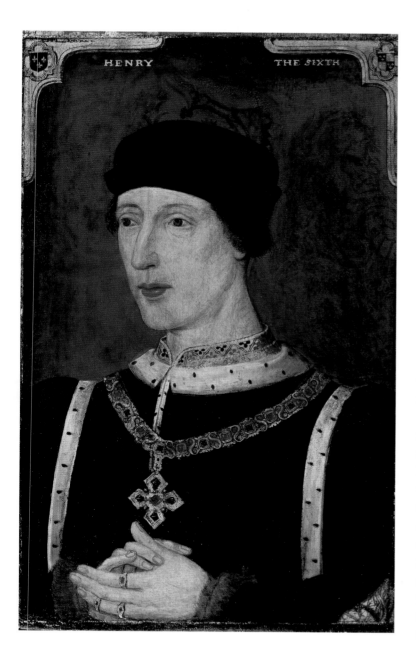

HENRY THE SIXTH

underdrawing in the *Henry VI* panel may simply be the work of a skilled assistant within the workshop.

The *Edward IV* panel (fig. 18) differs from the prominent red-and-black colour scheme of the three other king portraits, possibly indicating that it came from a different artist's workshop. The King is swathed in a rich gold brocaded gown. He holds a ring in his hands, a familiar symbol of wealth and power. The panel is slightly larger than the three discussed above, but it is close enough in size to function as part of the set, which was probably devised by Henry VIII early in his reign and intended to be hung together. The presence of these panels in the 1542 inventory of Henry VIII's collection informs us that they are some of the earliest surviving portraits of this type. Their royal provenance would have made them ideally suited to be official prototypes, from which other versions could derive.

Shortly after its creation, and probably during the reign of Henry VIII, the *Richard III* image (fig. 20) was altered. The outline of the King's right-hand shoulder (the left shoulder as we look at the painting) was extended upwards in an arch from the elbow to the neck so that one shoulder was made to seem higher than the other, creating the impression of a hunched back. Many portraits exist showing Richard as a hunchback, but the Royal Collection example is the only one that appears to have been altered in order to transform symmetrical shoulders into a distorted posture. If we apply what we have observed regarding these portraits, *Richard III* was probably originally created

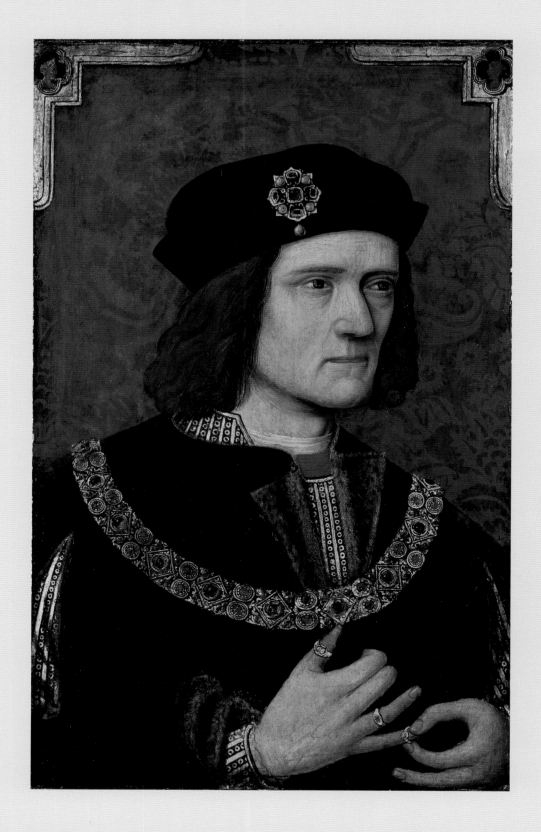

LEFT:
Fig. 20 British School,
Richard III, c.1500–1520.
Oil on panel with later
overpaint, 56.5 x 35.6 cm.
Royal Collection
(RCIN 403436)

RIGHT:
Fig. 21 Anon., *Richard III*,
late sixteenth century.
Oil on panel, 63.8 x 47 cm.
London, National Portrait
Gallery

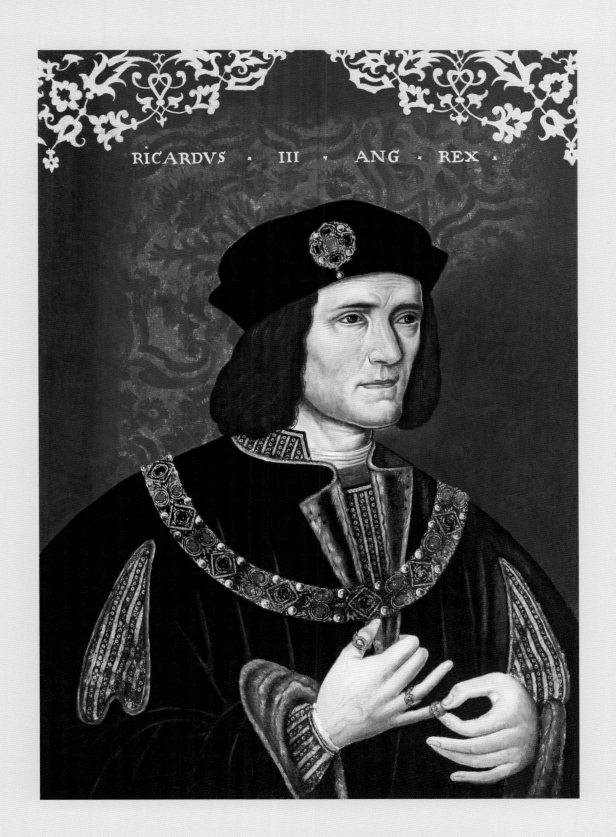

RICARDVS · III · ANG · REX ·

following a portrait drawing. As well as forming part of a set, the painting was intended to function as a pattern for other versions to follow. The figure of Richard was altered to make it seem more grotesque, possibly as a way of 'finishing' the painting after it had been faithfully copied from the drawing. Richard's right shoulder was rounded to make it appear hunched, the eyes were overpainted to appear steely grey and the mouth was turned down at the corners.[17] It is tempting to suggest that these changes were carried out at the orders of Henry VIII in an attempt to discredit the King yet further. If we compare the portrait to a later sixteenth-century version of the same painting (see fig. 21), it is apparent that the earlier Royal Collection painting was used as the model for the later panel, which faithfully repeats Richard's shoulder-line and facial expression.

The History of King Richard III written by Sir Thomas More around 1513 may provide evidence for such alleged Tudor-sponsored propaganda against Richard III. Allegiance to Henry VIII probably motivated More (who later entered royal service in 1517) to tarnish Richard III's reputation. He described the Yorkist King as 'little of stature, ill-featured of limbs, crook-backed, his left shoulder much higher than his right, hard-favoured of visage, and such as in states [noblemen] called warlike, in other men otherwise. He was malicious, wrathful, envious, and from afore his birth ever forward [perverse/awkward]'.[18] It is almost as though the artist who tampered with fig. 20 was referring to this text, or as though More was referring to the altered painting. The only dis-crepancy is in the identification of the hunched shoulder. This could be due to an intended function of the portrait as the basis for engravings and subsequent prints – wherein the image would be reversed – or perhaps because it did not really matter to Richard's detractors which shoulder was higher, as long as he appeared with distorted posture.

An anonymous portrait of Henry VII in the National Portrait Gallery was made with a different aim in mind (fig. 22). The King rests his hand on an illusionistic ledge on which is inscribed a Latin text informing the viewer that it was created on 20 October 1509 as a commission from Herman Rinck, the agent of the Holy Roman Emperor Maximilian I (1459–1519). In 1509 Henry VII was investigating the possibility of marrying Maximilian's daughter, Margaret. This portrait was created to be sent to the prospective bride for approval. Strange as it may seem to modern eyes, this harsh portrayal was the carefully constructed image of himself that the English King wanted Margaret and, more importantly, her father to see. It is an unforgettable portrayal of a strong, calculating character. Rather than the Order of the Garter, Henry prominently sports the collar of the Order of the Golden Fleece, the order established by Philip the Good, Duke of Burgundy (grandfather of Mary of Burgundy, Maximilian I's wife), in 1430. Typically, Henry's diplomatic victory in ending the Wars of the Roses is alluded to; he holds a Tudor rose prominently in his right hand as though proffering it, and by association himself, to the Emperor's daughter.

It seems extraordinary that no artist's name

FIG. 22 Anon., *Henry VII*, 1509. Oil on panel, arched top, 42.5 x 30.5 cm. London, National Portrait Gallery

Anno 1 5 0 5 29 octobz jmago henzirh vii trauccigz zegc illustzessim
ozdinata p hznismm zwck Yo zegie cliuczium · ·

can be securely associated with such a vivid and insightful portrait, but in this period it is notoriously difficult to match the names of artists mentioned in documents with paintings which survive today. In 1502, a few years before the creation of fig. 22 and in similar circumstances, depictions of Henry VII, Elizabeth of York, Prince Henry and Princess Margaret were sent to the Scottish King James IV. The records show a payment for these portraits made to the artist Maynard Waynwyck, a Flemish specialist portrait painter who was on the royal payroll from 1502 until 1520.[19] These were presumably sent at the time of the negotiations for the marriage of Princess Margaret and the young King. Unfortunately in this case there are no surviving paintings to accompany this otherwise unknown name.

We can perhaps deduce the function – if not the authorship – of two portraits that do survive in the Royal Collection. They depict the Spanish monarchs Ferdinand (1452–1516) and Isabella (1451–1504), the parents of Katherine of Aragon (figs 23a and b). First recorded in Henry VIII's 1542 inventory, they conform to the same portrait type as the Royal Collection's early royal portrait set mentioned above. They are small scale and portable, and are likely to have been sent as diplomatic gifts to England from Spain during the marriage negotiations of Katherine of Aragon and Prince Arthur (who married on 14 November 1501). A very similar portrait of Prince Arthur (1486–1502) was listed in the 1542 inventory. It shows the young Prince holding a gillyflower (carnation) in his right hand (fig. 24). Perhaps, in a similar man-

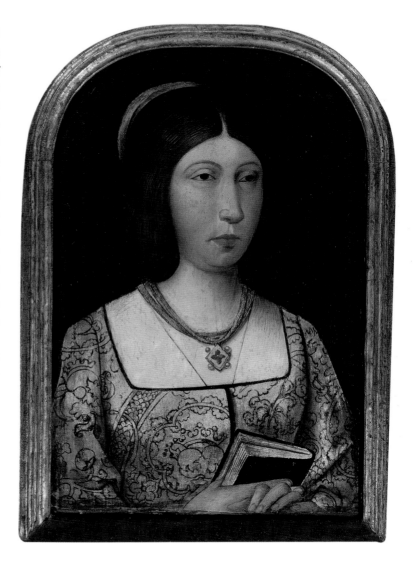

FIG. 23a Spanish School, *Queen Isabella I of Castile and León*, c.1470–80. Oil on panel, 37.4 x 27 cm. Royal Collection (RCIN 403445)

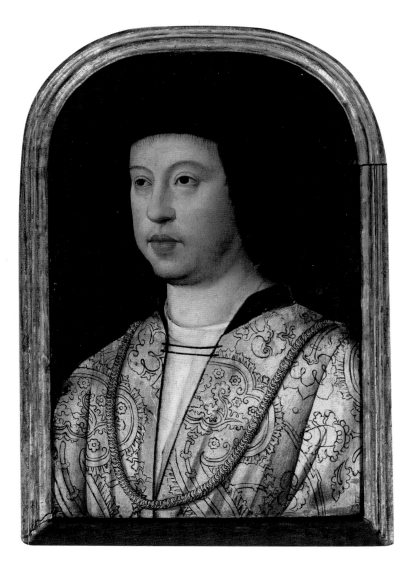

Fig. 23b Spanish School,
King Ferdinand V of Spain,
*King of Aragon, c.*1470–80.
Oil on panel, 37.4 x 27 cm.
Royal Collection
(RCIN 403448)

ner to the *Henry VII* portrait (fig. 22), this image was sent to Katherine of Aragon for her (and her parents') approval. She then conceivably brought it to England with her, so that it later became part of Henry VIII's collection after his marriage to his former sister-in-law in 1509.

Royal portraits were not always created with such serious intent. Occasionally artists were commissioned to create likenesses for more personal reasons. For instance, a painted terracotta bust of a young boy in the Royal Collection was probably made for private pleasure (fig. 25). It has been variously recorded in inventories as a girl, a dwarf and a Chinese boy.[20] However, the combination of royal provenance and the boy's rich clothing, suggest that this might be a portrait of Henry VIII at about the age of seven (*c.*1498). The Italian sculptor Guido Mazzoni created an image that is exceptionally lifelike and vibrant, a remarkable contrast to the formulaic representation of the Prince in *The Family of Henry VII with St George and the Dragon.* The little boy is cheekily depicted looking to his right, his eyes cast down at an angle as though he is about to turn and confront someone who is sneaking up behind him. If, as seems likely, this was a royal commission, it captures in an affectionate way the energy of the boy who, at this time, had a 12-year-old brother to shoulder the responsibilities of being heir to the throne.

In an age long before photographs it is difficult to make any judgement about a portrait's resemblance to its sitter. Five separate images of Henry VII (figs. 3, 4, 5, 22 and 26) are only

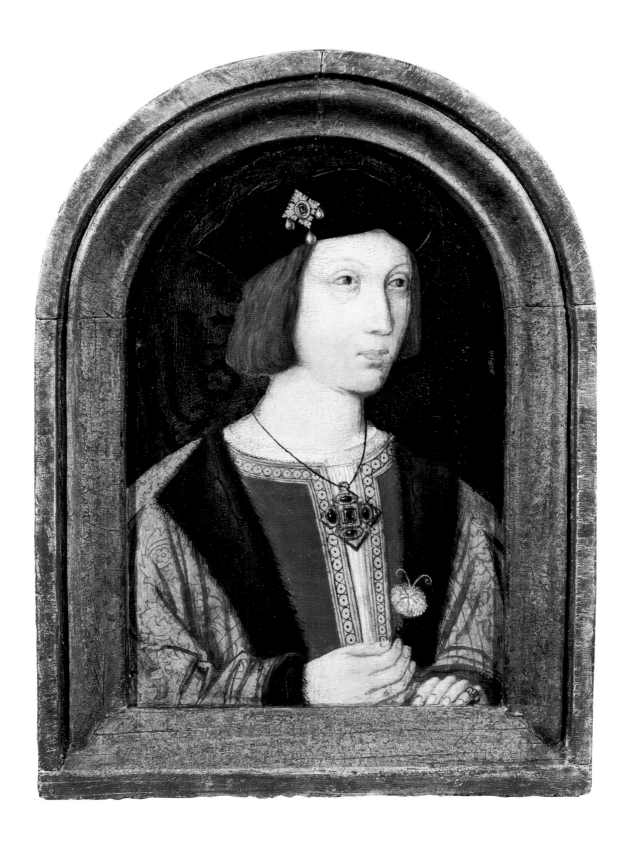

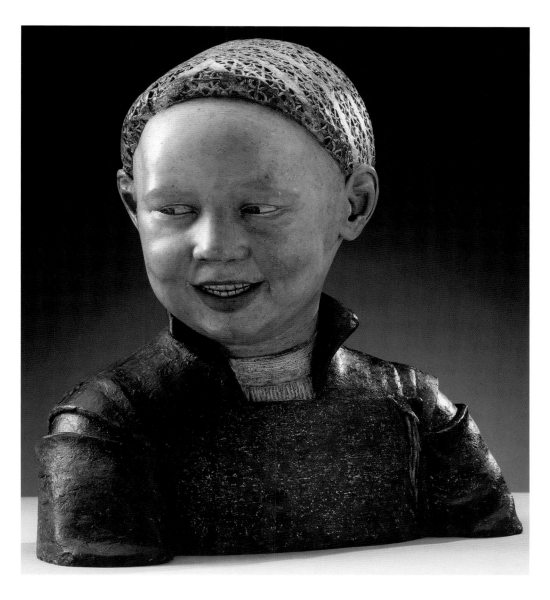

consistent enough to give a general idea of his physiognomy. The most reliable would seem to be the one based on a death mask (fig. 5), though death itself takes away the possibility of the image appearing 'life-like'. This group makes it clear that there is in the Renaissance a remarkable range of intention. Some portraits (such as fig. 22) seem to be concerned with the distinctness of a particular face at a particular time; others (such as fig. 3) show only the nobility of the office of the King and his flourishing family (ignoring the fact that only four out of the nine sitters were alive at the time the painting was executed). Without any comparison to the living person, we only judge the likeness of a portrait by its verisimilitude. When we assume that the *Laughing Child* (fig. 25) accurately records the features of a boy this is simply because to us, and in some general way, it looks real.

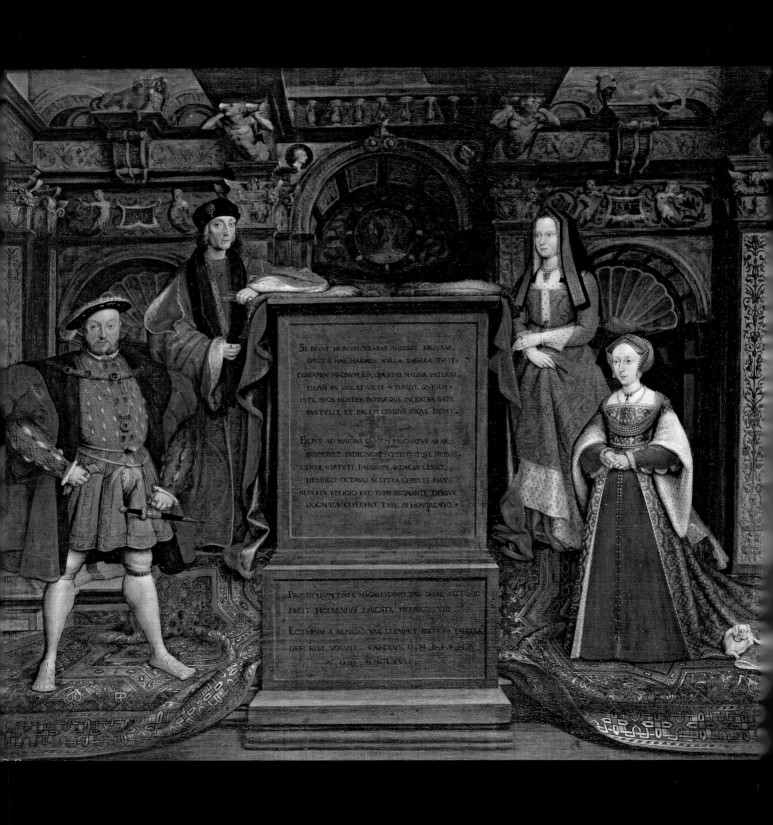

SI IVVAT HEROVM CLARAS VIDISSE FIGVRAS
SPECTA HAS MAIORES NVLLA TABELLA TVLIT
CERTAMEN MAGNVM LIS QVESTIO MAGNA PATERNE
FILIVS AN VINCAT VICIT VTERQVE QVIDEM
ISTE SVOS HOSTES PATRIÆQVE INCENDIA SÆPE
SVSTVLIT ET PACEM CIVIBVS VSQVE DEDIT

FILIVS AD MAIORA QVIDEM PROGNATVS AB ARIS
SVBMOVET INDIGNOS SVBSTITVITQVE PROBOS
CERTÆ VIRTVTI PARENTVM AVDACIA CESSIT
HENRICO OCTAVO SCEPTRA GERENTE MANV
REDDITA RELIGIO EST ISTO REGNANTE DEIQVE
DOGMATA CÆPERVNT ESSE IN HONORE SVO

PROTOTYPVM PISTÆ MAGNITVDINIS IPSO OPERE TECTORIO
FECIT HOLBENIVS IVBENTE HENRICO VIII

ECTYPVM A REMIGIO VAN LEEMPVT BREVIORI TABELLA
DESCRIBI VOLVIT CAROLVS II M B F E H R
A. D NI MDCLXVII

2

Henry VIII and Elizabeth I

*'A prince ought ... to show himself a patron of ability,
and to honour the proficient in every art.'*

NICCOLÒ MACHIAVELLI, *The Prince*, WRITTEN 1513, FIRST PUBLISHED 1532

As THE DIRECT RESULT of a portrait, the image of Henry VIII is universally recognisable. This was the group portrait commissioned in 1537 for a wall painting at Whitehall Palace (fig. 26). The painting embodies Henry's interest in image-making, inherited from his father, which he built upon to a remarkable degree so that the impact of the images created still resonates five hundred years later. But the King was not working alone. He introduced an artist to his court who transformed portraiture for ever. Through his direct patronage of Hans Holbein the Younger, Henry VIII (1491–1547) enabled the English court to stand comparison with the great European centres of the Renaissance.

The earliest paintings of Henry VIII's reign were unremarkable. *The Meeting of Henry VIII and the Emperor Maximilian* and *The Battle of the Spurs* seem to have been painted in or around 1513 and to have been commissioned directly by Henry VIII (figs 27 and 28). Naively painted with a lack of spatial complexity, they function more as historical documents than as creative masterpieces. To a certain extent these works are portraits, and they both contain identifiable representations of Henry VIII.

The two horizontal-format paintings commemorate Henry VIII's early military triumph

in France. On 16 August 1513 the French troops of Louis XII were defeated outside the town of Thérouanne by the English. The latter had combined forces with the Holy Roman Emperor Maximilian I who – remarkably – fought for, as opposed to alongside, the English King. The speed with which the French cavalry retreated gave the event its name: the Battle of the Spurs. The conflict was crucial for Henry's image-making, as it enabled him to present himself as a heroic leader in the mould of Henry V. It is the main event in fig. 28, where the figure of Henry VIII is (with much artistic licence) portrayed on horseback in the centre of the mêlée, the French Chevalier Bayard kneeling before him in surrender. In the more ordered depiction of fig. 27 the battle is portrayed in the middle distance, the emphasis of the painting being Maximilian's graceful supplication to Henry's leadership.

The fact that in *The Meeting of Henry VIII and the Emperor Maximilian* the protagonists require labels to identify them (IMPERATOR / MAXIMILIAN and HERICVS OCTAVVS / REX-ANGLIÆ) suggests that these are intended as symbolic representations of the rulers rather than as realistic likenesses. Artistically the two paintings are not sophisticated enough to stand comparison with the prevailing art of the time,

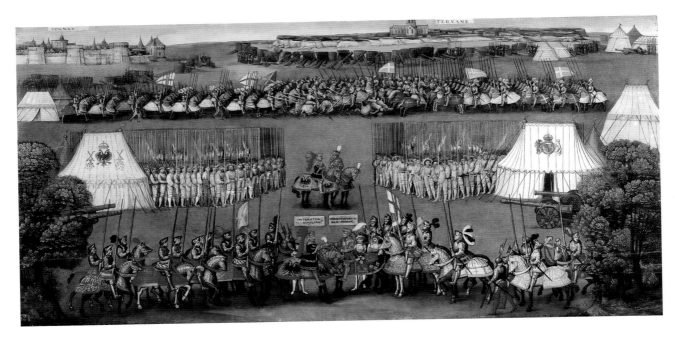

especially when we consider that their creation coincides with the careers of Titian, Raphael and Dürer on the Continent. When placed in direct comparison with Italian art, the nearest in style to *The Battle of the Spurs* (1513) would seem to be a fresco scene painted in Siena nearly two hundred years earlier (fig. 29). The rendering of landscape background without recourse to single-point perspective is charming, but artistically old-fashioned and unadventurous.

Henry VIII appears to have been obsessed with the details of his appearance. Two miniatures in the Royal Collection demonstrate the King's interest in keeping up with the latest fashions (figs 30 and 31). Painted around 1526, they show Henry aged 35, both without and with a beard. We know this was a preoccupation of

Henry's as in August 1519 he announced his intention to wear a beard until his meeting at the Field of the Cloth of Gold with the French King Francis I (1494–1547) in June 1520, possibly in order to emulate Francis I's fashion. According to records he had shaved it off by November 1519, apparently following the wishes of his Queen, Katherine of Aragon.[21] Katherine may simply have disliked bearded men, or alternatively, as the aunt of the Spanish King and Holy Roman Emperor Charles V, she may have discouraged the wearing of a beard, wary of Henry visually allying himself with the French King. The deliberate likening of the images of the French and English kings, particularly in terms of costume, may be seen by comparing portraits of Henry and Francis I (figs 32 and 33). This visual alignment belies the turbulent nature of

FIG. 27 Flemish School, *The Meeting of Henry VIII and the Emperor Maximilian*, c.1513. Oil on panel, 99.1 x 205.7 cm. Royal Collection (RCIN 405800)

TOP RIGHT:
FIG. 28 Flemish School, *The Battle of the Spurs*, c.1513. Oil on canvas, 131.5 x 264.2 cm. Royal Collection (RCIN 406784)

BOTTOM RIGHT:
FIG. 29 Ambrogio Lorenzetti (c.1290–c.1348), *The Effects of Good Government on the Countryside*, 1338–40. Fresco. Siena, Palazzo Pubblico

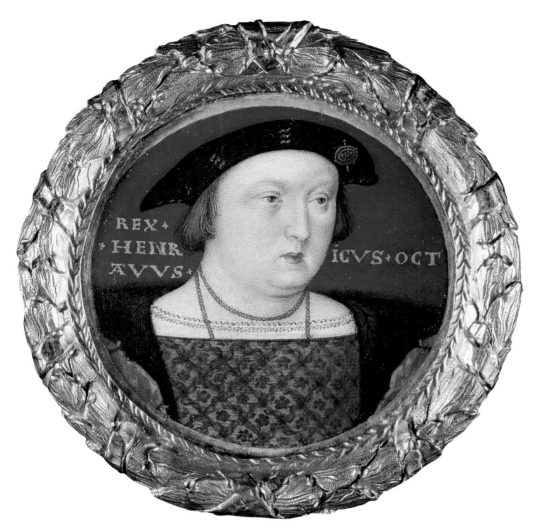

Fig. 30 Lucas Horenbout (1490/5?–1544), *Henry VIII*, c.1526. Watercolour and bodycolour on vellum, diameter 4 cm. Shown here enlarged. Royal Collection (RCIN 420010)

their relationship, and may best be described as political manoeuvring coupled with a shared interest in fashion.

The meeting of the two kings at the Field of the Cloth of Gold (7–24 June 1520) was an extension of this image-making on behalf of the King. The encounter was set up by Henry in order to present an outward show of amicable relations between the two nations. No expense was spared in the lavish preparations for the eighteen-day spectacle that was held near Calais, with the English camp at Guisnes and the French

camp at Ardres. Henry always intended that the meeting would spread positive propaganda about the English and about his own magnificence. Equally at home on the battlefield as in the jousting arena, he took every opportunity to demonstrate the heroic qualities that he hoped would define him and his country. In 1517, following festivities held at the English court, the Mantuan ambassador Francesco Chieregato had reported in a letter to Isabella d'Este, Marchesa of Mantua: 'In short, the wealth and civilization of the world are here; and those who call the Eng-

FIG. 31 Lucas Horenbout (?) (1490/5?–1544), *Henry VIII*, *c*.1526. Recent research has suggested that this miniature may be by Lucas Horenbout's sister Susanna. Watercolour and bodycolour on vellum laid on card, diameter 4.8 cm. Shown here enlarged. Royal Collection (RCIN 420640)

lish barbarians appear to me to render themselves such … this most invincible king, whose acquirements and qualities are so many and excellent that I consider him to excel all who ever wore a crown.'[22] This is exactly what Henry wanted people to think of him, and of his nation. The meeting at the Field of the Cloth of Gold was a single, exceptionally elaborate component in a lifelong campaign to achieve the status of a true Renaissance prince.

Henry commissioned a large-scale history painting outlining the major occurrences that defined the meeting at the Field of the Cloth of Gold (fig. 34). It is difficult to date the painting with any certainty. The normal placing of the painting in the mid-1540s is suggested by the manner of the portrayal of the King (on horseback in the foreground). The facial features appear to derive from the type of portrait created by Hans Holbein in 1537 (discussed below). However, the circle of canvas on which this face is painted is an addition, inserted later than the rest of the canvas (see detail, fig. 35). It is possible that Henry so much approved of the

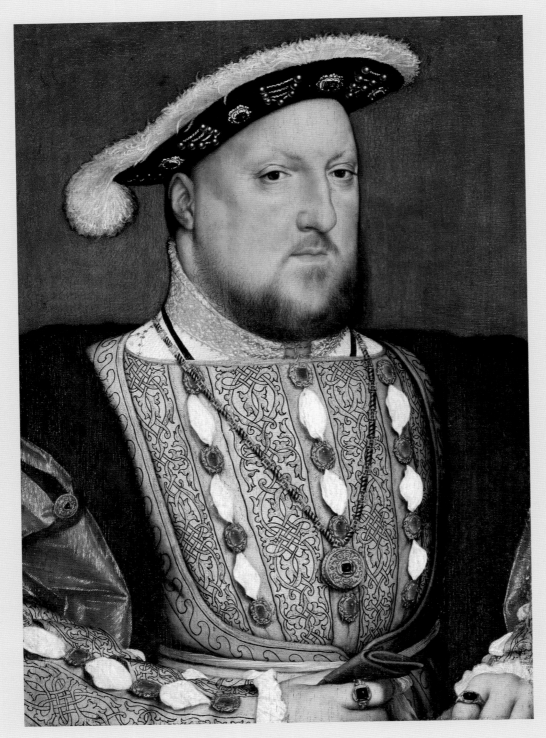

FIG. 32 Hans Holbein the
Younger (1497–1543), *Portrait
of King Henry VIII*, *c*.1537.
Oil on panel, 28 x 20 cm.
Madrid, Thyssen-Bornemisza
Collection

RIGHT:
FIG. 33 After Joos van Cleve,
Francis I, King of France,
c.1530–34. Oil on panel,
37.5 x 31.7 cm.
Royal Collection
(RCIN 403433)

OVERLEAF:
FIG. 34 British School,
The Field of the Cloth of Gold,
c.1520. Oil on canvas,
168.9 x 347.3 cm.
Royal Collection
(RCIN 405794)

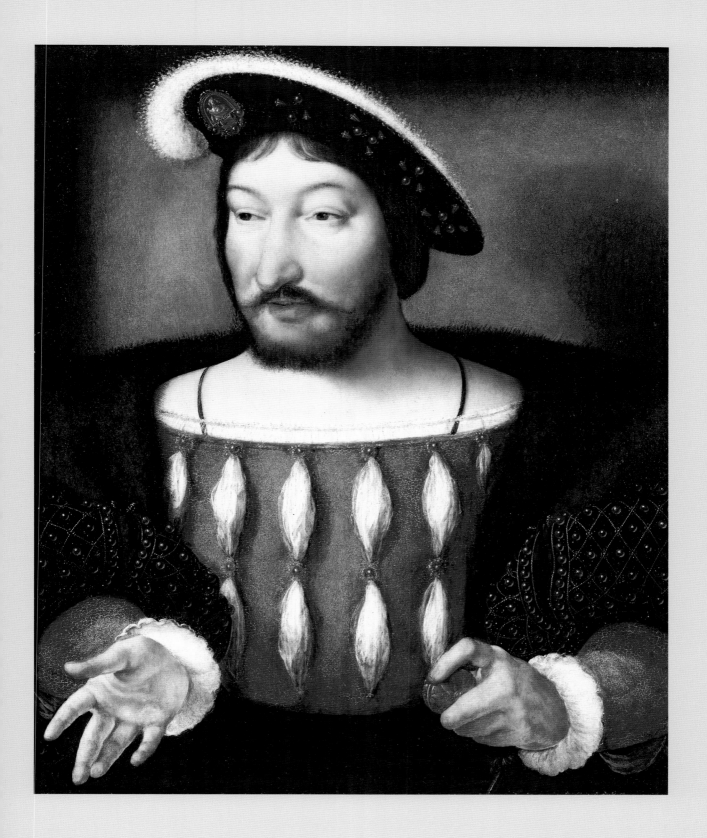

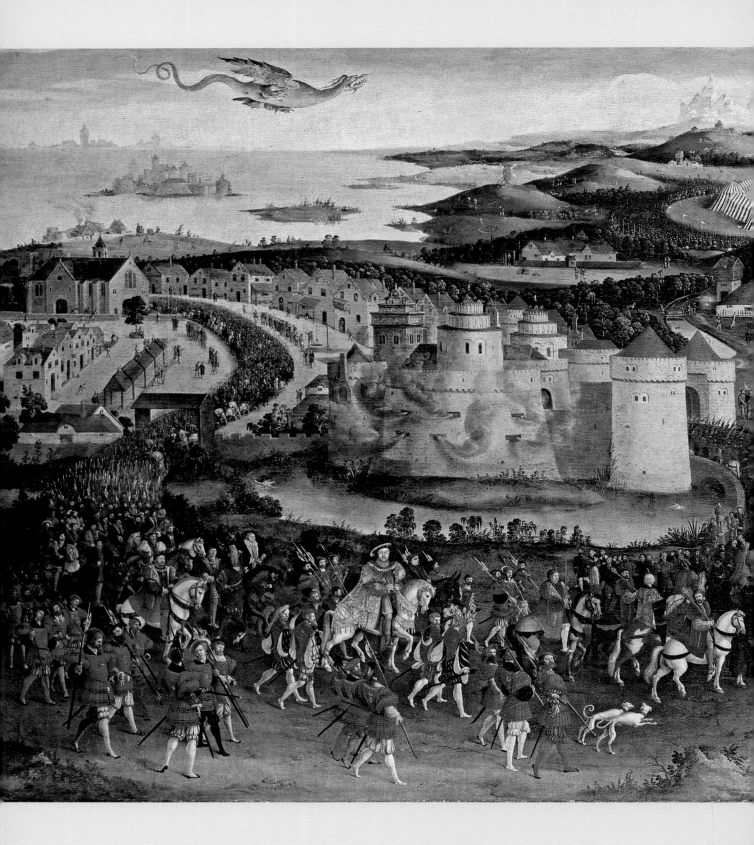

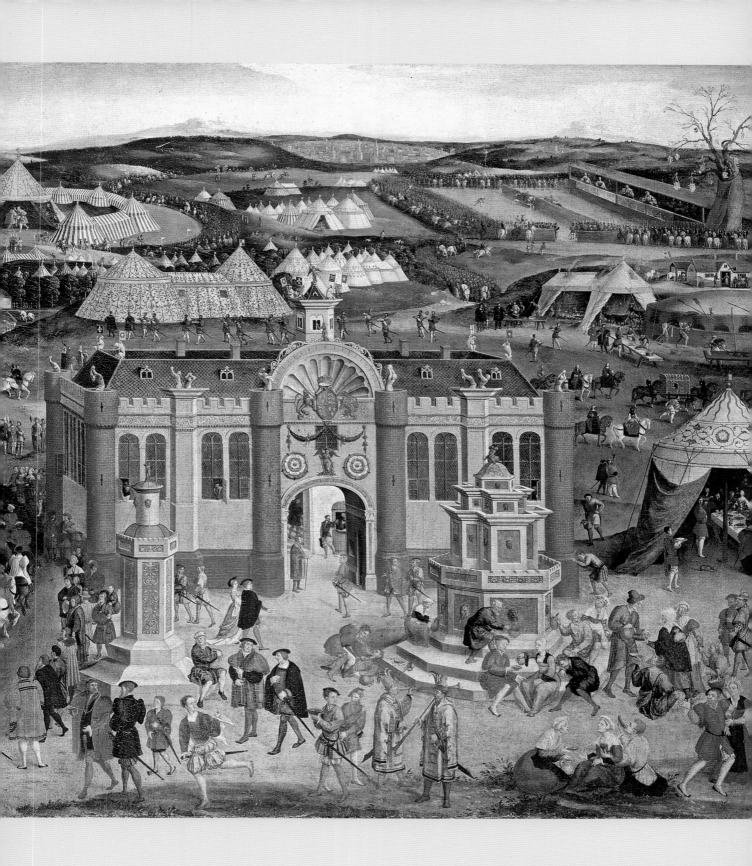

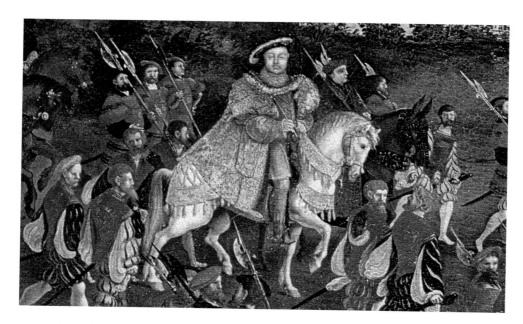

1. Calais
2. The Castle of Hammes
3. The Salamander firework
4. Henry VIII surrounded by his retinue
5. Guisnes Castle
6. The meeting of Henry VIII and Francis I
7. The temporary English castle, with fountains in front
8. The French camp at Ardres
9. The tournament field
10. Ovens and tents for preparing food
11. The tree of honour with shields of the tournament contestants
12. The King's dining tent

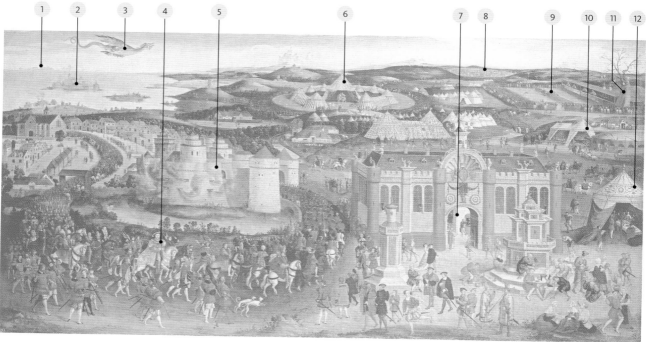

Holbein model that he wished to 'update' existing representations of himself, in which case the painting may be placed at the earlier date of *c.*1520; Henry is much more likely to have wished to commemorate the lavish event immediately, rather than 20 years later.

Although *The Field of the Cloth of Gold* does not appear in the 1542 inventory of works of art in Henry VIII's collection, it could be, as has been suggested, that this painting, along with a work traditionally considered to be its pair, *The Embarkation of Henry VIII at Dover* (fig. 37; showing the King and his retinue setting sail from Dover to Calais on 31 May 1520), were set into panels in Whitehall Palace as part of a frieze.[23] They would therefore have been seen as part of the fabric of the building (functioning in the same way as the *Whitehall Mural*) and not as individual items to be recorded in the inventory. If these two paintings were intended to hang together, the impact on the viewer would have been remarkable, serving as an elaborate and colourful reconstruction of the exuberance of Henry's ceremonial visit to France.

The Field of the Cloth of Gold contains three portraits of the English King: riding on horseback in the left foreground, watching the jousting in a tournament field in the right-hand distance and, most importantly, meeting Francis I in the gold tent in the centre background. In this pivotal moment, framed by the golden tent, the two royal figures merge in a companionable embrace, bringing to mind the description that the Duke of Norfolk gives of the event in Shakespeare's *Henry VIII*:

'Twixt Guynes and Arde –
I was then present, saw them salute
 on horseback;
Beheld them, when they lighted,
 how they clung
In their embracement, as they
 grew together,
Which had they, what four thron'd ones
 could have weigh'd
Such a compounded one?[24]

The artist's use of continuous narrative – the same figures appearing numerous times (see fig. 34) – gives this painting its naive quality and makes the point that content was regarded as of prime importance. The painting is intended to be 'read' from left to right, beginning with the journey of Henry VIII and his retinue to meet Francis I at the initial interview on Thursday 7 June 1520. The long procession of figures on foot and horseback have nowhere to go, since the castle that they appear to enter does not offer them any practical access out into the field beyond. The Salamander, a decorative firework to be released at the culmination of the festivities, flies above the scene as though surveying the 'view of earthly glory' below.[25] The focus is on the English King's lavish camp and retinue; the French camp, comparatively, is a small dot in the background of the painting, an incidental detail in the telling of this particular story.

This is not realistic reportage. The main aim of the painting was to convey the extravagance of the event through an assembly of impressive details. It is no accident that the English temporary palace, with the blended Tudor roses of red

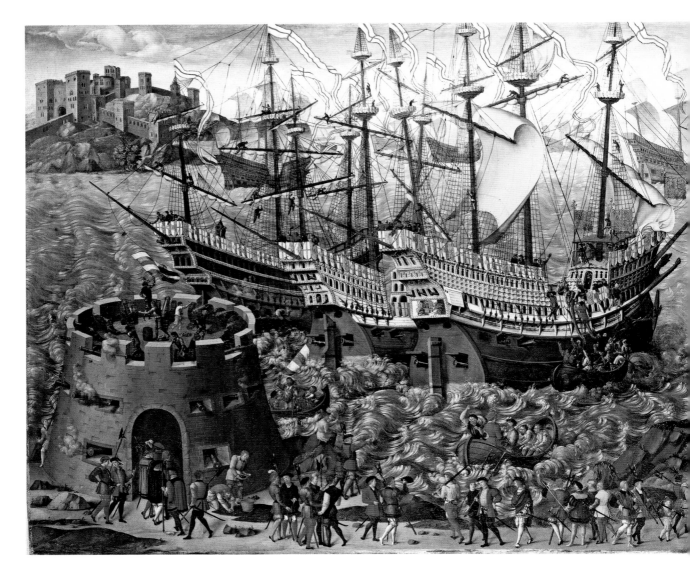

and white featuring prominently on the façade, is given disproportionate emphasis. The viewer can appreciate the apparent solidity of this structure with its brick towers, glass windows, decorated friezes above the cornice and two elaborate fountains supplying continuous streams of wine and beer. But in fact the palace walls were constructed of timber, covered in cloth painted to resemble stone. The Tudors were adept at the stagecraft of spectacle, creating the air of magnificence on a temporary basis.

The German artist Hans Holbein the Younger first visited London in 1526–8. In Basel he had painted three celebrated portraits of the humanist Desiderius Erasmus, through whom he was introduced to Sir Thomas More. He returned to England in 1532 and shortly afterwards was employed by Henry VIII, embarking on numerous court portraits of exceptional quality. Holbein remained in royal service until he died (probably of the plague) in 1543. Carel Van Mander, in his 'Lives of the Artists' of 1604,

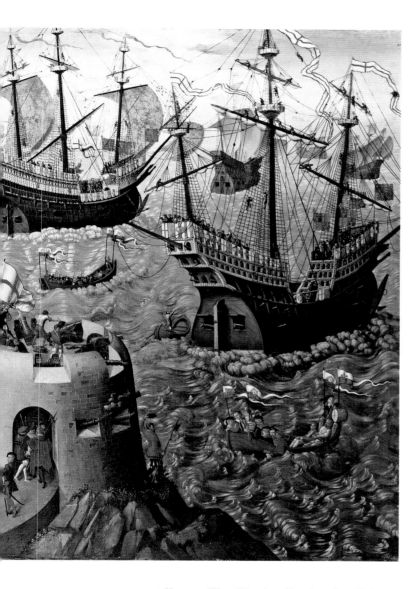

Fig. 37 British School, *The Embarkation of Henry VIII at Dover*, c.1520–40. Oil on canvas, 168.9 x 346.7 cm. Royal Collection (RCIN 405793)

powerful that it made the viewer feel as though it truly represented the monarch in all his intimidating splendour. The *Whitehall Mural*, which was created in 1537, depicted Henry VIII with his father, Henry VII, standing directly behind him. It was destroyed in a fire in 1698, but the design is known to us through a smaller-scale reproduction in the Royal Collection made by Remigius van Leemput in 1667 (fig. 26) and by the preparatory cartoon for the full-length figure of Henry (fig. 38). On the right-hand side of the painting are two further full-length portraits: Henry VIII's third wife, Jane Seymour (1509–37), and his mother, Elizabeth of York.

The fact that these life-size figures were painted directly on to the wall is essential to our comprehension of this image, as they literally became part of the fabric of the building. Henry, like his father before him, wished for a strong and lasting dynastic statement. It is no accident that the mural was devised in the year that, finally, a son was born to the King and Jane Seymour; the *Whitehall Mural* was a celebration of that birth. It must have seemed that God had smiled on him at last and had granted him a son as a sign of approval. Henry could build on the Tudor line that his father had begun. The Latin inscription on the plinth in the centre of the *Whitehall Mural* conveys this message: 'If it pleases you to see the illustrious images of heroes, look on these: no picture ever bore greater. The great debate, competition and great question is whether father or son is the victor. For both, indeed, were supreme. The former often overcame his enemies and the conflagrations of his country, and finally brought peace to its

tells us, 'The King's affection for Holbein increased, and he favoured him more and more, as the artist served him so well according to his wishes.'[26]

The impact of Holbein's *Whitehall Mural* is known from early sources. It was noted in 1604 that viewers of the painting were left feeling frightened in its majestical presence.[27] These are reactions that we would associate with a visitor's encounter with the King himself. Evidently the painting was so realistic and

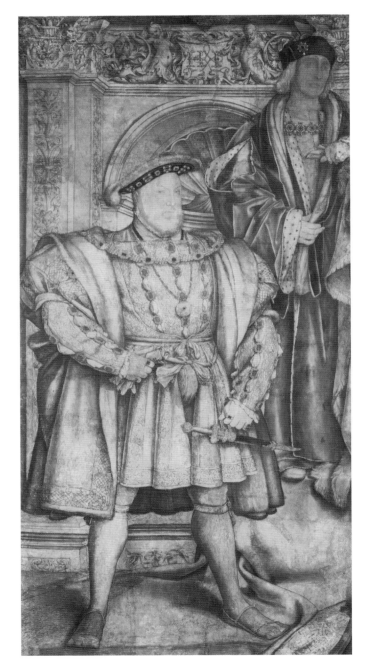

citizens. The son, born indeed for greater things, removed the unworthy from their altars and replaced them by upright men. The arrogance of the Popes has yielded to unerring virtue, and while Henry VIII holds the sceptre in his hand religion is restored and during his reign the doctrines of God have begun to be held in his honour.'[28] The use of the past tense here is revealing. Henry evidently expected this painting to live on long after his death as a testament to his achievements. He fully believed that the future of the Tudor dynasty was now assured and he was presenting himself and his father as powerful examples for his son to follow.

Comparison of the preparatory cartoon with the Van Leemput copy of the finished wall painting indicates that Holbein altered the stance of the King in the final composition, turning the figure from a slightly three-quarter angle to a full-frontal, more arresting stance.[29] The easily identifiable 'Holbein' depiction of Henry devised for the *Whitehall Mural* was widely disseminated in smaller-scale panel portraits, which vary between the full-frontal and the three-quarter profile models. The versions with the head turned at a slight angle (such as fig. 32, which is generally accepted as autograph) would probably have been based on an original (now lost) drawing for the Whitehall commission, taken from life and preceding the cartoon (fig. 38). Other, later, versions – showing the King looking squarely out at the viewer and depicted either standing full length or three-quarter length (fig. 39) – probably derive from the finished wall painting itself. The sheer number of these versions created throughout

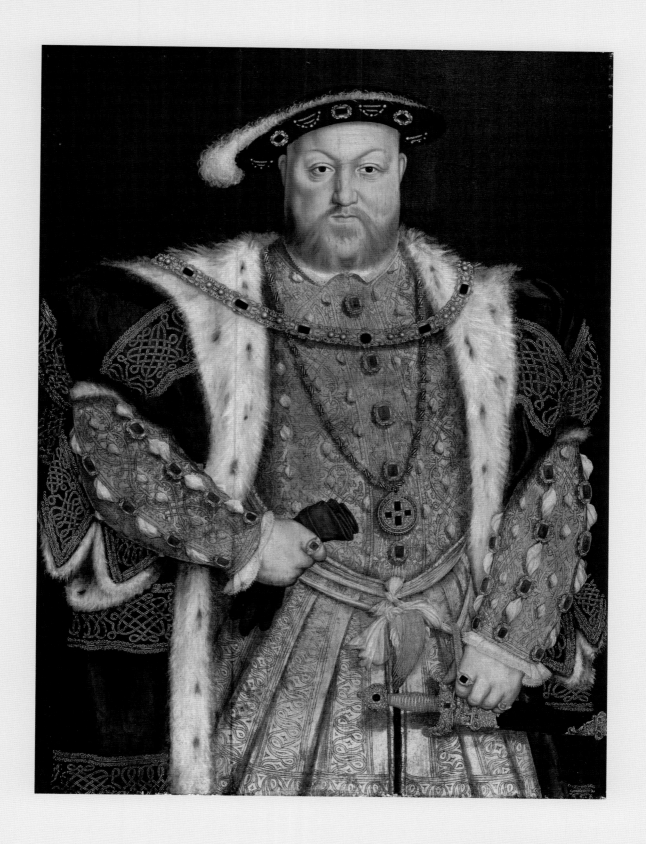

the sixteenth century and later indicates the timeless popularity of the image.

Another possible image of the King appears in a miniature of *Solomon and the Queen of Sheba* by Holbein (fig. 40). Perhaps commissioned by a courtier as a New Year's gift to the King, it was painted around 1534, the same year as Henry's break with Rome and the creation of the English Church. The central figure in the miniature represents King Solomon enthroned, but his face and posture bear a striking resemblance to Henry VIII. Whether or not this is intended as a portrait, there seems to be a conscious attempt to show Solomon and Henry as two kings made in the same mould. The Queen of Sheba addressing him with deferential outstretched hand may represent Anne Boleyn or may symbolise the clergy in England, who had acquiesced to Henry's proposed religious changes in 1532.[30] The miniature is a mixture of the lavish – with the rich use of expensive pigments such as ultramarine for the blue – and the understated, with its small-scale and extensive use of sober grisaille (grey) tones. The key to understanding this work is in the inscription. The Latin text inscribed on the cloth on either side of the throne and on the canopy directly behind the seated figure translates as:

> Happy are thy men and happy are these thy servants who stand in thy presence and hear thy wisdom. Blessed be the Lord thy God who delighted in thee to set thee upon his throne to be King (elected) by the Lord thy God.[31]

The viewer is intended to see a correlation between God's ordination of King Solomon and of King Henry. Both have been chosen by God, and therefore both are beyond human reproach. The enthroned figure appears majestic and wise, surrounded by a group of his subjects, some listening to his words and others kneeling before him proffering gifts. The words at the foot of the throne cement the message: 'By your Virtue you have Conquered Fame'.

At the heart of Henrician imagery was the ideal of the Tudor dynasty. The final royal portrait of Henry VIII's reign is a family group created by an unknown artist around 1545 (fig. 41). Henry, Jane Seymour and Prince Edward (1537–53) hold the centre stage underneath an elaborate gold canopy, with Princess Mary and Princess Elizabeth in the wings. Although she died in 1537, Jane Seymour is included because of her position as the mother of the heir to the throne. Henry's current wife, Catherine Parr, who accomplished so much in the last years of his reign in uniting the King with his daughters, is not represented in person, but the existence of the painting reflects her achievement in having created a degree of harmony within the family. The rich colourful materials, combined with the perspective illusionism of the floor and the classical spatial discipline introduced by the colonnade, are reminiscent of a scene in an Italian Renaissance interior, with the two servants in the background representing the normality of a flourishing court beyond.

The format of *The Family of Henry VIII* is

Fig. 40 Hans Holbein the Younger (1497–1543), *Solomon and the Queen of Sheba*, c.1534. Watercolour, bodycolour (including gold) and metal point on vellum laid on to card, 22.8 x 18.1 cm. Royal Collection (RCIN 912188)

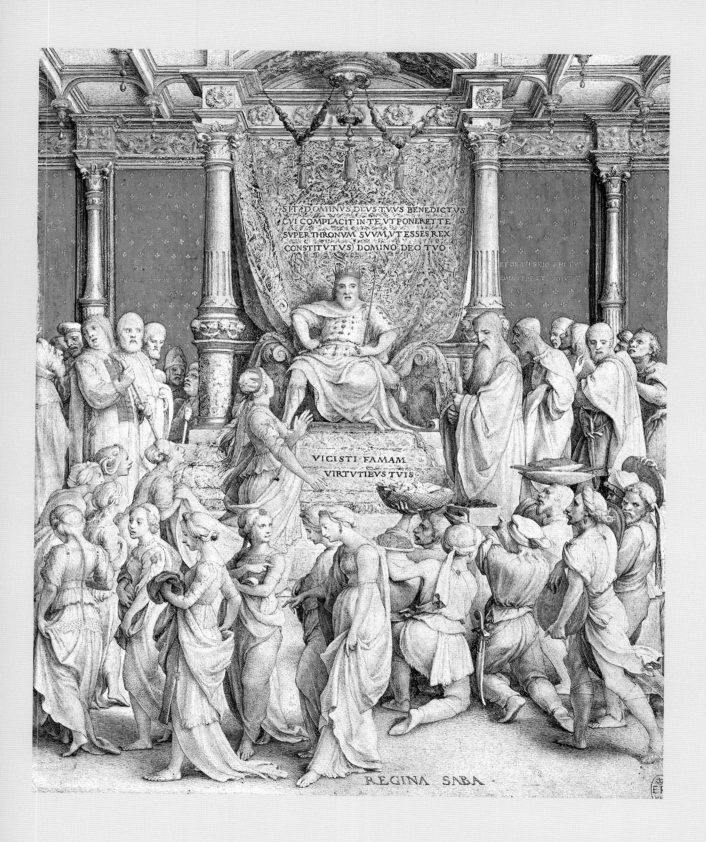

SIT DOMINVS DEVS TVVS BENEDICTVS
CVI COMPLACIT IN TE, VT PONERET TE
SVPER THRONVM SVVM, VT ESSES REX
CONSTITVTVS DOMINO DEO TVO

VICISTI FAMAM
VIRTVTIBVS TVIS

REGINA SABA

similar to that of *The Embarkation of Henry VIII at Dover* and *The Field of the Cloth of Gold* and all three were recorded in 1588–9 hanging in the Presence Chamber at Whitehall.[32] The greater width of the family portrait may indicate that it would have been the most prominent, to be hung in the centre of the three. The accumulated effect of the paintings seems to be to celebrate the strength of Henry's political alliances and the Tudor line. If this were the case, it would account for the 'updating' of Henry's face (as discussed above) in *The Field of the Cloth of Gold*, in line with his Holbein-like presentation in the family group portrait. The repetition of Henry's features and a compatible colour scheme lends a sense of continuity to the three paintings. They certainly function successfully together as a decorative ensemble.

Although self-consciously fashioning himself as a Renaissance prince, Henry did not adhere to the advice of Machiavelli to 'honour the proficient' in every art. The impact of the portraits of Henry VIII epitomises proficiency, but their execution sometimes lacked sophistication. This preference for the effect of the image over its artistic merit is something that also came to define the portraiture of Elizabeth I (1533–1603).

The earliest single-figure portrait of Elizabeth I shows her as an unaffected princess (fig. 42). It is interesting to compare it to her portrait in *The Family of Henry VIII*, created only a year or so before (fig. 43). The similarity of her dress and facial features in both images implies a certain degree of realism so that,

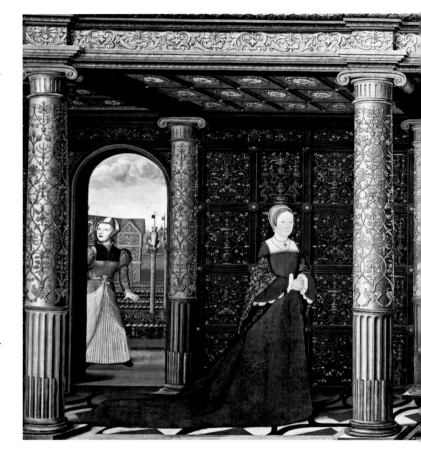

FIG. 41 British School, *The Family of Henry VIII*, c.1545. Oil on canvas, 144.5 x 355.9 cm. Royal Collection (RCIN 405796)

even though painted by different artists, Elizabeth emerges in these works as an identifiable princess with bright red hair, wise eyes and a pale complexion. Such an image is in marked contrast with the more renowned mask-like later portraits of the Queen. The work may have been intended to function as a pendant to a portrait of Edward VI when Prince of Wales, also in the Royal Collection (fig. 44). The two portraits work well together, even though both figures turn slightly to their right (a more natural pairing would have seen Elizabeth positioned in a mirror-like image of her half-brother). Both portraits were probably painted

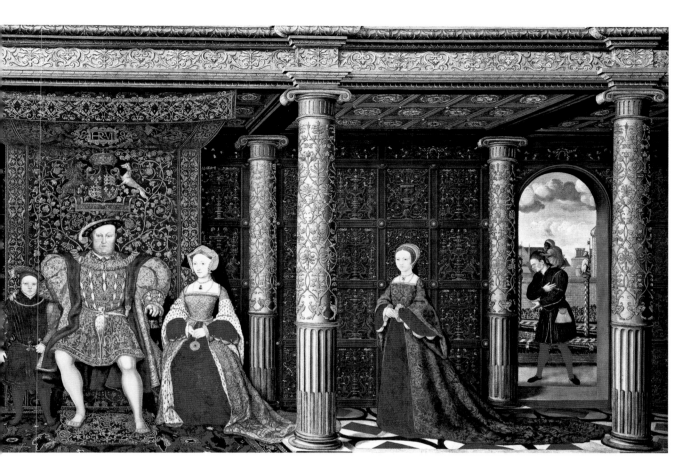

by William Scrots, an artist from the Nether-
lands who was employed by Henry VIII from
1545 and remained on the royal payroll until the
accession of Mary I in 1553. Dendrochronology
has shown that the central wooden panel in
both portraits came from the same tree, indicat-
ing that they were made in the same artist's
workshop and at a similar time.[33]

The portrait of Prince Edward clearly pres-
ents him as his father's heir. His pose strikingly
resembles the stance of Henry VIII as portrayed
by Holbein, and yet he is presented with the del-
icacy and promise of youth; his lynx fur-lined
robe appears slightly oversized and the column

to the right-hand side of the portrait dwarfs him.
The portrait of Elizabeth emphasises her piety.
Two books are included, the larger book repres-
ents the Old Testament and the smaller the New,
together symbolically presenting the Protestant
faith with its emphasis on the Word of God.[34] A
letter written by Elizabeth to her half-brother on
15 May 1547, sent to accompany the gift of a por-
trait, indicates the young Princess's attitude to
portraiture. In it she commented, 'as you have
but the outwarde shadow of the body afore you,
so my inwarde minde wischeth that the body it
selfe were oftener in your presence'.[35] The por-
trait she mentions acts as a substitute for the

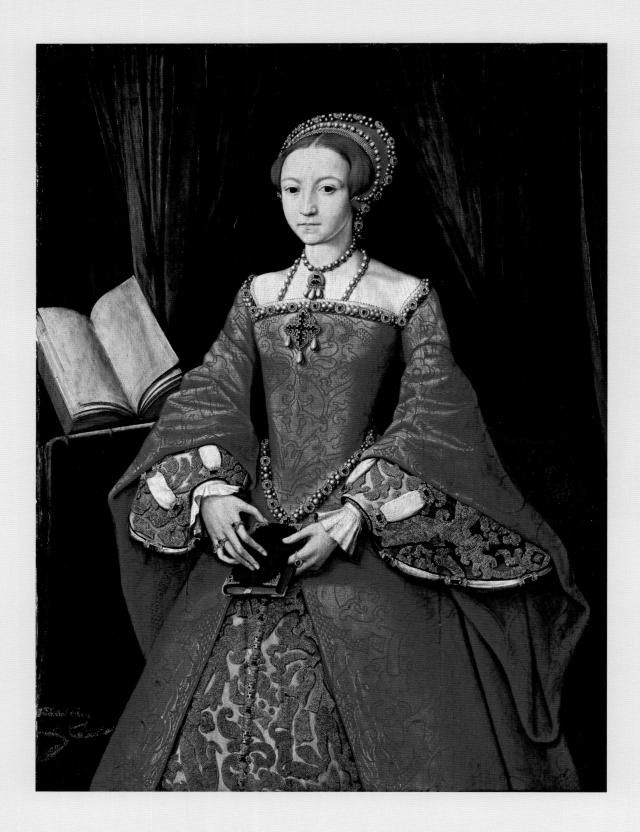

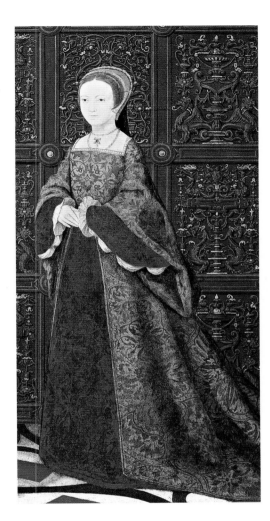

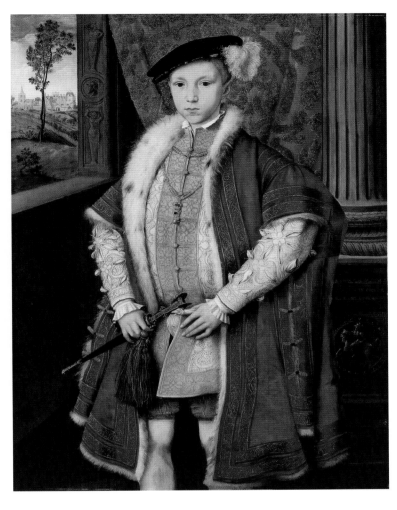

actual person and demonstrates her affection for Edward. Whilst it is possible that this is the very portrait that Elizabeth writes of, the letter more probably refers to a different work, or perhaps a copy of the present work, since it seems likely that the two portraits (figs 42 and 44) were commissioned by Henry VIII.[36]

Another naturalistic portrait of Elizabeth is a miniature, possibly by Levina Teerlinc (a female artist from the Netherlands who was in royal employ as a waiting gentlewoman to Elizabeth I), dating to about two years after Elizabeth's accession to the throne in 1558 (fig. 45). It is not a typical portrait of a queen. She appears as a youthful court beauty without any attributes of sovereignty. The miniature format simplifies the composition, and the artist indicates the sitter's significance through the elaborate costume and jewels. It is only in the sitter's light-coloured hair that we see the clue to her identity: a white and a red rose – indisputable symbols of her position within the Tudor dynasty – subtly decorate her headband.

The Queen guarded her image fiercely and in 1563 approved a decree aiming to manage the production of portraits of her to ensure that no official portrait (intended then to act as the pattern for numerous copies) could be made

without her consent. As Roy Strong notes, Sir Walter Ralegh recorded in his *History of the World* that Elizabeth 'caused all portraits by unskilful "common painters" to be cast into the fire'.[37] In 1596 Elizabeth sought to censor existing images by ordering the destruction of unflattering portraits of her. She was never fully successful in her attempt to control her image, but her actions illustrate the high demand for such portraits from loyal subjects wanting to show allegiance.

The most successful artist at Elizabeth I's court was the miniaturist Nicholas Hilliard. It is through his exquisite portraits that we can gain a clear idea of the ingredients of 'approved' Elizabethan royal portraiture. Hilliard had an ability to create a sense of commanding, magisterial presence on a very small scale. For instance, a tiny work measuring just 18 mm across shows the Queen's head encircled with a Tudor rose (fig. 46). She is portrayed as the centre of the flower itself, the very embodiment of her grandfather's dynasty, the symbolism cleverly combining her femininity with her identity. A slightly later miniature by Hilliard (fig. 47) dates to the period when portraits of Elizabeth ceased to record the process of ageing. From 1595 until her death in 1603 the Queen's appearance in some portraits remained static, and in some she even seemed to become younger – the eternally youthful monarch. Comparison of this miniature with a cameo in the Royal Collection that appears to have been made between 1575 and 1585 indicates Hilliard's shrewd economical handling of the truth (fig. 48). The cameo presents the

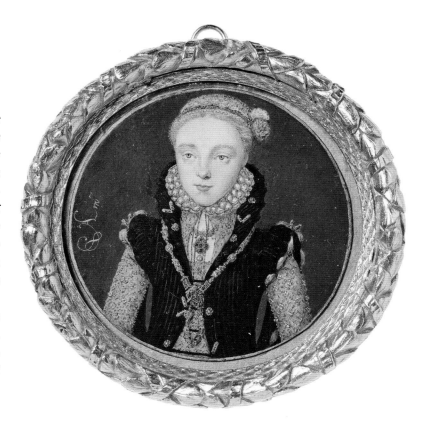

Queen in profile, which despite its classical overtones is never the most flattering aspect. She appears with the gravitas of a Roman emperor, shown in relief as though on a coin. The cameo is sardonyx (a type of onyx with alternating bands of light orange-brown and white), with the orange-brown colour employed to particular effect in Elizabeth's trademark red hair. In this image we do not have a portrait, but instead an iconic representation that is itself a precious object, created in order to be given as a gift to visiting foreign ambassadors. In contrast Hilliard's miniatures are immediate and lead the viewer to engage with the portrait. His great skill was to make the idealised appear real, so that his portrayals of Elizabeth I appear life-like despite the limitations involved in working from only one or two

FIG. 45 British School (attributed to Levina Teerlinc, *c*.1510–76), *Elizabeth I*, *c*.1560. Watercolour on vellum laid on a slightly larger card, diameter 5.2 cm. Royal Collection (RCIN 420944)

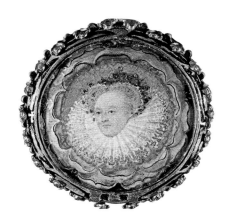

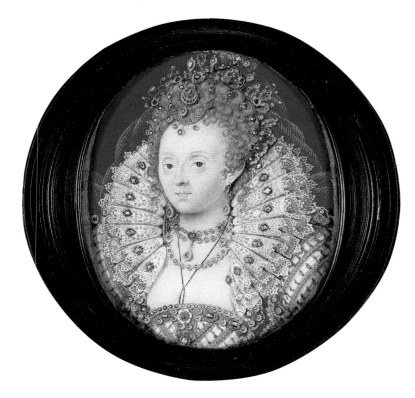

portrait sittings and constructing a visual fiction of everlasting, ageless beauty.

Why did Elizabeth not wish to grow old with dignity through portraiture? Rather than simply being a symptom of vanity, it seems that it was a decision on her part to appear as 'a woman but not a realistic woman, rather a manifestation of earthly and heavenly power'.[38] These ideas reached fruition in one of the largest surviving images of the Queen, the so-called *Ditchley Portrait* of about 1592 (fig. 49). Elizabeth stands over a map of England, her stance one of imposing authority, her face a mask. She is presented as a pure symbol of monarchy, bringing her land from the darkness of storms into sunshine, with the sonnet to the right hailing her as 'the Prince of Light' and a figure of 'power' and 'grace'. The portrait was commissioned by the Queen's champion, Henry Lee, and may commemorate entertainments held for her by Lee at his house at Ditchley, near Oxford. The overriding theme, as indicated in the fragmentary Latin inscriptions ('she gives and does not expect', 'she can but does not take revenge' and 'in giving back she increases'), is Elizabeth's forgiveness of Lee for having retired from court in 1590. The *Ditchley Portrait* follows well in the footsteps of Henry VIII's image-making; if ever a portrait were intended to frighten the viewer with its sheer power and grandeur, this is it. The costume was probably based on real items from Elizabeth's wardrobe, so to stand in front of this portrait is to experience something of the impact of being in the monarch's overwhelming presence. The Protestant Queen appropriated the imagery of everlasting youth and celestial brilliance

normally associated, in earlier Catholic art, with the Virgin Mary – Queen of Heaven.

While the *Ditchley Portrait* incorporates a sonnet to complement the symbolism, one painting in the Royal Collection works like a poem itself, with the figures acting out a scene from classical mythology (fig. 50). *Elizabeth I and the Three Goddesses* dates to 1569 and functions as a type of court masque, where the Queen takes on a theatrical role in order to illustrate a particular point. The setting is Windsor, with the castle shown in the middle distance, immediately identifiable by the round tower and the surrounding walls. The story is that of the Judgement of Paris, where Paris was set the task of judging a beauty pageant. The contestants were well known: one of Juno's attributes was that of patroness of marriage, and Minerva was celebrated as the goddess of war as well as of wisdom, while Venus was the goddess of love.

In the story (taken from Lucian's *Dialogues of the Gods*) Paris's mission is to present a golden apple to the winner. Elizabeth plays the part of Paris, standing in the entrance to a palace with two attendants behind her. No attempt is made to make her look like the Trojan Prince – she is wearing a full-length dress, the Imperial Crown is on her head and a sceptre is in her right hand. The orb, in her left hand, is the trophy in this retelling of the tale, and the rules have been changed. There is to be no winner; Elizabeth will claim the title for herself. She has no need of Juno since she is Queen in her own right with no need to marry; she is a strong commander of the army with no call for Minerva's powers; and her beauty far exceeds that

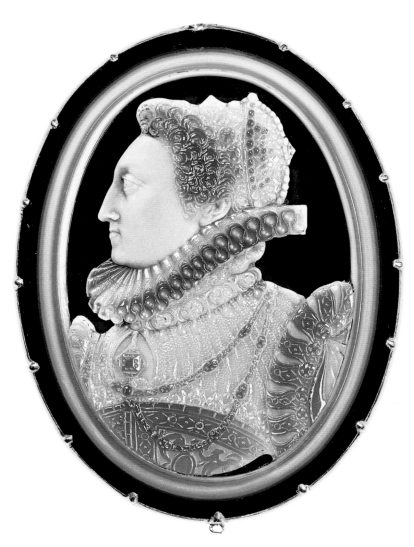

FIG. 48 English,
Cameo of Elizabeth I,
cameo c.1575–85; gold mount
early eighteenth century.
Brown and white sardonyx,
6.7 x 5.5 cm.
Shown here enlarged.
Royal Collection
(RCIN 65186)

FIG. 49 Marcus Gheeraerts
the Younger (c.1561/2–1636),
Queen Elizabeth I (*The
Ditchley Portrait*), c.1592.
Oil on canvas,
241.3 x 152.4 cm.
London, National Portrait
Gallery

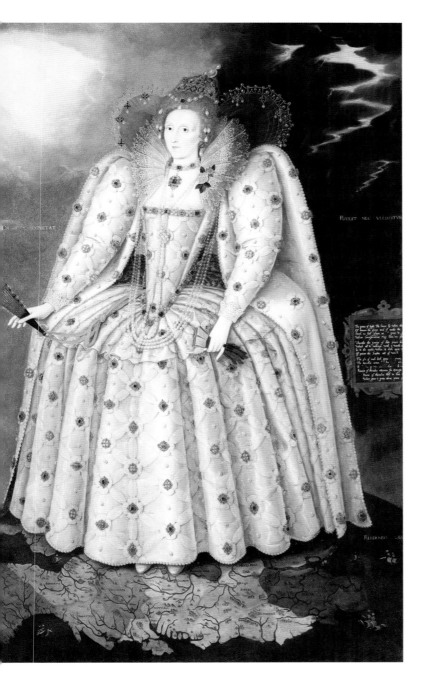

of Venus, who in the original story was chosen by Paris as the victor. A Latin inscription on the frame indicates the intended interpretation of this scene. It translates as: 'Pallas [Minerva] was keen of brain, Juno was Queen of might, the rosy face of Venus was in beauty shining bright. Elizabeth then came and, overwhelmed, Queen Juno took flight; Pallas was silenced; Venus blushed for shame.'[39]

The painting, by Hans Eworth, is clearly not a typical royal portrait, but as an allegory it gives an essential insight into the power of Elizabeth and the construction, by herself and by her courtiers, of her image as a supreme ruler. It seems most likely that it was commissioned by a loyal subject to illustrate his devotion to, and appreciation of, the Queen. In a gesture of unadulterated flattery she is presented as a figure far more powerful, wise and beautiful than the goddesses of classical antiquity.

The impact of her decision not to award the orb is immediately apparent in the reactions of the goddesses. Venus looks dumbfounded. It is no accident that her hair here is red; she appears as the lesser twin to England's Queen, who is more beautiful and chaste than the celebrated goddess. Cupid turns around awkwardly to look towards Elizabeth, as though on the brink of tears at this unexpected turn of events. Minerva, who should be indomitable in her breastplate, holds up her hands in defenceless amazement. She has been defeated by the element of surprise, the key ingredient for any military victory. Juno's attitude is the most striking. It has been suggested that her gesture with right hand raised may lead the viewer's eye to

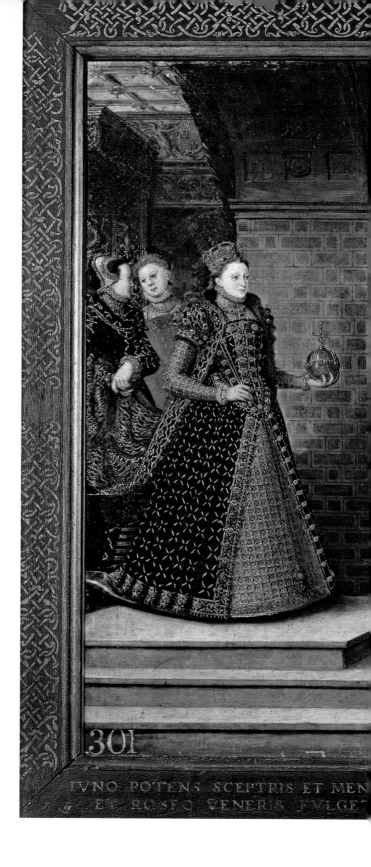

Fig. 50 Hans Eworth (active 1540–73), *Elizabeth I and the Three Goddesses*, 1569. Oil on panel, 70.8 x 84.5 cm. Royal Collection (RCIN 403446)

heaven as though to indicate that it is God's will that Elizabeth be crowned the winner.[40] However, hers is not a gracious acceptance of the decision. She turns away in haste, her foot has come out of her sandal, and her face and attitude indicate that she is outraged to have been outmanoeuvred by Elizabeth. Her gesture, therefore, is closer to resignation and a reluctant acceptance of Elizabeth's authority. By revealing herself as such a bad loser, Juno (along with her untidy companions) acts as a foil to Elizabeth's calm, ordered and dignified composure.

In his *Anecdotes of Painting* of 1771, Horace Walpole said of Elizabeth I that there 'was no evidence that [she] had much taste for painting, but she loved pictures of herself'. Elizabeth self-consciously fashioned herself as the perfect monarch, intent on appearing as powerful in her portraits as she was in the flesh. She showed little interest in mainstream Renaissance art, but instead managed to develop an identifiable language of portraiture, distinct from the rest of Europe. As Roy Strong explains, 'perhaps Elizabethan portraiture is better regarded as a branch of emblematics in the Renaissance than placed within the conventional textbook niche allocated to it within the history of art'.[41] The portraits created during Elizabeth's reign provide an insight into the overriding importance of imagery and status at her sycophantic court. At the heart of such metaphorical artistic language is the awareness, learnt from the paintings that she had inherited from her father and grandfather, that power is strengthened through images.

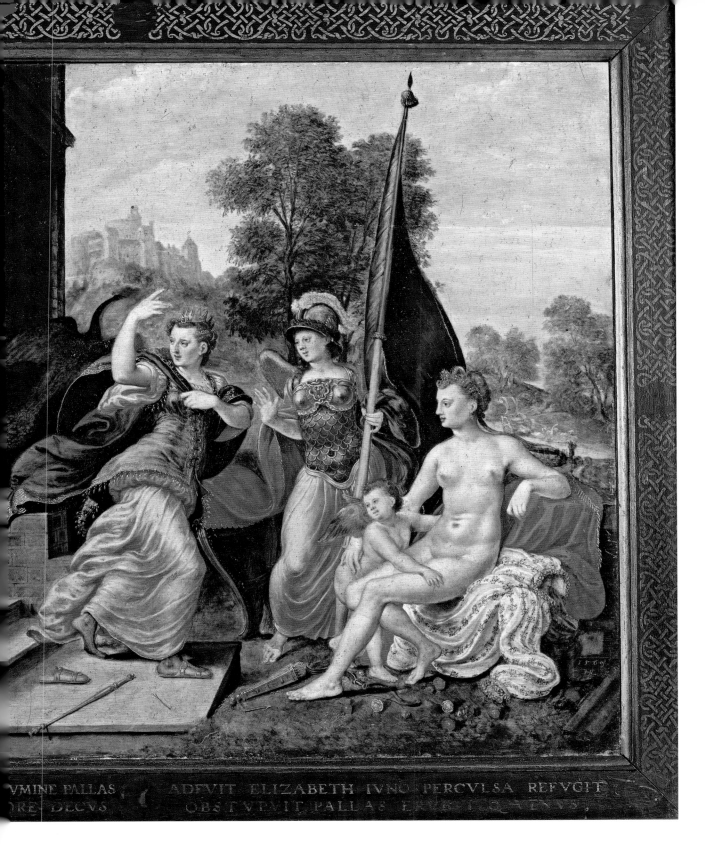

...VMINE PALLAS ADFVIT ELIZABETH IVNO PERCVLSA REFVGIT
...RES DECVS OBSTVPVIT PALLAS ...

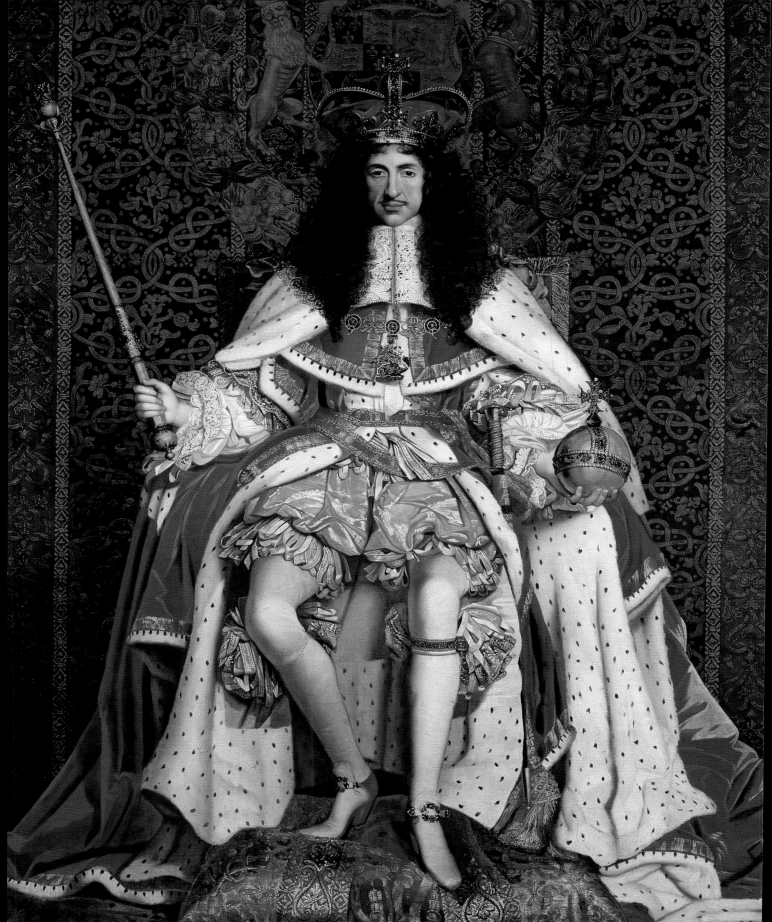

3

Stuart Portraiture

'The incumbent of a Dignity may decay, the Dignity itself
is nonetheless forever; it does not die.'

ERNST H. KANTOROWICZ, *The King's Two Bodies*, 1957

I N HIS TREATISE *The Trew Law of Free Monarchies* (1598), James VI of Scotland, and future James I of England, stated 'Kings are called Gods; they are appointed by God and answerable only to God'.[42] He later instructed his eldest son, Henry, Prince of Wales, in the same conviction: 'you are a little GOD to sit on his Throne, and rule over other men'.[43] The portraiture of James I and VI (1566–1625) reflects this belief in the Divine Right of Kingship, a notion that a king is directly ordained to rule by God and has absolute power, which came to define his reign. The earliest portrait of James in the Royal Collection shows him at the age of 16 months (fig. 51). He was in an unusual position as both King of Scotland and, because his great-grandmother was Henry VIII's sister Margaret, heir to the English throne. The painting demonstrates the difficulties surrounding his early years, and the necessity of distancing himself from his mother, Mary, Queen of Scots, in order to secure the crown of Scotland.

The Memorial of Lord Darnley (fig. 51) was painted in 1567/8 by the Flemish artist Lieven de Vogeleer and presents the deceased Henry, Lord Darnley (second husband of Mary, Queen of Scots and James VI's father), lying in a tomb, with the kneeling figures of his son, his parents (the Earl and Countess of Lennox) and his

brother Charles Stuart in the foreground. Darnley had been murdered in 1567 in circumstances thought to have been orchestrated by Mary, Queen of Scots and her lover, the Earl of Bothwell. After his mother's enforced abdication, James was crowned King of Scotland on 29 July 1567 at the age of 13 months. The painting was commissioned by Lord Darnley's bereaved parents, presumably as a means of linking their grandson, the young James VI, with his deceased father and thereby removing him from any association with the murder. The inscriptions illustrate this function of the painting. The Latin text written on a scroll from the young King's mouth, operating rather like a speech bubble, translates as: 'Rise up, Lord, and avenge the innocent blood of the king my father, and defend me with your right hand, I entreat.'[44] This is 'spoken' to the figure of the risen Christ standing next to the cross on the altar. This is a donor portrait, with a vision of Christ acting as intercessor for the family group. The political implications of the imagery give an insight into the reason for the commission of the painting. As has been noted, it is 'a damning indictment' of Mary, Queen of Scots' involvement in the murder of Lord Darnley, and its role is 'as a reminder ... to James VI ... of his father's murder and his mother's infamous conduct'.[45]

FIG. 75 (detail)
John Michael Wright
(1617–94), *Charles II*,
c.1661–2. Oil on canvas,
281.9 x 239.2 cm.
Royal Collection
(RCIN 404951)

As a portrait, the small-scale image of James is reminiscent of the kneeling figures in *The Family of Henry VII with St George and the Dragon* and *The Trinity Altarpiece* (figs 3 and 7). At such a young age James could not have sat for a realistic life portrait, so instead we are presented with an idealised image, but the roundness of his face and the youthful character of his features indicate his tender years. In the convention of the time, the young James is shown at half the size of the adults, his significance conveyed by his royal robes, crown and thistle collar.

The inscription on a white sheet of paper depicted to the right of the altar in the *Darnley Memorial* included a particularly strong defama-

Fig. 51 Lieven de Vogeleer
(active 1551–68), *The Memorial
of Lord Darnley*, c.1567/8.
Oil on canvas, 142.3 x 224 cm.
Royal Collection
(RCIN 401230)

on 15 June 1567, Mary, Queen of Scots was eventually defeated by troops that rebelled against her following her marriage to the Earl of Bothwell. The figure of James appears again in this mini-painting, in a banner held by rebel troops. This shows the infant King kneeling next to his dead father and an inscription reading 'Judge and defend my cause O Lord'. The most illuminating aspect of this exceptionally complex painting is that it reminds the viewer of the responsibility that James carried for the rest of his life. He was given no preparatory instruction in kingship, but was a self-professed 'cradle king' who 'could never recall a time when he had not borne the name and burdens of a monarch'.[46]

Despite the evident interest in self-promotion and self-image expressed by the Tudors, and the numerous large-scale portraits that exist in other collections, in particular of Elizabeth I, the earliest single-figure state portrait showing the monarch in coronation robes to survive in the Royal Collection is that of James I, painted by the Flemish artist Paul van Somer c.1620 (fig. 52). It was in the seventeenth century that official state portraiture – commissioned to celebrate the coronation of successive monarchs – came into its own. The Van Somer portrait shows James I looking somewhat awkward, just as in the *Darnley Memorial*, slightly swamped by the trappings of his royal position. Nonetheless the state robes, with their contrasting colours of red and white, create a strong, if not overpowering, effect.

James I commissioned this portrait directly from the artist, and it seems likely that he made certain iconographical demands. The King is

tion of James's mother. Some of these inscribed words were vandalised at a later date, possibly on the orders of James. Perhaps he did not entirely agree with his grandparents in their wholehearted condemnation of his mother. The image also includes, in the lower left-hand corner, a picture-within-a-picture of the Encounter at Carberry Hill. In this battle, which took place

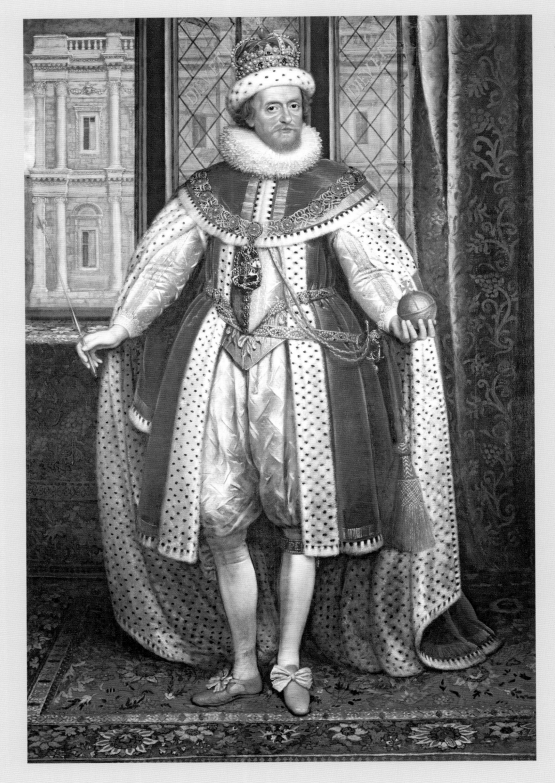

FIG. 52 Paul van Somer
(c.1577–1621), James I and VI,
c.1620. Oil on canvas,
227 x 149.5 cm.
Royal Collection
(RCIN 404446)

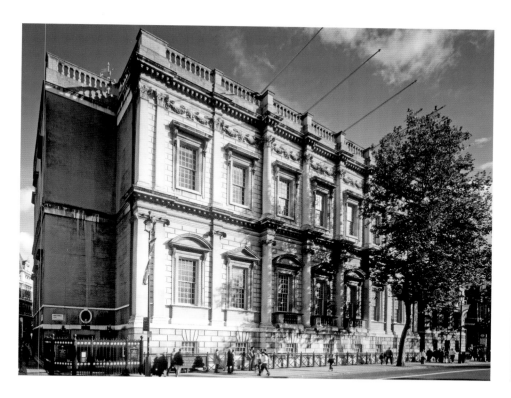

FIG. 53 Comparison of a section of the façade of the Banqueting House, Whitehall, and a detail from Paul van Somer's painting (fig. 52)

presented as an imposing monarchical presence, the orb in his left hand and the sceptre in his right, crowned and sporting the collar and badge of the Order of the Garter. He stands in front of a window within Whitehall Palace, with a direct view towards the Banqueting House.[47] James I commissioned the architect Inigo Jones to design the new Banqueting House in June 1619 and it was not completed until early 1622. James I wanted the building to be included in the background. The King was evidently proud of his involvement in this exciting new work of architecture, in which Inigo Jones quoted authoritatively from the language of classical architecture, a revolutionary approach in British building design of the time. However, the Banqueting House was not completed at the time of the painting, which explains the inaccuracies in Van Somer's rendering of the architectural details (see fig. 53).[48]

The Banqueting House was included in another major artistic commission, this time a series of works by the great Flemish artist Peter Paul Rubens commemorating James I and commissioned by his son Charles I between 1629 and 1630.[49] The scheme for the nine canvases was the invention of Charles I and was devised to commemorate and immortalise James I, who had died in 1625. Inigo Jones had already designed elaborately carved architectural details to frame the canvases which were delivered from Rubens's studio in Antwerp in 1635 (fig. 54). The choice of subjects for these painted scenes, as devised by Charles I in discussion with Rubens, explains the reason for this commission. The three main canvases in the centre of the room show *The Union of the Crowns of Scotland and England*, *The Peaceful Reign of James I showing the Benefits of his Government* and *The Apotheosis* (raising to glory) *of James I* (figs 55a and b and 56). This is posthumous royal portraiture celebrating the memory of

Fig. 54 The Banqueting House, Whitehall, view of the ceiling.

Charles I's father. Charles I was more than aware that in commissioning this work he was drawing direct comparison with Henry VIII's *Whitehall Mural* by Holbein created one hundred years earlier in the Privy Chamber of the same palace. Both paintings imitated religious compositions: Holbein's portrait is like an altarpiece and Rubens's ceiling resembles the visions of heaven with ascending saints depicted upon the vaults of Baroque churches throughout Europe. Instead of using 'speech-bubbles' (as in fig. 51) Rubens conveys his meaning through allegorical figures combined with idealised portraits. Though honouring his father, Charles I clearly wishes the ceiling to express the ideals of his own reign: advocating a policy of peace and reconciliation through a visual language of elegance and magnificence.

The celebration of James I's triumph in uniting two discordant nations echoes Henry VII's peacemaking union of the houses of York and Lancaster, as celebrated in *The Family of Henry VII with St George and the Dragon* and Holbein's *Whitehall Mural*. The image of the King enthroned between twisting columns in the two main rectangular panels of the central zone directly alludes to King Solomon.[50] This not only repeats the imagery utilised to great effect by Henry VIII (see p. 56), but also effectively makes an allegorical connection between James I and the biblical King to whom God gave great wisdom and insight. *The Union of the Crowns of England and Scotland* presents the crowned King gesturing with his sceptre to a baby, the future Charles I, who is simultaneously being crowned by surrounding figures. The symbolism is expertly carried out by Rubens on this large scale to achieve maximum impact. However, it is not all simply pomp and ceremony. The face of the King in the three main central canvases is imbued with appropriate expressions. In *The Peaceful Reign* King James is strong and forceful, his ruddy complexion and sweeping gesture conveying an impression of strength. *The Union of the Crowns* encapsulates an equally powerful nature, but here the deceased King is represented in profile, so that he appears with the classical gravitas that we expect from the profiles of Roman emperors presented on ancient coins.

In the central oval, *The Apotheosis of James I*, there is another change of mood. Here King James is carried up to heaven, a laurel wreath and crown suspended above his head in expec-

tation of eternal glory. The figure of the King is placed directly above an eagle, the symbol of St John the Evangelist, which carries him upwards from the earthly to the heavenly realm. This imagery is strengthened by the inclusion of the words *In principio erat verbum* (In the beginning was the Word), the opening of St John's Gospel, inscribed on the book held by the kneeling woman on the left. This symbolises James's reliance on the Word of God – which is central to the Protestant religion – during his life, as well as referring to his pivotal role in the new translation of the Bible (the Authorised King James Version published by the Church of England in 1611).[51] The King's face in this central image differs dramatically from the other two representations in the Banqueting House canvases. Royal authority is

replaced by an expression of humble awe at the moment of his judgement and the impending presence of God. Even a divinely ordained monarch is reverential in the presence of God, and Rubens shows us the only moment when he imagined the King would show deference and vulnerability, James's hand firmly linked underneath the arm of a nearby female figure (who probably symbolises Justice) for support.[52] It is an astounding irony that Charles I encountered this remarkable sight on his final walk through the Banqueting House on the day of his execution (30 January 1649).

Charles I was immortalised in paint by means of an unprecedented number of portraits, both formal and informal, all of which are testament to his exceptional passion for contemporary and Renaissance art. Curiously,

despite Charles's evident interest in Rubens, there is no single-figure portrait of him by the Flemish master.[53] Apparently Rubens did not have the opportunity to paint the King whilst in London (June 1629 to March 1630), but this might be explained by his other responsibilities during this visit. He was not only an artist but also a diplomat, engaged on a mission to secure a peace treaty between England and Spain.

However, prior to his return to Antwerp, Rubens created a painting that expressed his fondness for England and his respect for Charles I. *Landscape with St George and the Dragon* (fig. 57) is a cleverly constructed piece of flattery. A patriotic portrayal of England's patron saint, it presents St George as a chivalric hero, his legs astride the already-defeated reptilian dragon, presenting the princess with a cord that is attached to the dragon's neck.[54] The devastation that the monster has caused is evident in the dramatic gestures of the surrounding figures and the horrific details of mutilated, rotting corpses strewn in the foreground, but the central pairing of saint and princess appears as an oasis of calm, with two *putti* (cherubs) clutching laurel-leaf crowns flying above them in a stream of golden light.

The figures of St George and the princess may be intended as portraits of Charles I and Henrietta Maria. St George certainly resembles Charles I in Rubens's painting, with his distinctive moustache and beard and wavy shoulder-length hair. The features of the princess loosely resemble those of Henrietta Maria, although they are fleshed out somewhat and are more of an idealistic, generalised nod

to the Queen than a realistic portrait. The pearls interlaced through the hair seem to have been a favourite style worn by the Queen (fig. 58).

The landscape incorporates references to the time Rubens spent in England. The buildings in the background, including Lambeth Palace, are identifiable as the area of Southwark visible from York House, where the artist stayed. The landscape itself looks very English, the cloudy skies on the left tempered by the sunlight breaking through in the centre just above the hero, symbolising the hope generated by the saint's heroism, but also possibly referring to the typically inclement British weather that Rubens had experienced first hand. This painting alludes indirectly to the Order of the Garter with the imagery of St George (not only in the central story-telling itself, but also in the elaborate inclusion of a mounted knight holding aloft the flag of St George). It also expresses the idea of the divinely appointed monarch protecting his people as well as ruling them.[55] If the King embodies St George, he is presented as a warrior and a saint – the qualities expected of a king. Just as, around 60 years earlier, Hans Eworth demonstrated in Elizabeth I the combination of the qualities of three goddesses (fig. 50), so Rubens presents the St George figure as the epitome of chivalry and virtue, entwining his image with the symbols of the noble Order of the Garter. The figures on a knoll gazing in admiration at the saint-King represent Charles I's subjects and suggest the intended response of the viewer. What appears at first glance to be a lyrical landscape containing the legend of

FIG. 56 Sir Peter Paul Rubens (1577–1640), *The Apotheosis of James I*, c.1632–4. Oil on canvas, London, Banqueting House, Whitehall

Fig. 57 Sir Peter Paul Rubens (1577–1640), *Landscape with St George and the Dragon*, c.1630–34. Oil on canvas, 152.4 x 226.3 cm. Royal Collection (RCIN 405356)

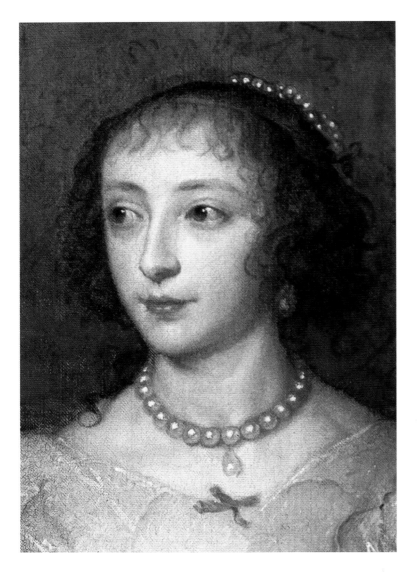

FIG. 58 Sir Anthony Van Dyck
(1599–1641), *The Great Piece*
(detail of Henrietta Maria
showing the pearls entwined
in her hair), *c*.1631–2.
Oil on canvas,
302.9 x 256.9 cm.
Royal Collection
(RCIN 405353)

home into Flanders, To remain there as a monument of his abode & employment here.'[56] It was a clever ploy to paint such a work and to make sure that it was noticed in England, then to transport it back to the Southern Netherlands. It would seem that Rubens was more than aware that the painting would attract attention, and it is no surprise that Endymion Porter, who acted as an agent for the King with the task of seeking out works of art on the Continent, acquired the painting a few years later and brought it back for Charles I.

Charles I's principal portraitist in the first years of his reign was the Dutch artist Daniel Mytens, who had worked previously for James I. A large-scale double portrait of *Charles I and Henrietta Maria departing for the chase* attests to his confidence and his innovative approach to the compositional placing of figures (fig. 59). Here the two protagonists are set off-centre in the left-hand side of the horizontal picture plane. The exact centre of the image is mainly empty, taken up simply with the gesture of Henrietta Maria's left hand, in which she holds a fan. The main point of this picture is anticipation of the hunt. The royal couple are captured in the moment before heading off. A servant is bringing their horses (the Queen's is identifiable by the side-saddle), while their dwarf Jeffery Hudson struggles to keep hold of their energetic dogs. The King and Queen are presented as real, fashionably dressed, active people, so that we appear to be given a glimpse of their private life. The fact that they hold hands further emphasises the informality of the moment, and a winged cherub flying above the

St George becomes instead an allegory of Charles I, with his subjects kneeling in adoration, depicted by the flattering and eloquent diplomat Peter Paul Rubens.

Rubens's motive for creating this painting is explained in a letter written by the Cambridge academic Joseph Mead on 6 March 1630, where he remarks that the artist has created a 'history' of St George: 'in honour of England and of our nation, from whom he hath received so many courtesies … the picture he hath sent

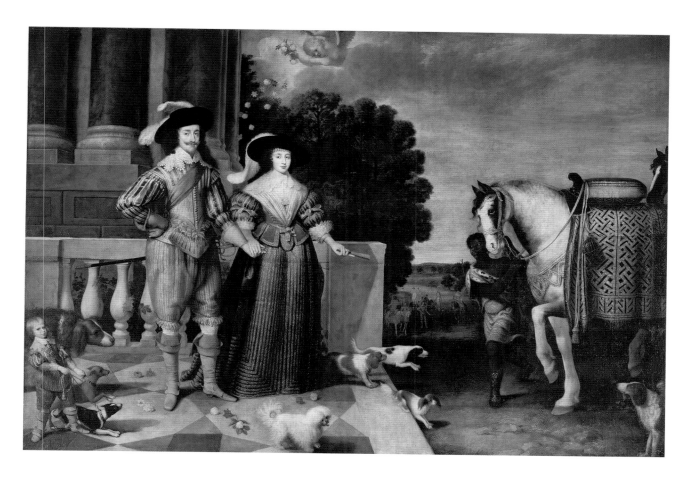

FIG. 59 Daniel Mytens
(*c.*1590–1647), *Charles I and Henrietta Maria departing for the chase, c.*1630–32.
Oil on canvas, 282 x 377.3 cm.
Royal Collection
(RCIN 404771)

couple and showering flowers upon them only serves to re-emphasise the point that theirs is a happy, loving relationship. The iconography is no accident. The King and Queen enjoyed renewed pleasure in their marriage after Charles I sought comfort in the company of his wife following the assassination of his greatest friend, George Villiers, 1st Duke of Buckingham, on 23 August 1628. It became common knowledge that at this point Charles I and Henrietta Maria started to share a bed every night.[57] The portrait dates to around 1630–32, which coincides exactly with this new bond between King and Queen. Their closeness seems to be an element of the King's private life that he

wished to be widely known, to the extent of commemorating it in paint.

One of the main commissions given to Mytens was to paint a series of royal portraits to be disseminated amongst friends and relatives and sent to the major European courts. These official royal portraits, interestingly, seem to have been created solely to impress others; for example, his portrait of 1628 (fig. 60) shows Charles I as we would expect to see him, standing in a commanding pose before an opening to a balcony with a landscape beyond. He wears the ribbon of the Order of the Garter and his right hand rests confidently on a baton. The painting is inscribed on the base of the wall

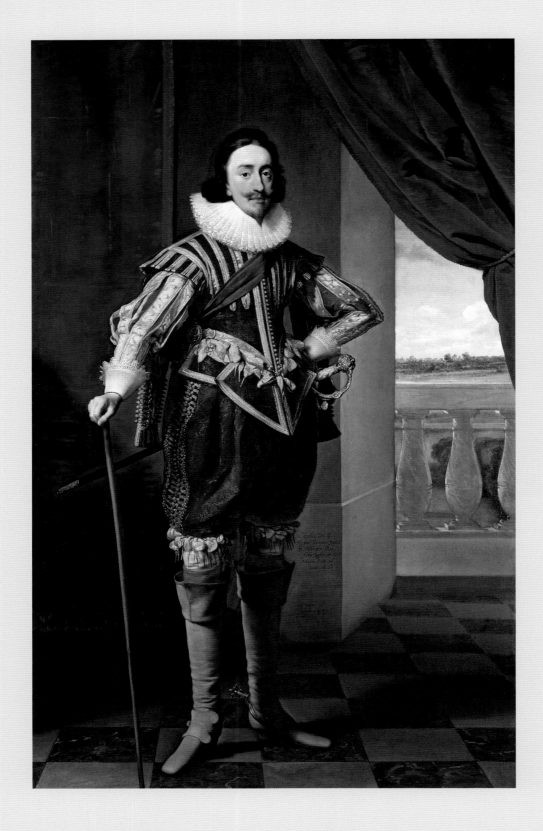

Fig. 60 Daniel Mytens (c.1590–1647), *Charles I*, signed and dated 1628. Oil on canvas, 219.4 x 139.1 cm. Royal Collection (RCIN 404448)

in Latin with the artist's name and date and the description of Charles as 'King' and 'Defender of the Faith'.[58] Just as Rubens's allegorical depiction presented Charles as warrior and saint, so here the portrait of the young ruler is annotated with a reminder that he is both King of lands and of souls, divinely appointed to uphold the Christian faith of Britain. This painting entered the Royal Collection only in 1961, when it was bequeathed to Her Majesty The Queen by a descendant of the Craven family, having been given originally to William, 1st Earl of Craven, by Elizabeth, Queen of Bohemia (Charles I's older sister). Charles I commissioned Mytens to paint a full-length portrait of his sister for a gallery of family portraits housed at Queen Henrietta Maria's residence Somerset House (fig. 61). Here the portrait would have hung alongside other full-length portraits of members of the Stuart family, some recent Tudor kings and several contemporary continental monarchs, including Louis XIII of France and Philip III of Spain. A display such as this served to underline the dynastic bonds linking the crowns of Europe and to establish that the Stuarts were part of the inner circle.

Sir Anthony Van Dyck worked full-time at the court of Charles I from 1632 to 1641 (the last nine years of the artist's life) and his skill took royal portraiture to an exciting new level. Van Dyck's output ranged from full-length single-figure portraits to family group portraiture such as *The five eldest children of Charles I* (fig. 62), where the Flemish artist innovatively presented young royal children interacting with one another as realistic figures rather than

scaled-down adults. In this painting Princess Mary (1631–60) and Prince James on the left are impeccably dressed, Mary looking out towards the viewer with a maturity that belies her 6 years, while the 4-year-old James appears slightly bored, his eyes glazing over and his hands crossed at his waist. Charles, Prince of Wales (1630–85), stands to attention at the centre, his hand placed commandingly on the head of a large mastiff, illustrating an impressive maturity in a 7-year-old. The infant Princess Anne is attentively looked after by her sister

Elizabeth. The baby reaches towards the mastiff as a reminder that despite its size, it, like the King Charles spaniel at her feet, is simply a much-loved household pet.

There is no portrait in the Royal Collection with more visual impact than the equestrian portrait of Charles I accompanied by his equerry, M. de St Antoine (fig. 63). The canvas dominates any room in which it is hung. The King is depicted riding through a triumphal arch on a white stallion. He controls the horse, whose spiritedness is indicated by the curl of its mane and the tilt of its head. The portrait presents the image of an all-powerful king and

RIGHT:
Fig. 63 Sir Anthony Van Dyck (1599–1641), *Charles I with M. de St Antoine*, signed and dated 1633. Oil on canvas, 368.4 x 269.9 cm.
Royal Collection
(RCIN 405322)

Fig. 62 Sir Anthony Van Dyck (1599–1641), *The five eldest children of Charles I*, signed and dated 1637. Oil on canvas, 163.2 x 198.8 cm.
Royal Collection
(RCIN 404405)

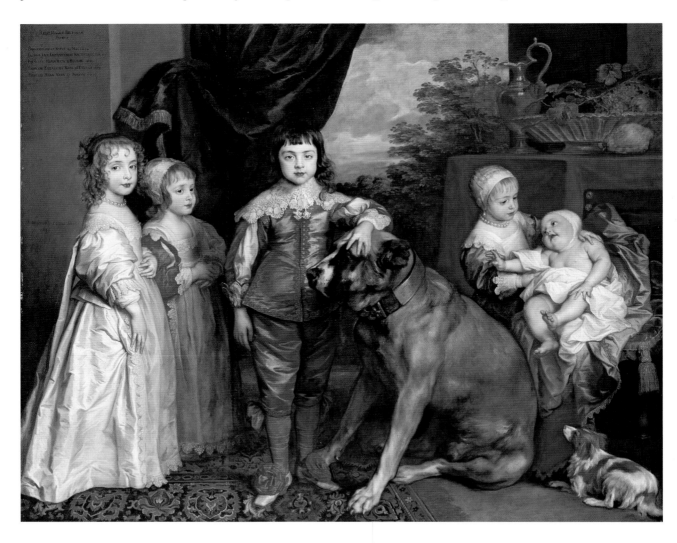

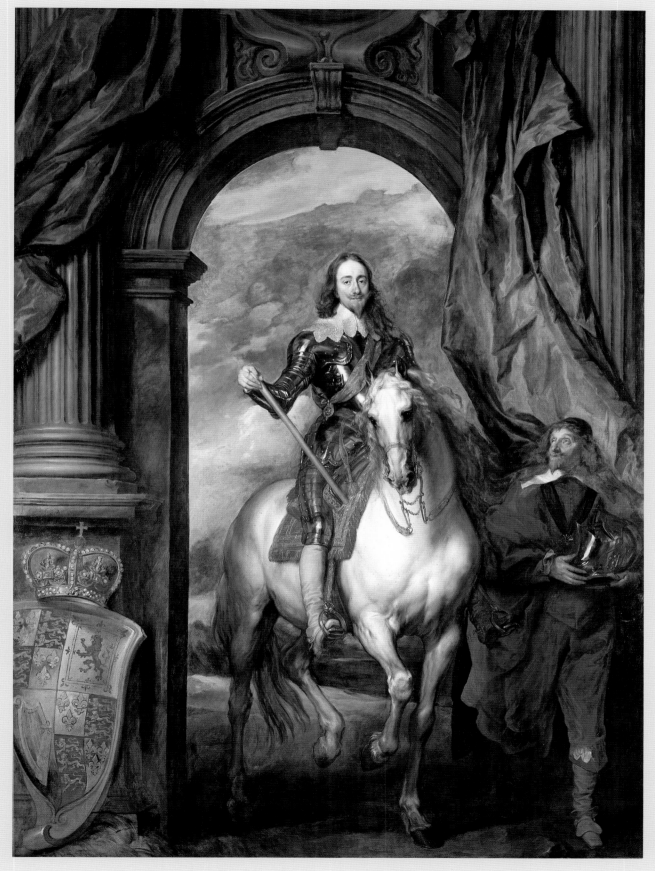

the intended reaction of the viewer is suggested by the expression on the equerry's face as he gazes up admiringly at his master. There is much poetic licence in this portrait: Charles I was small in stature, but here he towers above the viewer because of the size of the image and his elevation on horseback. The composition derives from the *Equestrian portrait of the Duke of Lerma* painted by Rubens in 1603 during the artist's first visit to Spain (fig. 64). The arched formation of the palm leaves from the Lerma portrait is reworked into the triumphal arch in Van Dyck's portrait, similarly framing the figure and creating a dramatic entrance. Although a long way from the bruising reality of Charles's unhappy reign, Van Dyck's image of the King, staff in hand, the very embodiment of wise and considered judgement, convincingly implies that his subjects might tremble in awe at the very sight of him.

Charles I placed this portrait at the end of the Gallery at St James's Palace, the location that he had intended from the moment of its commission. He also ordered Van Dyck to paint an equally dominating equestrian portrait (now in the National Gallery, London), the preparatory sketch for which is in the Royal Collection (fig. 65), to be hung in the Chair Room at Whitehall. One of the first paintings made by Van Dyck for the King, a slightly more informal group portrait of Charles I, Henrietta Maria, Prince Charles and Princess Mary – known as 'The Great Piece' because of its scale – was hung at the end of the Long Gallery at Whitehall (fig. 66).[59] These paintings were intended to have the same intimidating and lasting

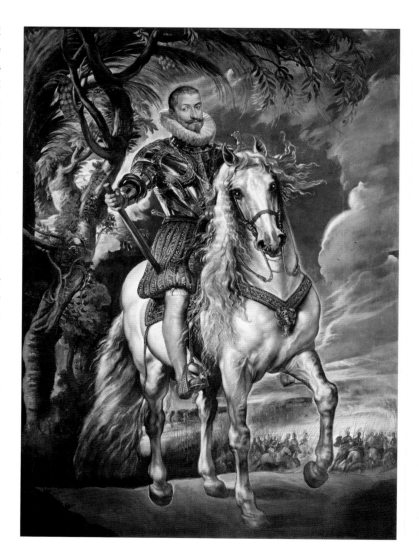

impact on courtiers and visiting dignitaries as Henry VIII's *Whitehall Mural*.

It was not only in the medium of paint that Charles I strove to commemorate his own image. During his reign the sculpted portrait bust came into fashion, owing in part to the fact

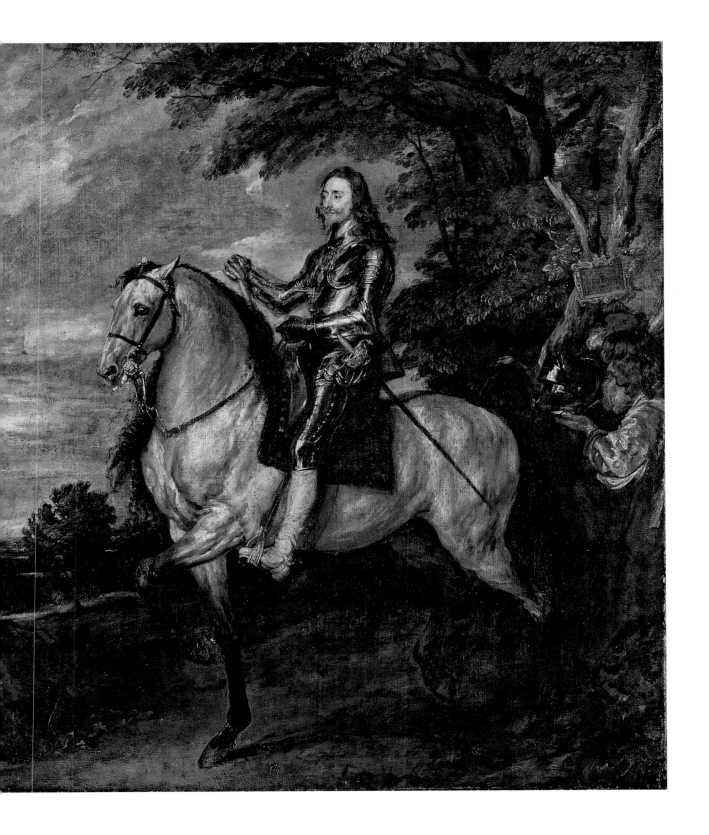

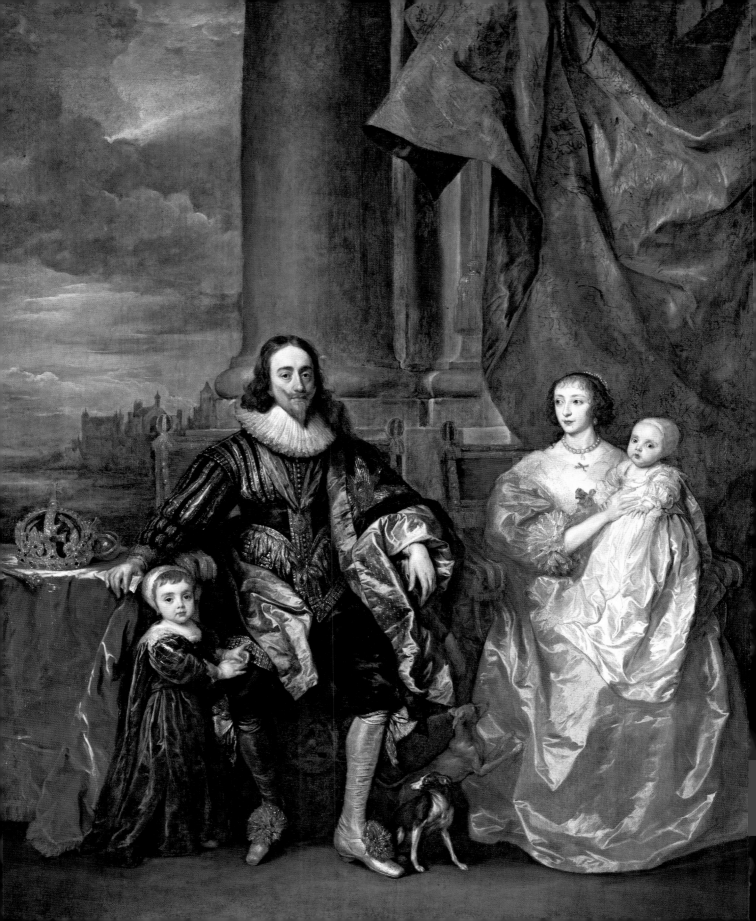

FIG. 66 Sir Anthony Van Dyck (1599–1641), *Charles I and Henrietta Maria with their two eldest children, Prince Charles, later Charles II and Princess Mary* (*The Great Piece*), *c*.1631–2. Oil on canvas, 302.9 x 256.9 cm. Royal Collection (RCIN 405353)

BELOW LEFT:
FIG. 67 Hubert Le Sueur (1580–1658), *Charles I*, 1630–33. London, Trafalgar Square

BELOW RIGHT:
FIG. 68 Hubert Le Sueur (1580–1658), *Charles I*, mid-seventeenth century. Bronze, height 83 cm. Royal Collection (RCIN 33467)

that Henrietta Maria brought Hubert Le Sueur, a talented sculptor from the French court, to England.[60] Le Sueur created the large-scale equestrian statue that stands on the road leading to Whitehall from Trafalgar Square (fig. 67). The majestic sculpted portrait employs similar iconography to that of Van Dyck, with the King wearing armour, confidently resting his baton against his thigh and commanding an elevated position on horseback. This work is contemporary with the Van Dyck portrait; it dates from 1630 to 1633 and was commissioned by Sir Richard Weston, Lord High Treasurer, to be placed in the garden of his house at Roehamp-

ton. A bronze bust of Charles I by Le Sueur in the Royal Collection derives from this large-scale model, and shows the King with his immediately identifiable, fashionably lopsided haircut (fig. 68). His armour has a Medusa head in the centre and lion heads on the shoulders. Frequently used as a symbol on armour, the Medusa's head allegorically places the King in the guise of Perseus, the mythological hero who killed the snake-haired monster.

The most celebrated bust of Charles I no longer exists. Created in marble by the Italian artist Gian Lorenzo Bernini and sent to Charles I in 1637, it was destroyed in the Whitehall fire

FIG. 69 Unknown sculptor,
perhaps after Bernini,
Charles I, *c.*1700.
Marble, height 95.3 cm.
Royal Collection
(RCIN 35856)

of 1698 (along with the Holbein mural). A bust
in the Royal Collection (fig. 69) probably
reflects the lost original. Bernini never met
Charles I. He created a three-dimensional
sculpture based solely on the triple portrait
painted by Van Dyck (fig. 70). It was a tremen-
dously difficult task, but Bernini rose to the
challenge and created an image of such suc-

cess that Henrietta Maria subsequently asked
Van Dyck to create three portraits of herself,
this time on three separate canvases. These
were intended to be sent to Bernini for the
same purpose but, following the outbreak of
Civil War, were never dispatched (two of these
remain in the Royal Collection). As a work of
art *Charles I in three positions* goes far beyond

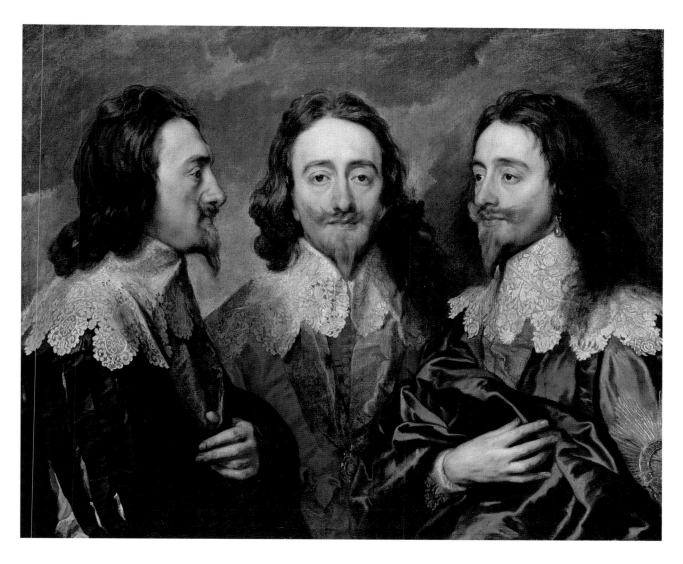

ABOVE:
FIG. 70 Sir Anthony Van Dyck (1599–1641), *Charles I in three positions*, 1635–6. Oil on canvas, 84.4 x 99.4 cm. Royal Collection (RCIN 404420)

FIG. 71 Lorenzo Lotto (c.1480–1556), *Portrait of a goldsmith in three positions*, c.1525–35. Oil on canvas, 52.1 x 79.1 cm. Vienna, Kunsthistorisches Museum

the mere purpose of Van Dyck's task. There was no need to differentiate the colour of the costume since the bust was to be created in white marble, but the artist did so nonetheless, to enliven the image, and he cleverly altered the placement of the arms in the two side-profile views so that both the left and right hands could be included.[61]

On receiving this painting Bernini allegedly identified sadness expressed in the eyes of Charles I, which he re-created in the mood of the marble bust.[62] In the painting the eyes of the central portrait are disconcertingly real, with the King's right eye staring resolutely ahead and the left eye realistically asymmetrical, so that the King appears simultaneously to engage and to see straight past the viewer. The modelling of the face demonstrates careful attention to detail in order to help the sculptor understand the contours of the King's features. Both painter and King were aware that the delivery of this painting to Rome was an opportunity for self-promotion. It is no accident that the composition, as well as fulfilling the functional need of the commission, also quotes from another renowned painting, the *Portrait of a goldsmith in three positions* from the Gonzaga collection (belonging to the Duke of Mantua) which Charles I had acquired in 1628 (fig. 71). Such an overt reference to the Lorenzo Lotto painting served as a reminder to Bernini, Pope Urban VIII and anyone else willing to look or listen that Charles I had exceptional taste in art; that he had built up an impressive princely art collection to rival that of any other European court; and that he had in his employ a Flemish artist of such

intelligence and skill that he could emulate the Venetian Renaissance artist Lotto with ease, to create a portrait of outstanding quality.

Charles I was put on trial at Westminster in January 1649, at which time the English artist Edward Bower (who had trained under Van Dyck) appears to have made some portrait sketches. In the finished portrait (fig. 72) the King sits on a crimson velvet chair wearing dark clothes, the star of the Order of the Garter emblazoned on his sleeve and the badge of the Order with the figure of St George hanging round his neck – possibly drawing comparison with the martyrdom of the patron saint of England. It is a far cry from the ostentation of Van Dyck's portraits, but the King on trial has unmistakable dignity and strength of character etched on his features. A portrait of this type was intended to reinforce the King's innocence and his noble acceptance of death. In the same way as painted depictions of Christ's Passion tend to show a calm rather than a panicked man, here the King accepts his fate with the insinuation that he, like Christ, was the victim of human ignorance and bad judgement; the people 'know not what they do' in committing the crime of deposing and executing him. This sentiment is echoed in an 'autobiographical' book, the *Eikon Basilike* (the Greek title translates as 'Image of the King'), which was ghost-written in the first person. The book, like the Edward Bower portrait, was perhaps masterminded by Charles I with the help of his royalist supporters.

The frontispiece of the *Eikon Basilike* was an engraving by William Marshall, later reproduced

Fig. 72 Edward Bower (active 1629–67), *Charles I at his trial*, signed and dated 1648. Oil on canvas, 131.1 x 99.2 cm. Royal Collection (RCIN 405913)

FIG. 73 Wenceslaus Hollar (1607–77), *Eikon Basilike*, 1649. Etching, 13.4 x 15.1 cm. Royal Collection (RCIN 802219)

in numerous versions, such as that by Wenceslaus Hollar in the Royal Collection (fig. 73). The iconography was carefully thought out: the King kneels at a table with his right foot resting on a globe. The setting, with column and curtain and a view of Westminster beyond, is reminiscent of state portraiture, but the King is turned away from the viewer, not posing for a portrait but instead absorbed in the moment of his divine redemption. The Latin inscriptions praise Charles's virtue which 'thrives beneath oppres-

sion'. He holds out a crown of thorns while his earthly crown lies discarded on the floor. A third crown is suspended in the top right-hand corner, emblazoned with light – the crown of eternal glory that awaits the martyred King. The fragmented sections of text function as a trio which, when joined together, translate as 'I spurn the crown of the world – splendid but heavy', 'I take the crown of Christ – prickly but light', 'I look to [the crown] of heaven – blessed and eternal'. The words on the prayer book in front of the King

attest to his faith: 'In thy word is my hope'.[63]

As in the portrait by Bower, the imagery of the crown of thorns in Charles's hand and the representation of a wilderness in the left-hand section of the engraving allude to Christ, the redeemer, and to ultimate sacrifice. This image of hope was intended to be interpreted and revered by the followers that Charles left behind. The popularity of the book and its illustrations was unprecedented. At a time when multiple versions of books were rare, more than 35 editions of this politically dangerous text were printed in England alone, as well as 25 on the Continent, and the first edition appeared ten days after Charles's execution, transforming the defeated King into a heroic martyr.[64] The way was paved for Charles's son Prince Charles to take up his birthright – the earthly crown – as soon as circumstances allowed.

On 30 May 1660 the exiled Charles II attended a party held by Prince Maurice of Nassau at his home in The Hague. This was the night before Charles departed the Netherlands for England to take up the crown. The monarchy was restored, and Charles celebrated in style before returning to his homeland to face his responsibilities. A painting by Hieronymus Janssens possibly depicts this event (fig. 74). Charles II dominates a crowded room, dancing with his sister Mary, Princess of Orange, accompanied by a group of musicians on the left-hand side. It is not certain whether this painting depicts the ball or a different event, or whether it is a fictitious scene.[65] The important point is that the painting exists at all. It is an upbeat group portrait celebrating the end of the Interregnum, possibly commis-sioned by a member of Charles's circle. Charles II is elegantly presented dancing on tiptoe, looking directly out of the picture plane. Janssens did not use sophisticated imagery – the continuous narrative technique of repeating characters (for instance with Charles reappearing in the background at a dinner table) is decidedly old-fashioned – but the effect is nonetheless a success, portraying a jubilant moment in history, when an exiled prince became a king.

A portrait of Charles II by John Michael Wright, painted in 1661–2, was intended to embody the manifesto of the newly restored King (fig. 75). It was commissioned as a means to commemorate not only the lavish coronation ceremony of Charles II, but also the creation at huge expense of a new set of coronation robes and regalia, the old set having been destroyed during the Commonwealth. The King is enthroned underneath a canopy. His orb and sceptre are balanced in either hand, and the Imperial State Crown adorning his head appears itself to be crowned by the royal coat of arms behind. Wright captures the triumph of the monarchy restored, and a sense that after a long wait the Stuart King has finally taken up his rightful place. Although it is not known who commissioned this painting or where it was meant to hang, it seems intended to impress the King's subjects in a large, public space. The figures emerging from behind the canopy to left and right are part of a tapestry hung behind the throne, but are painted to appear as though paying homage to the King. This painting becomes a grand statement of Charles II's own myth-making, his indomitable stare and stoic features

serving as testament to the difficulties he had endured in exile.

The portraiture of Charles I tended to combine an effect of royal authority with an impression of careless elegance; Van Dyck in particular excelled in delivering this double message of raw power and refined taste. Charles II had no artist of Van Dyck's stature to call on and was perhaps also more concerned, as a returned exile, to convey his message of royal legitimacy in an undiluted form. Certainly Wright's image is old-fashioned in its laboured decorative surfaces and flattening of the figure. The nearest visual precedent can be found in the anonymous portrait of the family of Henry VIII (fig. 41), created over a century earlier. In the re-created regalia and in the quality of imagery, the King wishes to convey that idea that the monarchy has remained stable, constant and unchanging through the centuries.

ABOVE:
Fig. 74 Hieronymus Janssens (1624–93), *Charles II dancing at a ball at court*, c.1660. Oil on canvas, 139.7 x 213.4 cm. Royal Collection (RCIN 400525)

Fig. 75 John Michael Wright (1617–94), *Charles II*, c.1661–2. Oil on canvas, 281.9 x 239.2 cm. Royal Collection (RCIN 404951)

4

The Hanoverians

'Sit to you for a Portrait, what, do you want to make a show of me?'

GEORGE III'S RESPONSE TO JOHN SINGLETON COPLEY AFTER
THE ARTIST ASKED TO PAINT THE KING'S PORTRAIT, 1806

DURING THE THIRTY YEARS after the death of Charles II in 1685, the British monarchy lost all but the shadow of its power and mystique. James II was driven from the throne at the Glorious Revolution in 1688 and succeeded by the Protestant daughters of his first marriage, Mary (1662–94) and Anne (1665–1714). After Queen Anne's death the crown passed to the Protestant Prince-Elector of Hanover, great-grandson of James I through James's daughter Elizabeth (see fig. 61), who became George I. But the main branch of the Stuart line did not become extinct: through his second marriage to Mary of Modena James II produced a healthy and legitimate son, James Edward Stuart 'The Old Pretender' (1688–1766), who himself fathered two legitimate boys, Charles Edward Stuart 'Bonnie Prince Charlie' (1720–1788) and Henry Benedict Stuart (1725–1807). Supporters of the Stuart claim (called 'Jacobites' after the Latin form of the name James) mounted two armed rebellions against the Hanoverians, in 1715 and 1745. In the so-called 'Forty-Five' the Jacobite army marched unchecked from Scotland as far as Derby, before turning through loss of nerve and retreating to the Highlands. The slaughter of this army by the Duke of Cumberland at the battle of Culloden eliminated the

direct threat to the Hanoverian dynasty. But James III (as he called himself) maintained a British court in Rome and is buried in St Peter's with this royal title upon his tomb.

The Pope only recognised the legitimacy of George III upon the death of Charles III in 1788. Any British subject who took seriously the sacred ideas of monarchy as outlined in previous chapters of this book would have supported the Jacobite cause. The Hanoverian dynasty's claim depended upon the pragmatic Act of Settlement of 1701, which prohibited any Roman Catholic from occupying the throne (thus condemning the Stuarts to their exile) but which also confirmed Parliament's limitation of royal power imposed at the time of the Glorious Revolution. The throne was in Parliament's gift; the Hanoverians had to accept the limits of that gift with as good a grace as they could muster.

This real diminution in royal power was matched by a diminution of royal prestige which occurred with the arrival of an unknown and unimpressive family with an imperfect command of the English language. The early years of the eighteenth century saw a dramatic explosion of un-courtly behaviour – adversarial politics, satirical and scurrilous literature and speculative capitalism. The bubble of a mystical, divine air surrounding the role of kingship

FIG. 80 (detail)
Allan Ramsay (1713–84),
George III, c.1761–2. Oil on
canvas, 249.5 x 163 cm.
Royal Collection
(RCIN 405307)

99

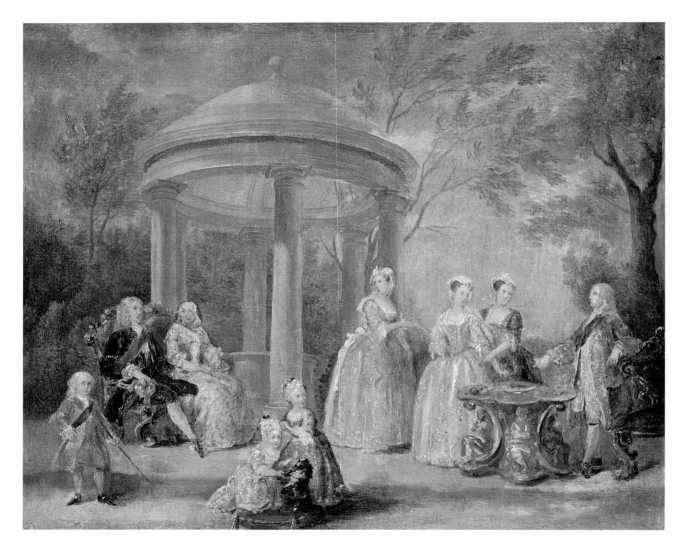

had well and truly burst. As Thackeray noted when reflecting on the period, the Hanoverian kings seemed to be 'splendid and idle'.[66]

In portraiture the interesting innovations of this period arise from the depiction of informality. As the Hanoverian dynasty adapted to their adopted home they began to explore the possibility of presenting themselves as English gentlemen rather than German princes.

An oil sketch by William Hogarth depicting George II and Queen Caroline with their children (fig. 76) has a staged informality. At the time, Hogarth was hoping to secure the commission for a painting commemorating the marriage of Princess Anne to William, Prince of Orange, and this sketch may have been intended to serve as a basis for the portraits to be included in the marriage painting, but the project was never completed.[67] The sketch functions as an animated composition, where the characters appear grouped together outdoors, interacting with one another. The term 'conversation piece' describes such informal group portraits, which derive from Van Dyck's

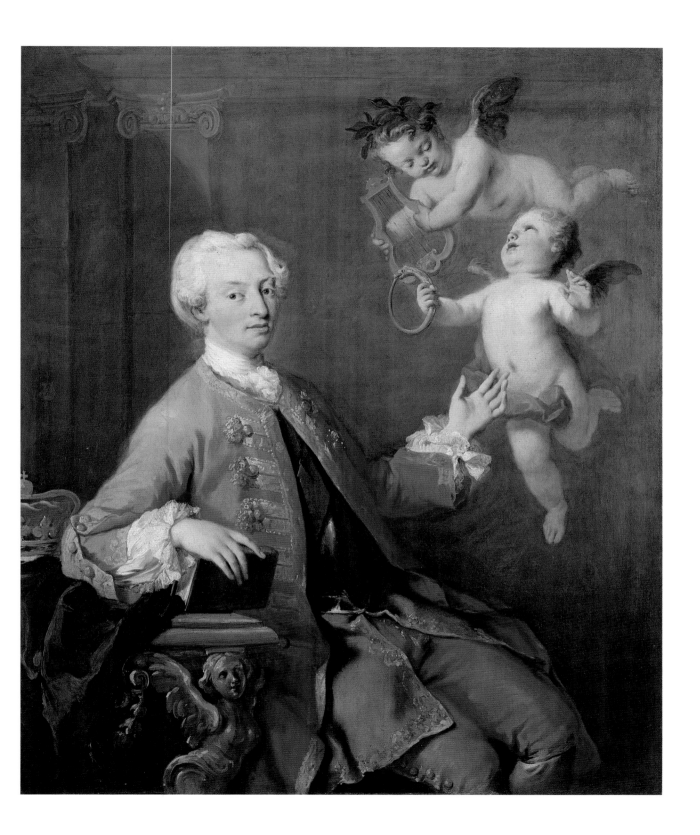

family groupings of the previous century (fig. 62), but have an increased sense of an impromptu, natural moment captured for the viewer's delight.

A portrait of Frederick, Prince of Wales (1707–51) – George II's eldest son and father of the future King George III (1738–1820) – by the Italian artist Jacopo Amigoni epitomises eighteenth-century elegance (fig. 77). The Prince is presented as a fashionable gentleman. He wears a pink silk frock coat and knee breeches, far removed from the coronation robes of Stuart state portraiture. His crown is pushed to the extreme left edge of the painting and appears to be forgotten as other interests occupy the main picture. He holds a book in his right hand, giving the impression that he has just been distracted from the pursuit of reading. An inscription tells us that it is one of the translations of Homer by Alexander Pope, either *The Iliad*, which was published in 1715–20, or *The Odyssey* of 1725–6.[68] When in *c.*1546 Princess Elizabeth was portrayed at the age of 13 (fig. 42), books were included to symbolise her piety and it was generally accepted, without the need for inscriptions, that books in Tudor portraits would represent either the Bible or a prayer book. By the eighteenth century, books tend to indicate cultivation, and so the character of Frederick, Prince of Wales, who constantly sought popularity, is identified with a best-selling book.

The Prince of Wales perches delicately on the edge of an elaborate carved and gilded chair with sculptural detailing of a winged female figure. Two *putti* fly above him as though vying which of them should present their attributes first. The lyre symbolises poetry and the circular golden snake immortality. The Prince gestures towards the cherubs and his measured outward gaze appears to seek our approval. The two Ionic pilasters behind him suggest the importance of classical influences and, somewhat surprisingly, beneath the Prince's coat we glimpse a breastplate and the ribbon of the Order of the Garter, perhaps indicating a chivalrous – even heroic – character.

Music is prevalent in the portraits of Frederick, Prince of Wales. Three portraits by Philippe Mercier (National Trust, National Portrait Gallery and Royal Collection) are variations on the theme of music-making and the pleasures surrounding it. The Royal Collection version (fig. 78) shows a group of royal sitters inside a house (perhaps the Banqueting House of Hampton Court, although it is impossible to say for certain). The Prince of Wales and his sisters are playing instruments together in a relaxed atmosphere. Viewers are given the impression that they are the privileged spectators of the informal concert. It seems like a personal commission, intended to hang in a private space of a royal residence for decorative purposes. However, the relaxed atmosphere is contrived. In 1733 the royal children were not happy.[69] Frederick and his sisters barely knew each other as he had been raised separately from them in Hanover and had only recently come to join them in England. This misleading scene of family unity, a manifesto of a harmonious, talented royal family, intended to promote an ideal view of the Prince and his

FIG. 78 Philippe Mercier (*c.*1689–1760), '*The Music Party*': *Frederick, Prince of Wales with his three eldest sisters*, 1733. Oil on canvas, 79.4 x 57.8 cm. Royal Collection (RCIN 402414)

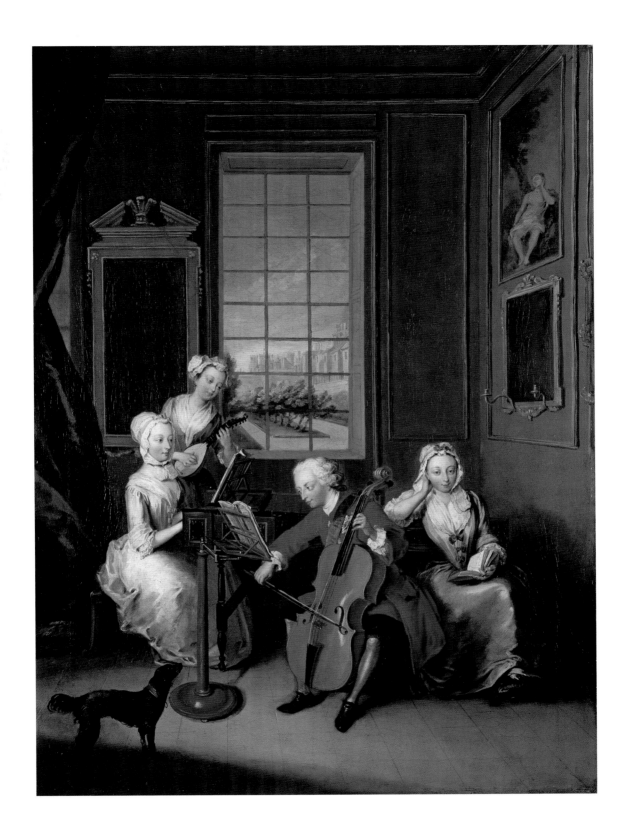

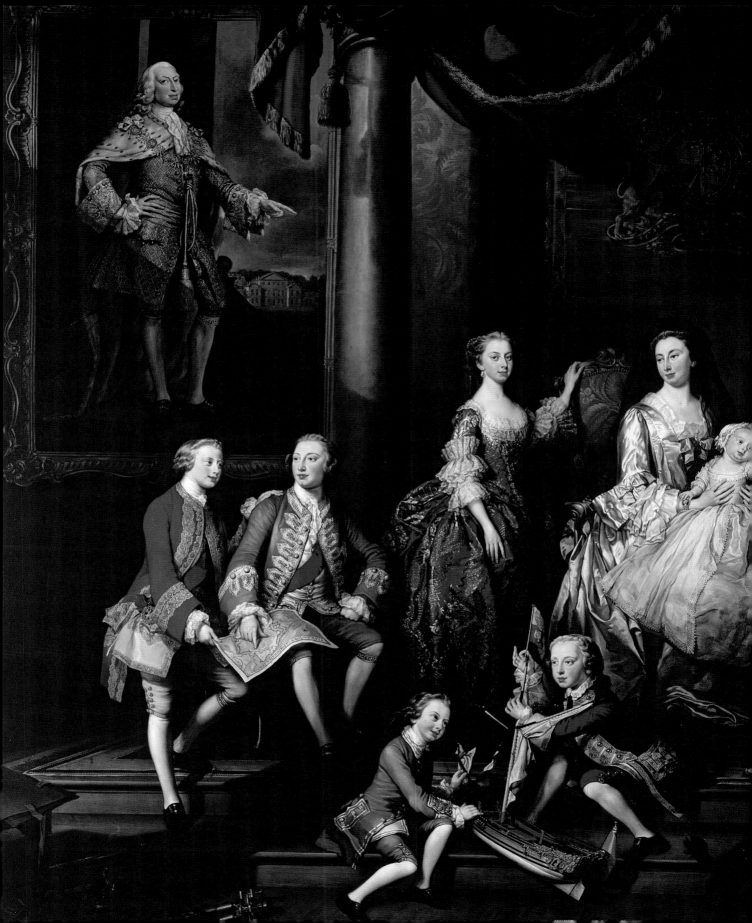

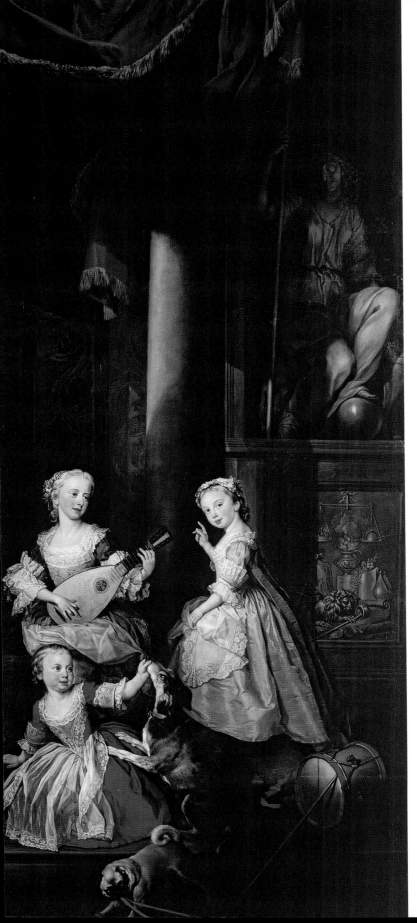

FIG. 79 George Knapton (1698–1778),
*The family of Frederick, Prince of
Wales*, signed and dated 1751.
Oil on canvas, 350.9 x 461.2 cm.
Royal Collection (RCIN 405741)

sisters, may have been intended for external eyes, and the existence of three similar versions implies that they were created with the intention of being given away.

In 1751, shortly after the death of Frederick, Prince of Wales, his widow, Augusta, organised a family portrait on an exceptionally large scale (fig. 79), painted by the English artist George Knapton. The Princess sits at the centre under a canopy, much as the King in the Wright portrait of Charles II (fig. 75), except that she sits on a chair at a slight angle, indicating that she is not the reigning monarch but protector of the royal children who surround her. Again musical instruments are incorporated, but, unlike the Mercier portrait, there is no pretence that this is a spontaneous grouping. It is evident that this is a structured setting, and the figure of Frederick himself is cleverly included in a portrait-within-a-portrait format. He looks out of the painting, gesturing towards his large, healthy-looking family as though to say, 'This is my legacy.' If we compare this with the *Whitehall Mural* of the family of Henry VIII and *The Family of Henry VII with St George and the Dragon*, we can see that this is, in a sense, a return to sixteenth-century styles of dynastic and posthumous portraiture, in which labels are even included to identify the sitters.

The reign of George III (1760–1829) coincided with the golden age of portraiture in Great Britain. For the first time, British artists were at the forefront of artistic developments

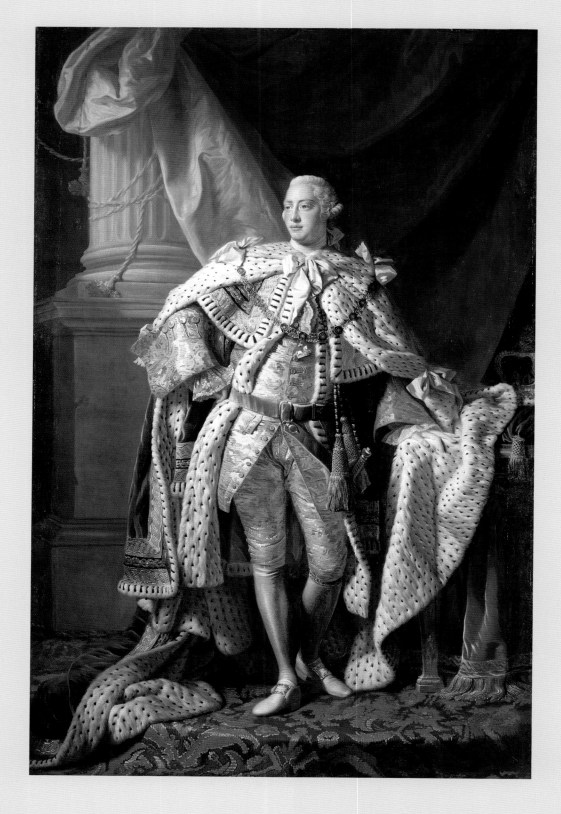

Fig. 80 Allan Ramsay (1713–84), *George III*, c.1761–2. Oil on canvas, 249.5 x 163 cm. Royal Collection (RCIN 405307)

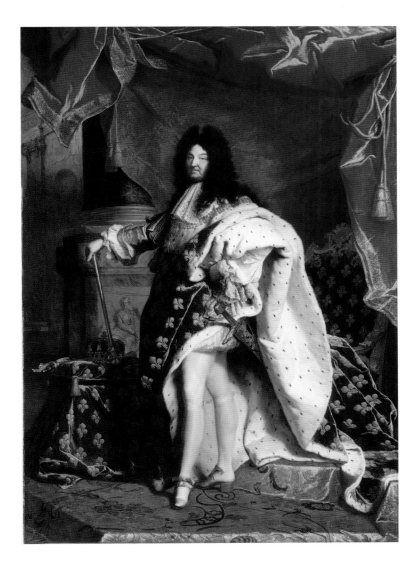

FIG. 81 Hyacinthe Rigaud
(1659–1743), *Louis XIV*,
1701. Oil on canvas,
277 x 194 cm.
Paris, Musée du Louvre

in Europe and the New World, and the best society portraitists were home grown. In a letter to his friend Sir Horace Mann, Horace Walpole described George III as 'tall, and full of dignity; his countenance florid and good-natured; his manner ... graceful and obliging'.[70] Such a positive account is backed up by the state portrait of the King executed by the Scottish artist Allan Ramsay *c*.1761–2 (fig. 80). This was a monarch who could speak English fluently (unlike his grandfather and great-grandfather) and who had been raised as an educated prince, ready to fulfil the requirements of the role. A sense of hope surrounded his accession to the throne, which is conveyed in Ramsay's portrait. The composition derives from the highly successful conventions of eighteenth-century French portraiture, for example the imposing yet elegant portrait of *Louis XIV* by Hyacinthe Rigaud painted in 1701 (fig. 81). Just like Louis XIV, George III is depicted standing in coronation robes. His crown is on the table to the side, partially hidden from sight. A robust column on a solid base rises up on the left-hand side of the composition, swathed in a crimson velvet curtain. This is intended to convey the message of strong leadership, and forms a supportive backdrop for the opulently clad King. George III has an easy vigour, with a youthful, rosy complexion and an open countenance that compares favourably with the more severe features of the earlier French portrait. Unlike James I and VI, whose robes appeared to engulf him (fig. 52), George III wears the state vestments with a natural grace. He inhabits his clothes, and by association his role, with ease.

FIG. 82 Allan Ramsay
(1713–84), *Queen Charlotte*,
*c.*1760–61. Oil on canvas,
248.9 x 161.3 cm.
Royal Collection
(RCIN 405308)

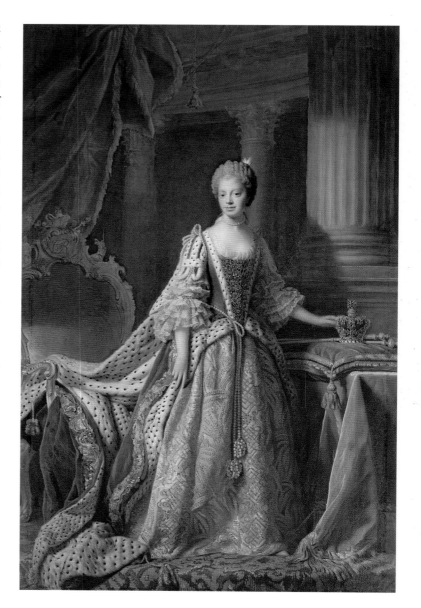

The Ramsay coronation portrait was the most popular and most frequently copied royal portrait of all time and the definitive image of the King. In addition to the two original portraits, a staggering 188 extant versions of the images of George III and Queen Charlotte (fig. 82), including paired and individual versions, are known. These would have been created for royal patrons, courtiers, ambassadors and the general public.[71] This commission secured Ramsay a very strong position at Court but unfortunately it also meant that the rest of his professional output was dominated by the task of overseeing the production within his studio of countless replicas on different scales and formats.

The German artist Johan Zoffany flourished under the patronage of George III. His portraits have an informal air, much influenced by Hogarth's innovations earlier on in the century (fig. 76). Even Zoffany's striking official portraits of the seated King and Queen, which were exhibited at the Royal Academy in 1771 (figs 83a and b), underline this point. Informality was expressed to great effect in the many group portraits of the royal family, depicted indoors and out, seemingly in a relaxed, off-the-cuff manner. One of the most celebrated of these images is the painting of *Queen Charlotte with her two eldest sons* (fig. 84). It shows the Queen sitting before her dressing table in a room on the ground floor of Buckingham House, the residence that George III bought for her in 1761 and

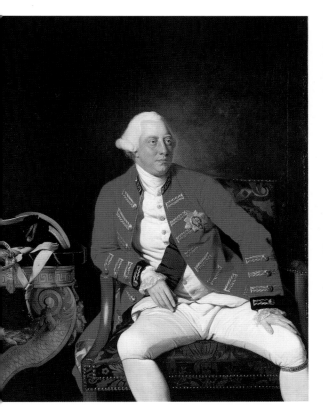

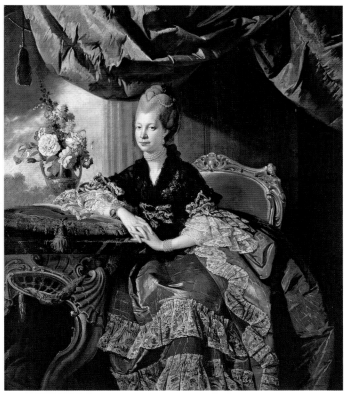

FIG. 83a Johan Zoffany
(1733–1810), *George III*, 1771.
Oil on canvas,
163.2 x 137.3 cm.
Royal Collection
(RCIN 405072)

FIG. 83b Johan Zoffany,
Queen Charlotte, 1771. Oil on
canvas, 162.9 x 137.2 cm.
Royal Collection
(RCIN 405071)

that came to be known as The Queen's House.

Zoffany was inspired by Van Dyck's group portrait of *The five eldest children of Charles I* (fig. 62), which had been commissioned by Charles I in 1637 and rejoined the Royal Collection when it was acquired by George III in 1765, at about the same time Zoffany completed this informal group portrait. Zoffany took Van Dyck's ground-breaking composition and developed the idea into a charming scene with soap-opera-like reportage. The dog is friendlier than the mastiff in Van Dyck's portrait, but it is included for the same reason as in the seven-teenth-century group, to dwarf the royal children, whilst giving the Prince of Wales an air of bravery in his authoritative relationship with the royal pet. The royal children are depicted in fancy dress: George as Telemachus (the heroic son of Odysseus and Penelope in Greek mythology) and Frederick as a Turk. Queen Charlotte sits in a relaxed pose, looking to the side. In the mirror her face is reflected in clas-sical-style profile.[72] Through the open doorway there is another mirror in which a figure is also reflected, this time possibly Lady Charlotte Finch, governess to the children. The

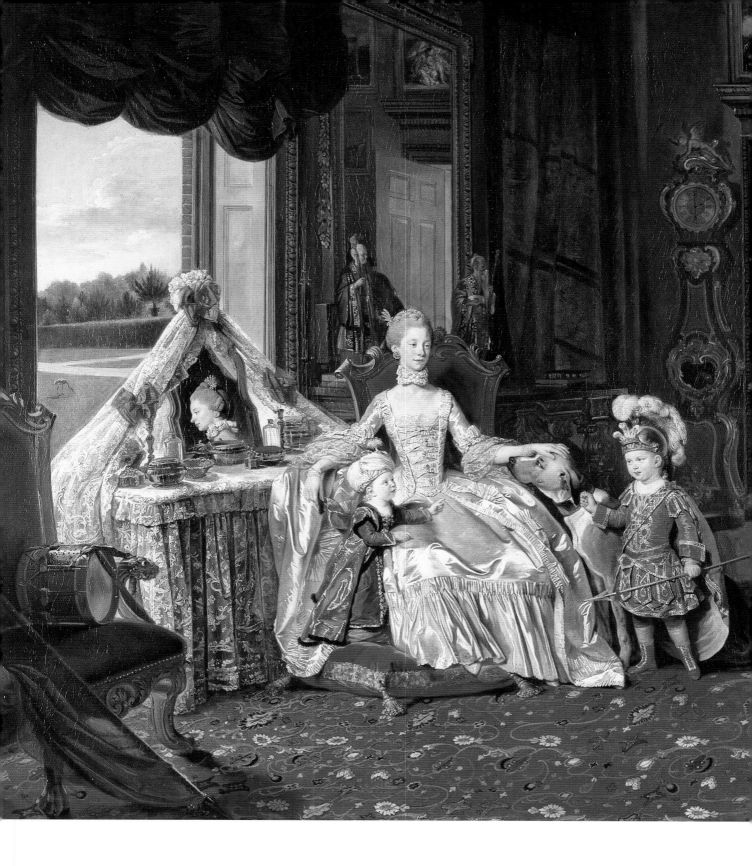

FIG. 84 Johan Zoffany
(1733–1810), *Queen Charlotte
with her two eldest sons*, c.1765.
Oil on canvas, 112.2 x 128.3 cm.
Royal Collection
(RCIN 400146)

governess may be waiting in an antechamber, but the viewer of the painting enjoys privileged access to the Queen's dressing room at this private moment. It is however difficult to say who that 'viewer' was intended to be; certainly not the public at large as the painting was neither exhibited nor engraved. But even if for the royal family's eyes only, this private image underlines the importance of the domestic virtues which were also reflected in the King's public image as an unaffected, accessible family man. Zoffany did exhibit some of his later (and strikingly informal) royal images, including the pair of 1771 (figs 83a and b). The royal couple wished to embody this informality in reality, especially during visits to Kew and Windsor when they were often to be seen walking and riding out in their carriage without attendants.[73]

This emphasis on family and a less formal image of royalty was the impetus for a set of oval portraits of the royal family designed to be hung together in Buckingham House, commissioned in 1782 by Queen Charlotte from the English artist Thomas Gainsborough (fig. 85). The 15 individual canvases illustrate Gainsborough's remarkable ability to capture a moment 'in transience' and to 'catch the face actually in motion'.[74] The looseness and confidence of the artist's handling of paint may be seen in these portraits, which are immediate and entrancing. Portraits of the King and Queen are included, along with 13 of the children. The second oldest son, Frederick, Duke of York, was omitted as he was in Hanover when the portraits were made, and Princess Amelia, the youngest child, was not

born until 1783. The portrait of Prince Alfred (1780–82) was posthumous, based on the artist's memory of his appearance. George III's youngest son, Prince Octavius (1779–83), died a few months after this work was painted. When the finished ovals were exhibited as one unit at the Royal Academy in 1783, the Octavius portrait, which depicts the 4-year-old adored favourite with wavy light brown hair and red lips as though on the brink of speaking, caused Queen Charlotte and her daughters to weep at the sight.[75]

In 1768 George III established the Royal Academy, a foundation created with the aim of giving artists a forum for exhibiting their work annually and for teaching. The King was evidently proud of his involvement with the Royal Academy. An engraving of 1788 (published in spring 1789) shows the King and Queen and some of their children enjoying a private view of the Royal Academy exhibition in the Great Room of Somerset House (fig. 86). Such an image was intended to show a role of the monarch which expanded during the eighteenth and nineteenth centuries, not so much as ruler but *encourager*. Soon after its foundation George III commissioned Zoffany to paint a group portrait of the members of the Royal Academy (fig. 87). It is typical of patron and artist that the academicians are not shown in public, at an exhibition, but in private and at work in the drawing schools, a space more functional than elegant. The presence of the King may be to some extent implied as the viewer in this depiction of *his* artists who, as the most successful painters, sculptors and architects of their time, are being recorded for posterity.

FIG. 85 Thomas
Gainsborough (1727–88),
The Royal Family, 1782.
Each oil on canvas,
approx. 59.4 x 44.1 cm.
Royal Collection
(RCIN 401006–20),

from left to right:
George III (1738–1820),
Queen Charlotte (1744–1818),
*George IV when Prince of
Wales* (1762–1830),
*Prince William, later Duke of
Clarence* (1765–1837),

Charlotte, Princess Royal
(1766–1828),
*Prince Edward, later Duke of
Kent* (1767–1820),
Princess Augusta (1768–1840),
Princess Elizabeth
(1770–1840),

*Prince Ernest, later Duke of
Cumberland* (1771–1851),
*Prince Augustus, later Duke of
Sussex* (1773–1843),
*Prince Adolphus, later Duke of
Cambridge* (1774–1850),
Princess Mary (1776–1857),

Princess Sophia (1777–1848),
Prince Octavius (1779–83),
Prince Alfred (1780–82)

FIG. 86 P. Martini (1738–97) after Johan Heinrich Ramberg, *Portraits of Their Majesty's* [sic] *& The Royal Family Viewing the Exibition* [sic] *of the Royal Academy, 1788.* Engraving, 33.4 x 48.8 cm (sheet). Royal Collection (RCIN 750535a)

Of the artists portrayed in Zoffany's *The Academicians* George III had his preferences, and these are reflected in his portrait commissions. Surprisingly, the first President of the Royal Academy, Sir Joshua Reynolds (1723–92), was not favoured by the King, and it was not until the Regency (1811–20) and subsequent reign (1820–30) of George IV that a considerable number of works by Reynolds entered the Royal Collection. George III seemed to prefer more conservative artists, and commissioned numerous paintings from the American artist Benjamin West. He is seen in *The Academicians* on the left-hand side of the group, wearing a dun-coloured suit with a grey overjacket, standing with his left leg bent, turning confid-

ently to talk to another artist behind him. West specialised in history painting in a distinctive classical style, but he also carried out straightforward royal portraits, such as the single-figure full-length portraits of George III and Queen Charlotte of 1779 (figs 88a and b). Compared to the lightness of touch and elegance of works by Gainsborough, in particular his full-length portrait of Queen Charlotte (fig. 89) painted two years later, West's portraits seem heavy-handed and conventional. As might be expected from a history painter, his portraits seem to be more concerned with ideas than with character, with the office rather than the individual: the King is shown as commander-in-chief of the armed forces and the

Queen as mother of the children playing in the background.

It is in the more informal works that the King's true nature is revealed. In two pendant works painted in the 1790s William Beechey came closer than West to conveying the character of the monarch and his consort (figs 90a and b). Beechey, like West, presented George III in military dress, but he did not include a crown. Although the portrait of the King was exhibited alone at the Royal Academy in 1800,

the two works were hung together shortly afterwards in the King's Dining Room at Kew Palace – informal portraits for an informal setting. In the monarchs' expressions we see a man who had already suffered, in 1788–9, the first bout of the illness (now identified as porphyria) that came to define him as 'the King who went mad'; and his wife, who considered herself unattractive, and who must have been under considerable strain at the time that this portrait was made. In such portraits George

FIG. 87 Johan Zoffany (1733–1810), *The Academicians of the Royal Academy*, c.1770–72. Oil on canvas, 101.1 x 147.5 cm. Royal Collection (RCIN 400747)

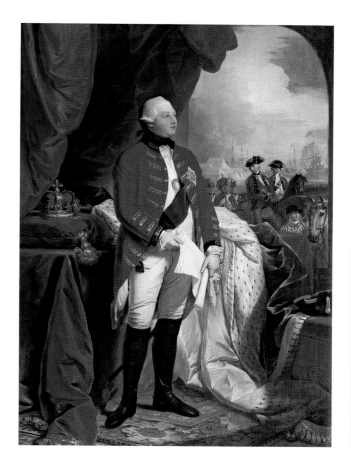

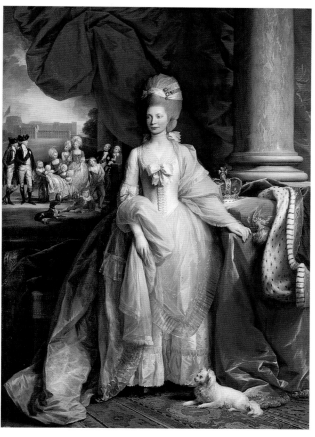

III's sense of duty can be understood. He set aside his preference for a private, quiet life, taking on instead the responsibilities that come with the position of being 'born for the happiness or misery of a great nation'.[76] These portraits have a sobriety and human frankness that go far beyond the usual formal constraints of royal portraiture.

John Singleton Copley, a successful artist in New England, looked to his compatriot Benjamin West for an introduction to George III. He received the royal commission for a group portrait of the three youngest princesses, Mary, Sophia and Amelia, in 1785 (fig. 91). Copley adopted the informal air that typified the most successful royal portraits of George III's reign, but his large-scale painting was unsuccessful and he received no further royal commissions. This, it is thought, was mostly due to the fact that the artist John Hoppner was damagingly critical of the painting in a review of the Royal Academy exhibition of 1785. Although Hoppner

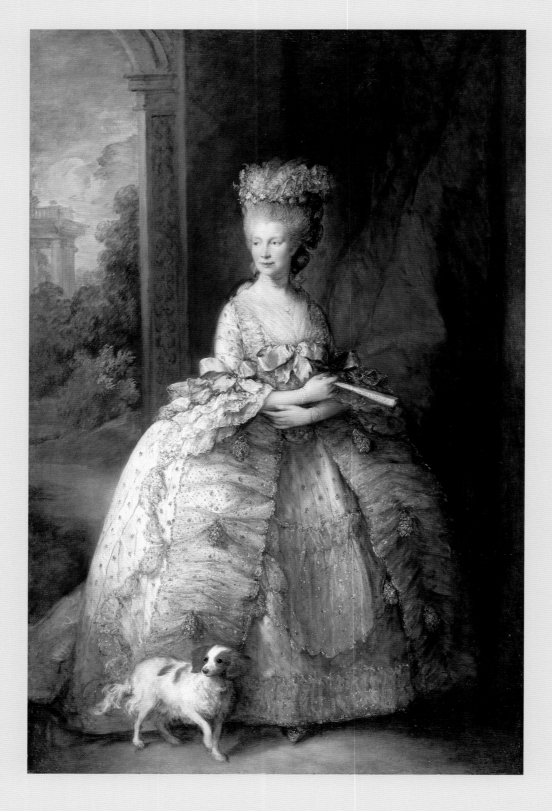

Fig. 89 Thomas
Gainsborough (1727–88),
Queen Charlotte, c.1781.
Oil on canvas,
238.8 x 158.7 cm.
Royal Collection
(RCIN 401407)

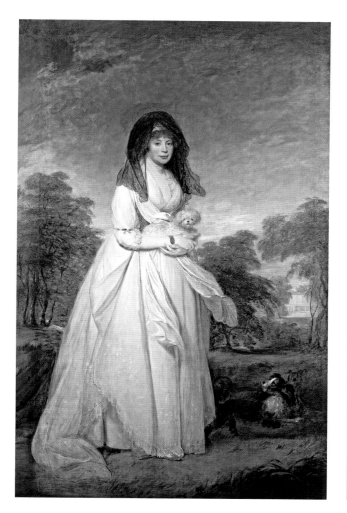

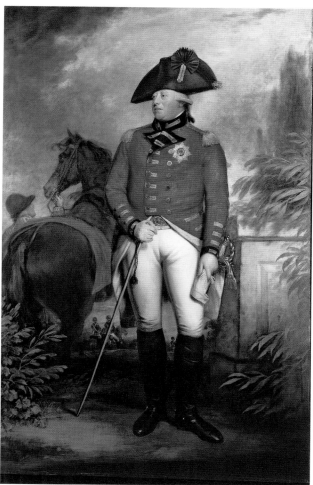

was predominantly motivated by professional jealousy, he may have had a point. In his grouping of the princesses Copley attempted to convey the exuberance of youthful abandon, but the elements are overly staged, so that the composition appears crowded and artificial.

A small-scale enamel portrait of George III attributed to Joseph Lee was created around the last year of the King's life during his final illness, when he was kept for his own safety in Windsor Castle (fig. 92). The enamel captures the pathos of the King's condition, with the monarch presented in profile without a wig, staring vacantly ahead. The darkness of the background looms behind the figure; in it we see the outline of an organ. The King was not responsible for the commission of this work – any command over artists was, by this point,

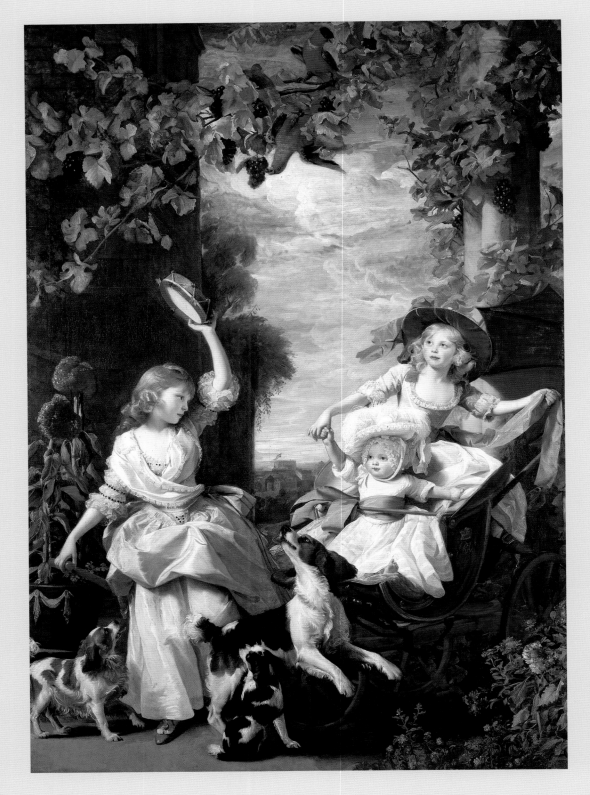

FIG. 91 John
Singleton Copley
(1738–1815), *The three
youngest daughters
of George III*, signed
and dated 1785.
Oil on canvas,
265.4 x 185.7 cm.
Royal Collection
(RCIN 401405)

Fig. 92 Attributed to Joseph Lee (1780–1859), *George III*, c.1810–20. Enamel, 21 x 16 cm. Royal Collection (RCIN 421492)

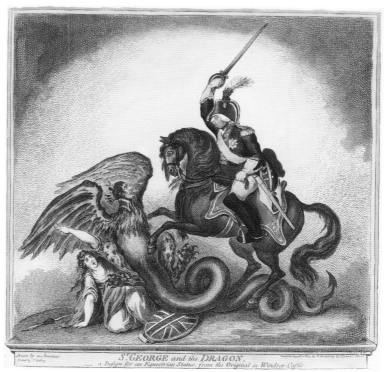

out of his hands, just as his power was no longer his own following his son's appointment as Prince Regent in 1811. With this melancholy depiction of George III in solitude, painted from imagination rather than from a portrait sitting, the artist brings to mind Shakespeare's *King Lear*: 'We are not ourselves / When nature, being oppress'd, commands the mind'.[77]

It was not only in the last decade of his life that George III was unable to censor images. Throughout the eighteenth century the freedom of the press was upheld by law and exploited by fearless and often brutal satirists. These immensely irreverent works, which were reproduced to reach a large audience, tapped into the mood of the time. Not all such images were critical of the monarchy; for instance, the famous printmaker and caricaturist James Gillray produced a print of *St George and the Dragon* showing George III in the guise of the heroic

saint on a horse which tramples the monster (fig. 93). The dragon has the features of Napoleon Bonaparte and the princess who narrowly escapes being crushed represents Britannia. Even though the King has somewhat exaggerated features in the manner of a caricature, this image is a metaphor for national pride, centred on the leadership of George III.

However, the number of prints ridiculing the royal family far outnumbers the respectful. In many ways George III's character made him an easy target for satirists. He was thought of as overly frugal and conservative, and his love of agriculture, combined with his habit of walking round his estates to talk to his workers, earned him the nickname 'Farmer George'. Another image by James Gillray, entitled *Affability*, pokes fun at these features (fig. 94). The King wears a large floppy hat, his eyes are bulging and the diminutive figure of Queen Charlotte links her

Fig. 93 James Gillray (1757–1815), *St George and the Dragon*, published by Hannah Humphrey, 2 August 1805. Hand-coloured etching and aquatint, 40.5 x 40.5 cm paper size. London, National Portrait Gallery.

FIG. 94 James Gillray (1757–1815), *Affability*, published by Hannah Humphrey, 10 February 1795. Hand-coloured etching and aquatint, 35.3 x 25 cm paper size. London, National Portrait Gallery.

AFFABILITY.

"Well, Friend where a'you going, Hay? _ what's your Name, hay? _ where d'ye Live hay? _ hay?"

A VOLUPTUARY under the horrors of Digestion.

FIG. 95 James Gillray (1757–1815), *A Voluptuary under the horrors of Digestion (The Prince of Wales)*, 1792. Stipple etching, 36.8 x 29.8 cm (platemark). Royal Collection (RCIN 809343, No. 383)

arm through his. The King interrogates a peasant, asking, 'Well, Friend, where a' you going, Hay? – what's your Name, hay? – where d'ye Live, hay? – hay?' To the modern viewer this is no more than a *Spitting Image* type of satire, basing the visual repertoire on an exaggeration of identifiable habits (the King reputedly littered his speech with interrogative 'hey's). The King here may be grotesque, but he is also admirable: indeed it is precisely his affability (however absurd) which has prevented this menacing-looking peasant from imitating his French equivalent and reducing the King to something like the contents of his bucket.

No such admiration tempered images of

George III's son. The excesses of the future George IV (1762–1830), manifested in his sexual misdemeanours, greed and overspending, were a gift to caricaturists. According to the Duke of Wellington, George IV hated to be ridiculed. In 1820, during the trial of Queen Caroline (which attempted to prove that she had been unfaithful and therefore that she should not be given the title of Queen Consort), he attempted to buy the copyright of all existing images that mocked him, and he paid the caricaturist George Cruikshank £100 in return for the artist's 'pledge not to caricature His Majesty in any immoral situation'.[78]

George IV was incensed by the disrespect-

ful portrayal of him by caricaturists such as James Gillray. *A Voluptuary under the horrors of Digestion (The Prince of Wales)* shows the Prince as a grossly overweight squanderer, surrounded by food bills, betting receipts, 'debts of honour unpaid' and medicines for undignified complaints such as 'stinking breath' and 'piles' (fig. 95). He aspired to be presented, and generally perceived, as a handsome hero. In the sixteenth century Lucas Horenbout revealed in miniature portraits Henry VIII's concern about the different effects of facial hair (figs 30 and 31); in the eighteenth the Prince of Wales showed great interest in the impact of different looks, experimenting with varying hairstyles that were captured in around 30 miniatures by Richard Cosway. This may be seen by comparing a portrait by Cosway in 1783–4 (fig. 96) with the appearance of the Prince one year earlier in the portrait by Gainsborough as part of the *Royal Family* group (fig. 97). As Lady Spencer noted in a letter to the Duchess of Devonshire, 'The Prince dresses his hair in a new way, flattish at sides, frizzed and widish at each side and three curls at the bottom of this frizzing' [sic].[79] In Cosway's miniature we can see the Prince as he wished to appear, and numerous works in the Royal Collection attest to his preferred appearance.

A drawing by Thomas Lawrence of 1814 presents the Prince Regent in classical profile (fig. 98). He is wearing armour, with a stock dramatically adorning – and having a slimming effect on – his neck. His own hair, rather than a wig, is shown curling in a dramatic, windswept style, drawing parallels with the dashing looks

Fig. 96 Richard Cosway (1742–1821), *George IV, when Prince of Wales*, c.1783–4. Watercolour on ivory, diameter 3.1 cm. Shown here enlarged. Royal Collection (RCIN 420005)

Fig. 97 Thomas Gainsborough (1727–88), *The Royal Family: George IV when Prince of Wales*, 1782. Oil on canvas, 59.4 x 44.2 cm. Royal Collection (RCIN 401009)

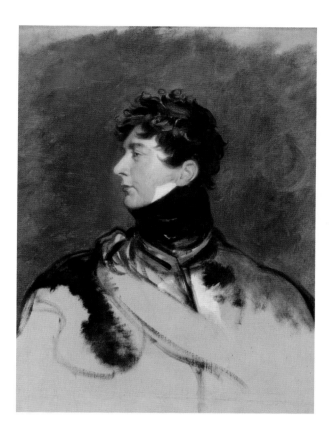

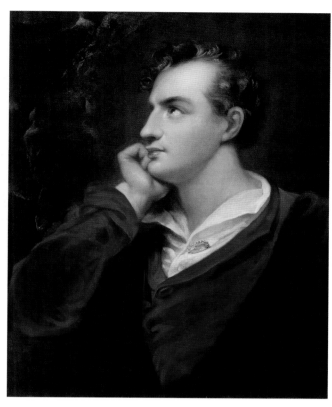

of the Romantic poet Byron (1788–1824; fig. 100). That similarity is also evident in an oil sketch (fig. 99). Both the portraits of the Prince Regent were carried out as preparatory studies for a full-length portrait of him commissioned by Lord Stewart (Ambassador to Vienna). This was Lawrence's first portrait of the Prince. It is thought that his earlier lack of royal patronage may have been due to the rumours that he had an affair with Queen Caroline. He had stayed with her at Montagu House, Blackheath, in 1802 in order to paint a double portrait of her with her daughter Princess Charlotte. Remarkably, Lawrence managed to clear his name of this charge, receiving a knighthood in 1815 and going on to create the definitive image of George IV.[80]

Lawrence's flattery of George IV in paint led to the description of him by the painter Benjamin Robert Haydon (1786–1846) as 'a perfumer to His Majesty'.[81] The flattery may be seen in Lawrence's idealised but extremely successful full-length portraits of George IV. The first version of the Prince Regent in Garter

robes, with his hand resting lightly on a table, was the source of numerous versions by Lawrence's studio, four of which are in the Royal Collection. The inclusion of the table is significant and was in accordance with the Prince Regent's specifications. It is the *Table of the Grand Commanders* (fig. 101), a work in Sèvres porcelain originally commissioned by Napoleon Bonaparte. The centre is decorated with a profile portrait of Alexander the Great (looking remarkably like Napoleon himself), surrounded by 12 smaller heads of classical military commanders painted to resemble cameos (compare with fig. 48). The table was given to the Prince Regent by the restored French King Louis XVIII in 1817. The Prince Regent was pleased with Lawrence's finished portrait and declared it his official image. It was subsequently used as the basis for Lawrence's coronation portrait of *George IV*, where coronation robes were substituted for Garter robes and the Imperial State Crown was included, resting prominently on the table (fig. 102).

Lawrence's full-length portrait type also appears to have influenced the sculptor Francis Chantrey. He created a full-length plaster model of the King to be cast in bronze for public monuments to be displayed at Brighton and Edinburgh. It was later used as the source for an over-lifesize marble sculpture of George IV, housed at Windsor Castle (fig. 103). This sculpted portrait was intended to have a dramatic effect on the viewer, positioned on the Grand Staircase at the entrance to the State Apartments, an impressive effect that may still be appreciated by visitors to Windsor Castle.

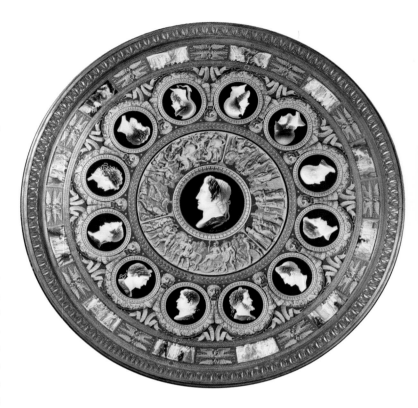

The pose is comparable to the striking painted portrait by Lawrence. The King stands confidently with his right leg projecting forwards, his head turned slightly so that he is in three-quarter profile. George IV is portrayed as a strong, heroic monarch, conforming perfectly to the King's self-image. He reportedly declared, 'Chantrey I have reason to be obliged to you, for you have immortalised me'.[82]

The Waterloo Chamber at Windsor Castle functions both as a glorious display and as a vivid demonstration of George IV's somewhat inflated view of his power and influence (fig. 104). He first commissioned Thomas Lawrence to begin a series of portraits commemorating

ABOVE:
Fig. 101 Sèvres porcelain factory, *Table of the Grand Commanders* (detail), 1806–12. Hard-paste porcelain with gilt-bronze mounts, overall diameter 104 cm.
Royal Collection
(RCIN 2634)

Fig. 102 Sir Thomas Lawrence (1769–1830), *George IV*, c.1818–21. Oil on canvas, 295.4 x 205.4 cm.
Royal Collection
(RCIN 405918)

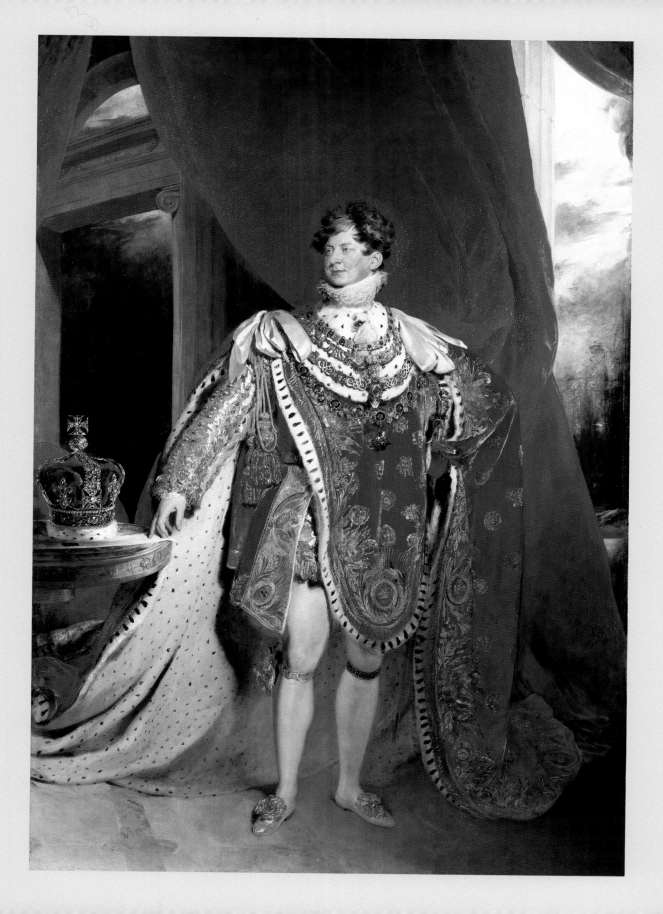

Fig. 103 Sir Francis Chantrey
(1781–1841), *King George IV*,
1830. White marble,
12 x 125 x 140 cm.
Royal Collection
(RCIN 93005)

the victory of allied forces over Napoleon to be
housed at Carlton House, but after the decision
was taken to demolish his London residence in
1826, the location for the finished works was
switched to Windsor Castle. The designated
room was specifically designed by Jeffry
Wyatville for George IV in a space that was pre-
viously an open courtyard. Sadly neither the
King nor the artist lived to see the works
installed.

The commission began in the summer of
1814, when a group of influential political and
military leaders came to London, following the
surrender of Napoleon. The Emperor of Russia
Alexander I, the King of Prussia Frederick III,
the German-Austrian politician Prince Metter-
nich, the Prussian General Field-Marshal
Gebhardt von Blücher and the Russian General
Matvei Ivanovitch, Count Platov, all sat to
Thomas Lawrence for their portraits. These
paintings were the backbone of what became
Lawrence's crowning achievement, a high-pro-
file project that entailed him traveling round
Europe to paint the principal allied leaders.
The task occupied him until his death in
January 1830.

Thirty-eight portraits adorn the Waterloo
Chamber, and the majority are by Lawrence.
They are a grand statement intended to function
in the same way as the historical paintings of
Henry VIII, to glorify a military and political vic-
tory, and – as Benjamin West stated – they rose to
the 'dignity of history'.[85] In recording history in
this way, George IV was self-consciously placing
himself at the head of those responsible for the
defeat of Napoleon. Not content with master-

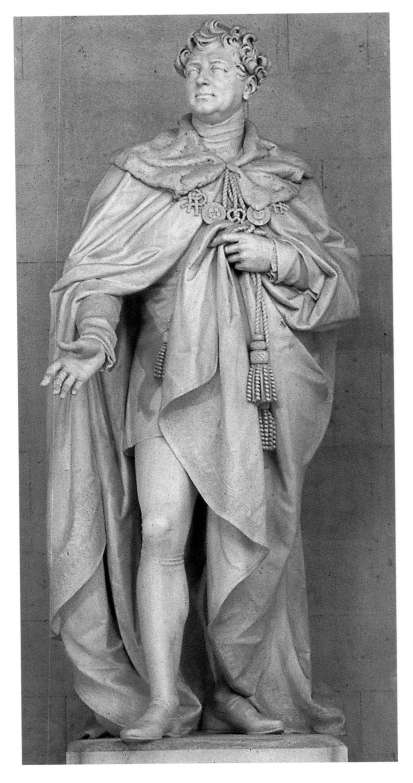

FIG. 104 Joseph Nash (1808–78), *The Queen dining with the Emperor of Russia in the Waterloo Gallery, 5 June 1844*, 1844. Watercolour and bodycolour, 28 x 36.7 cm. Royal Collection (RCIN 919785)

minding the commission of these portraits, and of course including an image of himself as one of the key players on the European stage, he also seems to have ensured that Lawrence included further references to him within the portraits. In the images of Count Platov and Gebhardt von Blücher, George IV is included in the form of miniature portraits in a jewelled setting worn by both sitters. More obscurely, George IV is present in the exceptionally fine portrait of *Pope Pius VII* (fig. 105). The left-hand section of this image presents a view of the Braccio Nuovo, a gallery intended to house the renowned Vatican collec-

tion of classical sculpture that had been looted by Napoleon. This imagined detail (for the gallery was yet to be built), lit dramatically by a stream of golden light, alluded to the fact that when the Pope admitted that the Vatican could not afford to transport these works back to Rome from Paris, George IV had undertaken to pay the expenses of their delivery.[84]

The dramatic silhouette of the *Apollo Belvedere* (fig. 106) against the background in Lawrence's portrait of *Pope Pius VII* may even have been intended to represent not just the iconic sculpture, but also the benevolent figure of the British

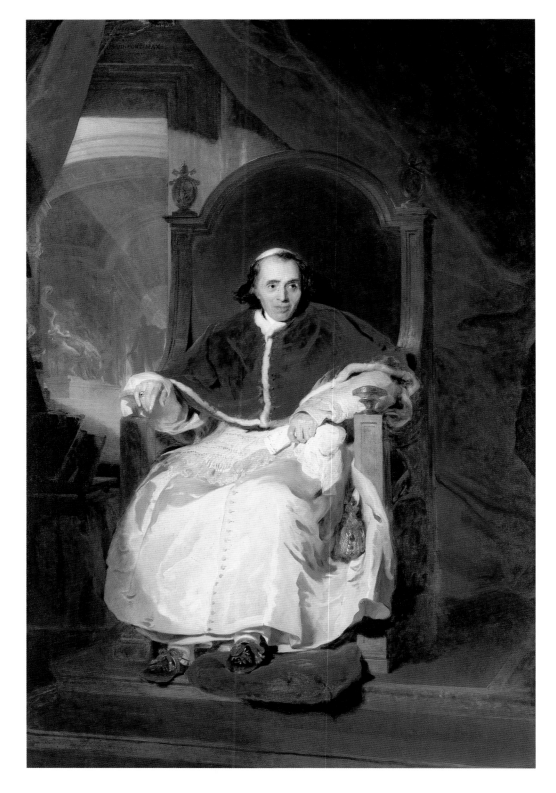

FIG. 105 Sir Thomas
Lawrence (1769–1830),
Pope Pius VII, 1819, 1819.
Oil on canvas,
269.4 x 178.3 cm.
Royal Collection
(RCIN 404946)

FIG. 106 Attributed to Leochares (4th century BC), *Apollo Belvedere* (restored Roman copy of the Greek original). White marble, height 224 cm. Rome, Vatican City, Vatican Museums

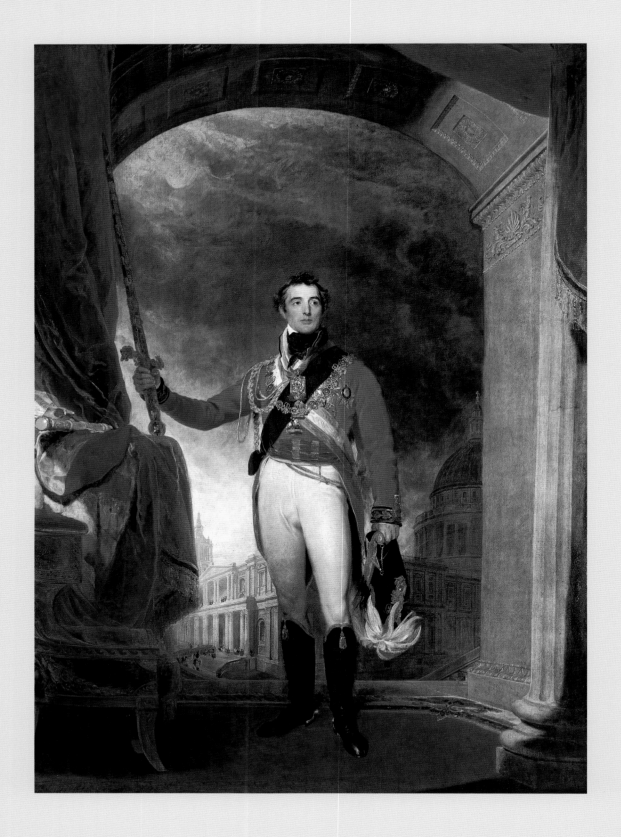

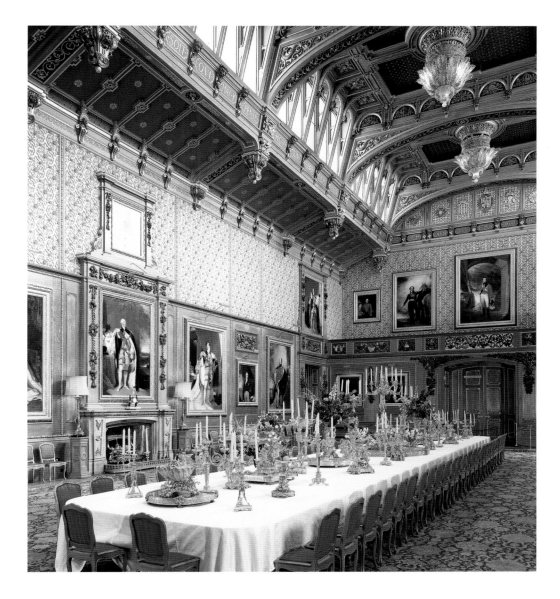

King who had subsidised its safe return home.
Moreover the inclusion of this figure, framed by
the decorated triumphal arch above it, creates a
visual reference to Lawrence's portrait of *Arthur
Wellesley, 1st Duke of Wellington* (fig. 107), created
five years previously as the central image in the
iconography of the Waterloo Chamber series (fig.
108). In an ingenious amalgamation of imagery,
the pose of Lawrence's *Wellington* mirrors that of
the *Apollo Belvedere*. George IV thereby emerges
from the Waterloo Chamber as the absolute
British hero, the victor of the Battle of Waterloo,
a delusion which, towards the end of his life, the
King allowed himself to believe. In spite of the
growing cynicism about monarchy which char-
acterised his age, with the Waterloo Chamber
paintings, Lawrence had fashioned the perfect
royal portrait.

5

Queen Victoria

'I shall do my utmost to fulfil my duty towards my country;
I am very young and perhaps in many, though not in all things,
inexperienced, but I am sure that very few have more real good
will and more real desire to do what is fit and right than I have.'

Queen Victoria's Journal, 20 JUNE 1837

QUEEN VICTORIA painted a clear portrait of herself in words. Never before had a monarch been so literary. It is thought that she wrote on average 2,500 words a day, most of which were entries in her diary or letters.[85] As a result we are not reliant solely on our eyes when looking at official portraits of the Queen. She often recorded the circumstances surrounding their commission, her thoughts on the artist and her opinions on the work in progress and the finished painting. Images of Queen Victoria (1819–1901) were widely disseminated through engravings, so that public portraits and more private sketches could easily be printed in newspapers and magazines. The Queen's image became instantly recognisable and was mass-produced to an unprecedented extent. Also, for the first time the veracity of portraits could be proven by comparing them to that most modern and exciting of scientific inventions, which was born and developed dramatically during her reign: the photograph.

While staying in Ramsgate in the winter of 1835 after suffering an illness (thought to have been tonsillitis), Princess Victoria recorded in her Journal: 'I am still VERY weak and am grown VERY thin'.[86] The 16-year-old, who was a keen amateur artist, drew a self-portrait a few days later (fig. 109). It is an innocent rumina-

tion of self-pity and her surprised reaction to the physical change in her face indicates how ill she had been. Her features are exaggerated, her eyes are extremely large and sorrowful, and her eyebrows are creased. This image is engagingly real, as the viewer is placed in the privileged position of sharing the sight that greeted the young Princess when she looked in the mirror. This element of accessibility characterises the portraits of Queen Victoria throughout her life, but with added poignancy here as it was created by her.

When she was 11 Princess Victoria's drawing master, Richard Westall, portrayed her while she was sketching outdoors (fig. 110). The painting was based on a head-and-shoulders preparatory drawing (fig. 111) that has charming immediacy. The Princess's lips are characteristically parted, and she appears to be innocently unaware that she is being observed. The composition of the finished painting sets Victoria in an idyllic wooded landscape. Her bonnet lies discarded at her feet and her dog, Fanny, jumps up at her knee as though entreating her mistress to play rather than diligently sketch from nature. This work was commissioned from Westall by Victoria's mother, the Duchess of Kent. Its encapsulation of the sheltered innocence of the Princess (who was

FIG. 109 Princess Victoria,
Self-portrait, 1835.
Pencil, 22.7 x 18.7 cm.
The Royal Archives, Windsor

raised by her mother in quiet seclusion at Kensington Palace) may be due as much to the wishes of the patron as to the artist's invention.

The first painting that Victoria herself commissioned on becoming Queen was a painted account of *The First Council of Queen Victoria* (fig. 112). She appointed the Scottish artist Sir David Wilkie for the task. He had been a favourite of George IV, but was more renowned for his genre scenes than for portraiture. Wilkie was officially Queen Victoria's principal painter, continuing in that role from the reigns of George IV and William IV. The painting shows Queen Victoria addressing the Accession Council on 20 June 1837, the morning after her uncle (William IV) had died. This unusual

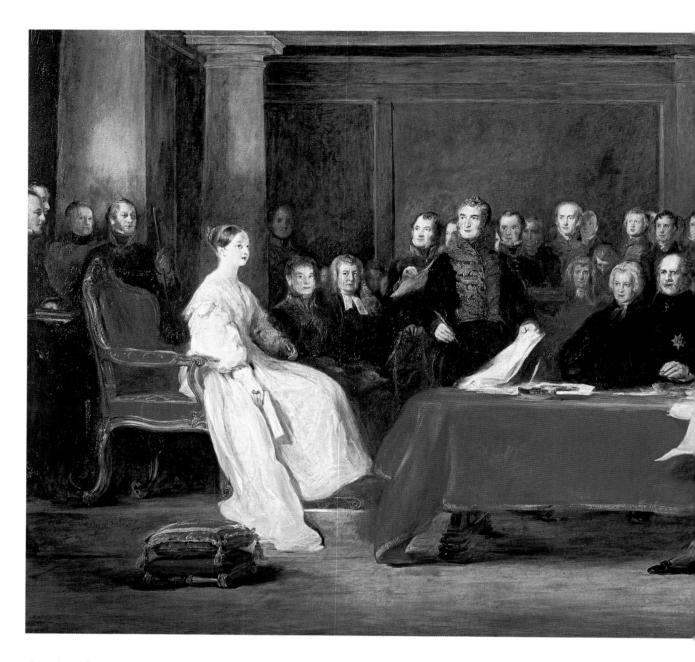

situation of a young woman suddenly being thrust into the midst of a group of influential men captured the public imagination.[87] Wilkie's presentation of the scene is a romanticised vision of the event. Queen Victoria is dressed in white instead of the black mourning that she wore on the occasion, and the number of privy councillors in attendance is drastically reduced. The Queen is elevated on a chair, giving her a commanding position over the assembled group of men. The Duke of Wellington noted that at the meeting she had incredible composure, so that 'she not merely filled the chair, she filled the whole room'.[88]

ABOVE:
FIG. 112 Sir David Wilkie
(1745–1841), *The First Council
of Queen Victoria*, c.1837–8.
Oil on canvas,
151.8 x 238.8 cm.
Royal Collection
(RCIN 404710)

FIG. 113 Sir David Wilkie
(1745–1841), *Queen Victoria
seated with a dog; study for
'The First Council of Queen
Victoria'*, 1837. Pencil, red
chalk, watercolour and
bodycolour, 30.1 x 19.1 cm.
Royal Collection
(RCIN 913590)

The painting was conceived at the Royal Pavilion at Brighton, and Queen Victoria wore a white satin gown for her portrait sittings there, which is presumably why Wilkie chose to depict her in these garments.[89] A sketch in the Royal Library indicates that the artist considered including a dog at her feet, which he replaced in the finished painting with a footstool (fig. 113).

Even though Wilkie positions the Queen to the left of the scene, she is undoubtedly the central figure and all attention is focused on her. Even so, she is made to seem out of place and slightly awkward. She perches on the edge of her chair, holding the declaration paper down by her side as though uncertain about what to do with it, and she is placed too far away from the central table for it to be of any practical use to her. Only her face has gravitas; it is composed as she stares confidently ahead towards the seated figure of her uncle, the Duke of Sussex, who is being handed a pen by the Duke of Wellington. Wilkie's composition may derive from depictions of Christ as a boy preaching with authority to an intimidating group of elders in the temple, in order to emphasise the mixture of vulnerability and wisdom in the young Queen (fig. 114).[90]

At first it seems that Queen Victoria liked the painting, but later she decidedly took against it, describing it in 1847 as 'one of the worst pictures I have ever seen, both as to painting and likeness'. Similarly she did not approve of the state portrait that Wilkie made of her (fig. 115), which she called 'atrocious'.[91] In stark contrast Queen Victoria considered (in the early days of

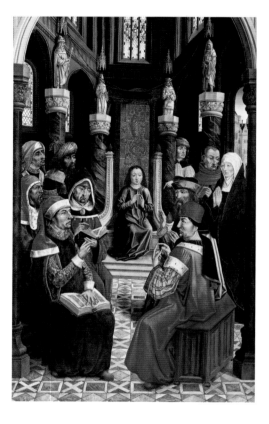

Fig. 114 Master of the Catholic Kings (active 1485–1500), *Christ among the doctors*, c.1495–7. Oil on panel, 136.2 x 93 cm. Washington DC, National Gallery of Art (Samuel H. Kress Collection)

her reign at least) Sir George Hayter to be 'out and out the *best* portrait painter'.[92] Hayter was keen to secure a position within the Royal Household, and received significant commissions until Sir Edwin Landseer and Franz Xaver Winterhalter replaced him in the Queen's favour. Queen Victoria was aware of the potential of portraits to influence ideas, and was keen to ensure, for instance, that the British Embassy in Paris should not have a version of the Wilkie portrait, but that instead a copy of the coronation portrait by Hayter should be sent there.[93]

Hayter's portrait of *Queen Victoria* shows the

Fig. 115 Sir David Wilkie (1745–1841), *Queen Victoria*, 1840. Oil on canvas, 271.5 x 190.5 cm. Port Sunlight, Lady Lever Art Gallery

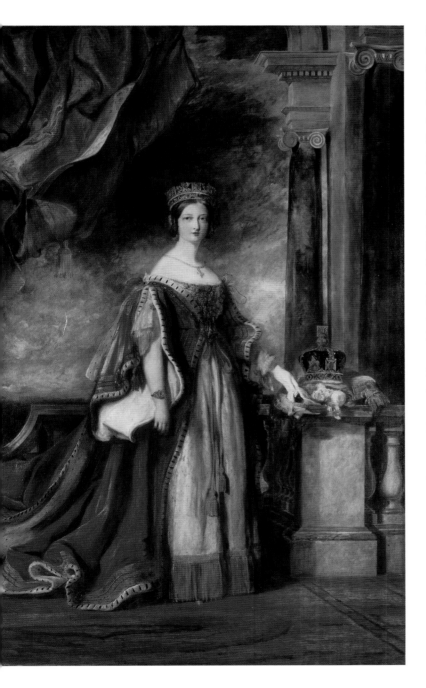

monarch seated on a throne. The original version of the painting measures 128 x 102.9 cm and is what the artist termed 'a small whole length on a half length canvas'. It was an immediate success. Princess Feodora of Leiningen (Queen Victoria's half-sister by her mother's first marriage) described it as: 'That beautiful picture by Hayter, I always see it before me, with that beautiful look upwards which is so like.'[94] The 'look upwards' is probably what gives this portrait its resonance. The Queen is portrayed as a calm and dignified ruler, dressed in coronation robes. She wears the Imperial State Crown, which had been remade specifically for her. The new crown was considerably lighter than that worn by her two predecessors and more suited to her slight physique (she was just 1.55m tall). Even so, it gave her some discomfort at the coronation ceremony. The Queen recorded in her diary on the day of the event (28 June 1838) that the crown 'hurt me a good deal'.[95] The tilt of the head upwards in Hayter's portrait creates the illusion that she wears the crown with ease, and she gazes humbly towards heaven so that her eyes do not engage with the viewer. This contrasts with Wilkie's representation of the Queen (fig.115) as a more diffident – even vulnerable – figure, inviting a degree of interaction with the viewer.

Hayter painted numerous versions of this painting, but on a larger, life-size scale. The first of these larger variations (fig. 116) was commissioned directly by Queen Victoria, and in this the artist made an alteration to the background. Where before he had painted a view of Westminster Abbey behind the throne, on the revised

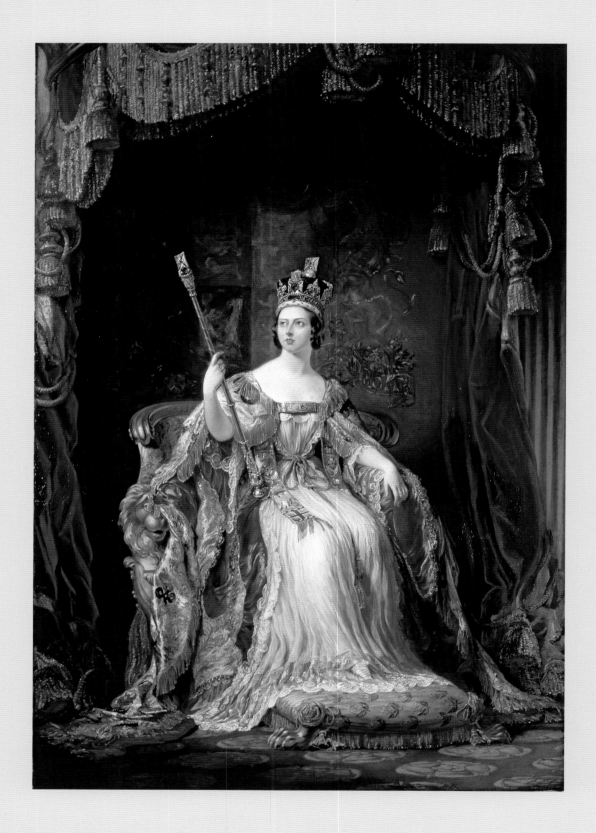

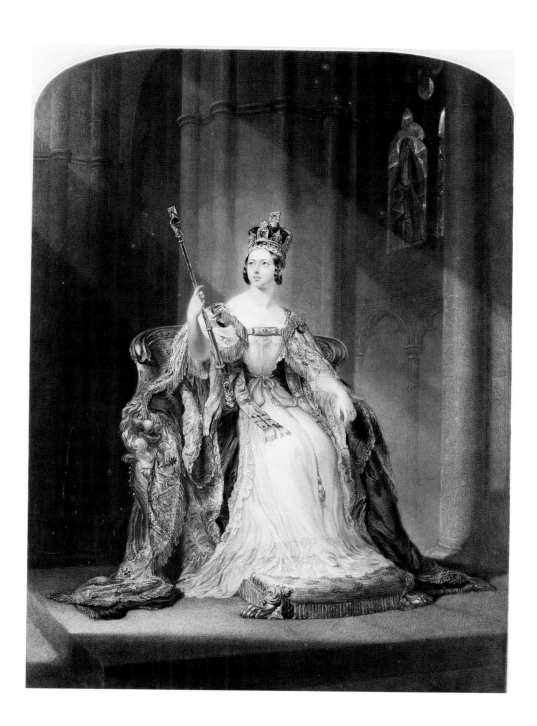

LEFT:
Fig. 116 Sir George Hayter
(1792–1871), *Queen Victoria*,
1840. Oil on canvas,
270.7 x 185.8 cm.
Royal Collection
(RCIN 405185)

Fig. 117 H.T. Ryall (1811–67)
after Sir George Hayter,
Queen Victoria, 1840
(published 1 September
1840). Mezzotint,
68 x 49 cm. Royal Collection
(RCIN 503334)

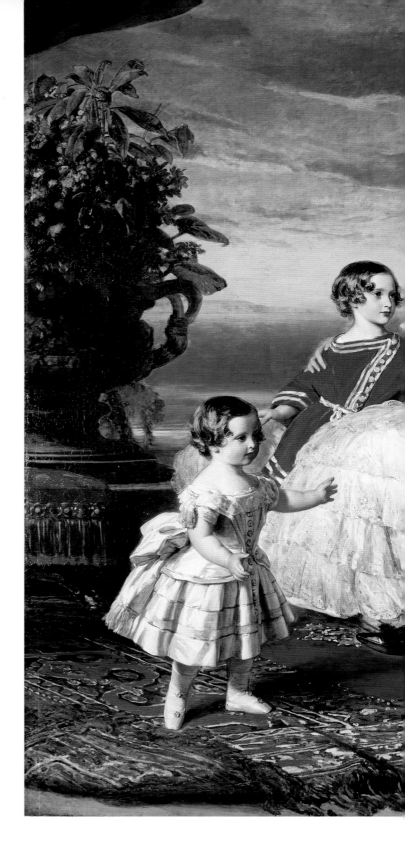

FIG. 118 Franz Xaver Winterhalter (1805–73), *The Royal Family in 1846*, 1846. Oil on canvas, 250.5 x 317.3 cm. Royal Collection (RCIN 405413)

version he inserted a backdrop of a royal canopy. Rather than a vast medieval architectural space beyond – the grandeur of which vies with the dominant figure of the monarch – the canopy background in the new portrait frames the Queen and strengthens the impact of her magisterial presence. This evidently gained Victoria's approval, as Hayter repainted the background of the original smaller-scale portrait to match this new version. Before the alteration was made, the original design, complete with the Westminster Abbey background, had been engraved by H.T. Ryall (fig. 117), and in consequence prints of the original composition were in circulation.

Engravings of portraits enabled images to be reproduced in newspapers and magazines, and individual prints could be purchased by the public. In the 1820s the invention of steel engraving meant that thousands of copies could be made from one plate, as opposed to around five hundred copies using the old method of copper-plate engraving.[96] Images that previously would only have been available in the circle of the owner of the painting were now widely disseminated. This not only contributed to the renown of the painting (and by extension of the artist), but also, in the case of royal portraits, made the image of the monarch much more accessible. Many of the works already discussed were reproduced as prints for popular consumption. The Westall portrait of the Princess innocently sketching was published in 1897 in *The Glorious Reign of Queen Victoria* (an edition of the *English Illustrated Magazine*, vol. 17, celebrating the Queen's

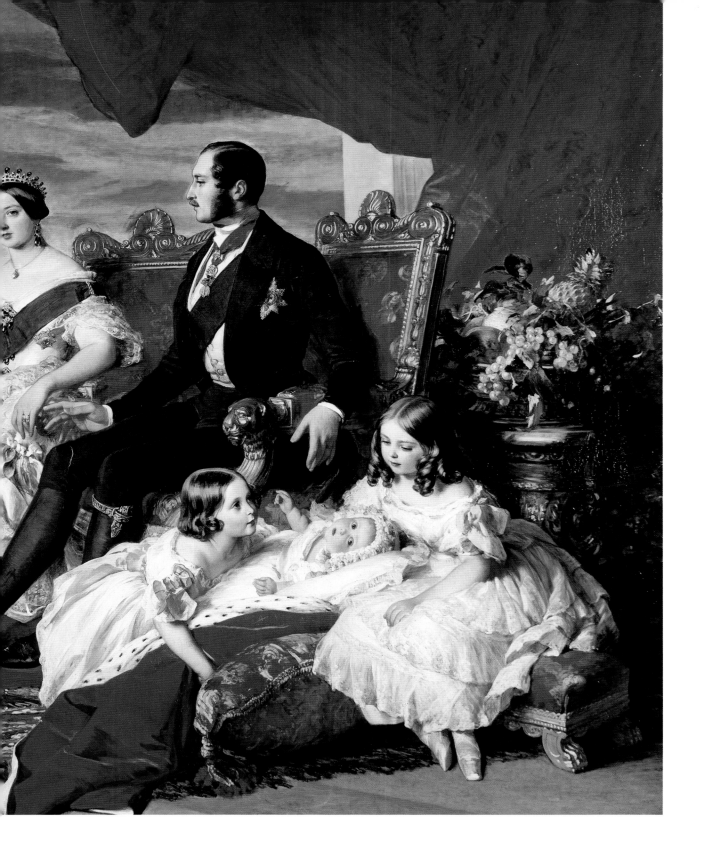

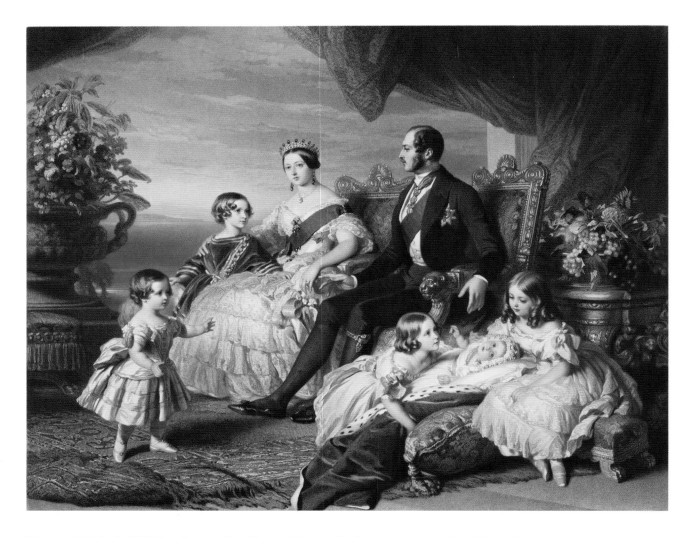

Fig. 119 Samuel Cousins (1801–87) after Franz Xaver Winterhalter, *The Royal Family in 1846*, 1850. Mezzotint, 73.8 x 97.3 cm (sheet).
Royal Collection
(RCIN 630531)

Diamond Jubilee). Wilkie's painting of the *First Council* was 'immediately' sent back to the artist to be engraved.[97]

It is interesting to compare the original image of one of the most imposing royal portraits created during Queen Victoria's reign, *The Royal Family in 1846* by Winterhalter (fig. 118), with a print of the same (fig. 119). This group portrait of the royal family shows Queen Victoria and Prince Albert seated, surrounded by their first five children: Prince Albert Edward (the Prince of Wales), Princess Victoria (the Princess Royal), Princess Alice, Princess Helena as a baby and Prince Alfred as an unbreached toddler slightly unsteady on his feet. In commissioning this work Queen Victoria would have been more than aware of Van Dyck's masterful portrait of *The five eldest children of Charles I* (fig. 62). The influence of the seventeenth-century portrait is most evident in the right-hand section of the group portrait, where Winterhalter's inclusion of the baby and the still-life details seems to indicate a direct borrowing from the Flemish master, but with a contemporary edge.[98] In the opinion of Lord Palmerston (at the time Foreign Secretary and later to become Prime Minister), as Queen

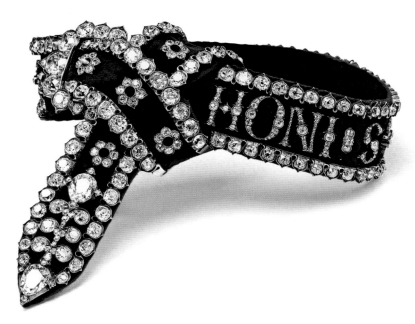

FIG. 120 Rundell, Bridge & Co., *The Garter of Prince Albert*, 1840. Diamonds and velvet, 35.5 x 11.5 cm. Royal Collection (RCIN 441143)

Victoria noted in her Journal, it was 'the finest modern picture he had ever seen'.[99]

The painting's success lies in its presentation of Queen Victoria as monarch, mother and wife. The values of Victorian society placed an increasing emphasis on family life, and the Queen was the most obvious inspiration for this change. She is not wearing robes of state, but instead an elegant evening gown, which enhances her femininity. The jewelled tiara was designed specially for her by her husband and she prominently sports the ribbon and star of the Order of the Garter. Prince Albert wears the Garter (fig. 120) below his knee, as well as the ribbon and star of the Order and the badge of the Golden Fleece. The blend of costume and insignia adds to the impression that this depicts both the private and public faces of the monarch and her family. The most touching aspect of the portrait is its presentation of the strong familial bond, founded on the loving relationship of the royal couple. Prince Albert raises his right hand towards that of his wife, subtly gesturing towards her (as the most important figure in the group), while also reaching out to hold her hand in a moment of informal tenderness.

This painting functions as a positive image of family, in the tradition first established by Henry VII, demonstrating a secure continuation of the royal line. Winterhalter added to this straightforward imagery a more sophisticated tone and a rich colour palette, but the basic ingredients of standard royal portraiture are all present, including the dramatic framing of the image with a curtain, and a view to an atmospheric landscape beyond (in this case a view of the sea, as the painting was created at Osborne House on the Isle of Wight). The official engraved copy, by Samuel Cousins, was published by F.G. Moon in 1850 (fig. 119). When reproduced as a print the individual elements can be appreciated, but the smaller scale and the lack of colour inevitably reduce the effect of the original painting. The knowledge that the finished work would be engraved has influenced Winterhalter's decisions in making his portrait, and may also account for specific elements of the composition, such as the strong framing device of objects positioned at the left and right edges, and the angle of the group subtly receding towards the background to avoid overcrowding.

The impact of *The Royal Family of 1846* can be judged by the fact that when it was first publicly exhibited in 1847 at St James's Palace

(where it was shown with an endearing portrait of *The Prince of Wales, in a sailor suit,* fig. 122), it was seen by over 100,000 visitors.[100]

A sketch by Queen Victoria of *The Royal Family in 1846* may also be seen as a type of reproduction of the original, but it is uniquely valuable as a record of the Queen's perception of Winterhalter's portrait (fig. 121). It differs slightly from the original painting, mainly in the positioning of the heads. Victoria draws her own head inclining more towards her eldest son and her eyes appear to be looking towards him rather than out at the viewer, while Princess Victoria's face (foreground right) is turned round at more of an angle, so that she seems to be gazing enquiringly at her baby sister. These slight differences add a more motherly perspective to the group; it seems that for Queen Victoria this was first and foremost a portrait of her tight-knit family. She does not include the jewelled crown-like adornment in her hair and she depicts her husband sitting bolt upright, while she gives herself a lower aspect than in Winterhalter's original. Her husband appears as the more regal head of the family and Queen Victoria as a doting wife and mother. Whether this represents what she wished Winterhalter had executed or is simply her version of what she saw when viewing the finished portrait is open to interpretation. In any case, both the drawing and painting convey the complexities of this monarch, who held a position of great authority, but who strove to be seen as an ideal wife and mother.[101]

A seemingly fresh glimpse into the life of the monarch may be seen in another commission. *Queen Victoria riding out* by Sir Francis Grant depicts the Queen riding side-saddle alongside the Prime Minister, Lord Melbourne, who was a favourite of hers at the time and who had a formative influence on the early years of her reign (fig. 123). It is thought that Queen Victoria

Fig. 123 Sir Francis Grant (1803–78), *Queen Victoria riding out*, *c*.1839–40. Oil on canvas, 99.1 x 137.2 cm. Royal Collection (RCIN 400749)

may have commissioned this painting as a lasting record of the frequent happy occasions when they went riding together.[102] The painting has an air of spontaneity and jocularity; the Queen is caught in mid-conversation with Lord Conyngham, who respectfully raises his hat to her. Victoria is elegant and relaxed, surrounded by trusted friends, with her two much-loved dogs Dash and Islay scampering off in excitement in the right foreground.

Another portrait by Grant, *Queen Victoria with Victoria, Princess Royal, and Albert Edward, Prince of Wales* (fig. 124), is equally informal, and painted with Grant's characteristic spontaneity, with rapid brushwork and a sense of movement in the paint layers. The Prince of Wales holds a rattle aloft and looks directly out at the viewer. Victoria's head is turned so that she is presented in very flattering three-quarter profile. The composition references earlier royal portraits, in particular *'The Great Piece'* by Van Dyck (fig. 66) and the

painting by Allan Ramsay of *Queen Charlotte, with her two eldest sons* (fig. 125). The status of the sitters is shown through the use of classical columns, a dramatic curtain and sumptuous costume. The homeliness of family life is indicated, in the eighteenth-century Ramsay portrait, by the inclusion of a sewing basket, a toy drum and the bow that Prince George carries, and in the Grant portrait by the flowers in the vase on the table, the rattle and the prominent position of the family dogs Eos and

Dandie Dinmont. Princess Victoria interacts with the dogs, holding out a biscuit towards them. Queen Victoria gave this portrait to Prince Albert as a Christmas present in 1842. The choices made regarding its composition, such as the flattering presentation of the Queen as a glamorous mother in an elegant dress, the charming interaction of the children with the viewer and with the family's favourite pets, and the quotation from masterpieces that were already in the Royal Collection, may well have

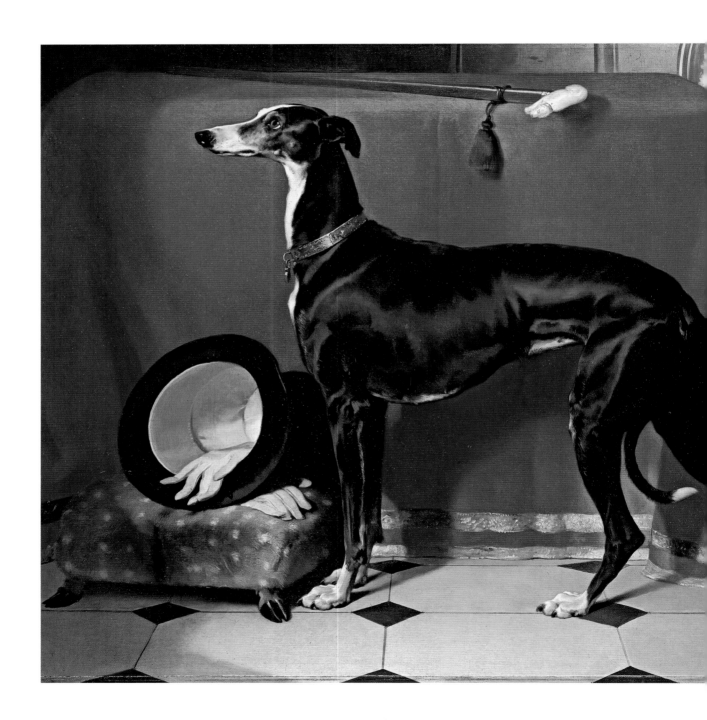

been specified by the Queen and reveal the elements of a painting that she thought her husband would appreciate.

Queen Victoria had a great love of animals. In a letter to the Crown Princess of Prussia she wrote: 'I feel so much for animals – poor, confiding, faithful, kind things and do all I can to prevent cruelty to them which is one of the worst signs of wickedness in human nature!'[103] Unsurprisingly Queen Victoria took a great liking to the artist Sir Edwin Landseer, who specialised in animal paintings as well as being a proficient portrait painter. Like the royal family, Landseer was passionate about Scotland, describing himself as 'a little crazy with the beauties of the Highlands'.[104] Landseer received numerous royal commissions, which continued even after Winterhalter had seemingly overtaken him as the Queen's favourite painter. Playing to Landseer's strengths as an animal painter, Queen Victoria commissioned numerous portraits of royal animals. The finest example of these could be classed as a royal portrait. Again it was commissioned by the Queen as a Christmas present for Prince Albert and is a magnificent portrayal of his favourite dog, *Eos* (fig. 126). The painting is remarkable for the dignity and importance that it gives to the dog. Eos stands proudly in the centre of the composition, her coat glistening with health, her body in prime condition. However, the painting is not solely about Eos but is to some extent a portrait of Prince Albert, whose presence is indicated by his very absence. His top hat and gloves lie on a footstool and his cane rests on the table, its ivory handle invitingly overhanging the edge. The

scene is flooded with light from the left, leading the viewer to imagine that the Prince Consort has just come through the door and is about to take up his cane, put on his hat and gloves, and go out for a walk with the greyhound. This adds an atmosphere of anticipation to the painting, which is mirrored in the dog's attentiveness. Never before had an animal received such a privileged position in portraiture (even the impressive mastiff in Van Dyck's portrait of Charles I's five eldest children was included simply to act as a visual foil to the royal children), and the high esteem in which Eos was held was further indicated by a monument to the dog, based on Landseer's painting, that was erected on the Slopes at Windsor following her death in 1844.

Animals feature prominently in Landseer's group portrait *Windsor Castle in Modern Times* of 1840–43 (fig. 127). It is a typical informal conversation piece, showing an apparently private moment. In contrast with the anticipation of action expressed in *Eos*, this painting conveys the triumphant completion of action. Prince Albert has just returned from hunting and is still wearing his sporting clothes. The painting presents Albert as the masculine hero, the pile of dead game on the left of the image attesting to his prowess at shooting. In contrast to the representation of the outside world embodied in Prince Albert, Queen Victoria signifies the home. She wears an elegant white dress not at all suitable for sport, and her face illustrates her composed beauty as she stands before Albert, the posy in her hand indicating that she contemplates nature rather than conquers it. The young Princess Victoria is depicted with a

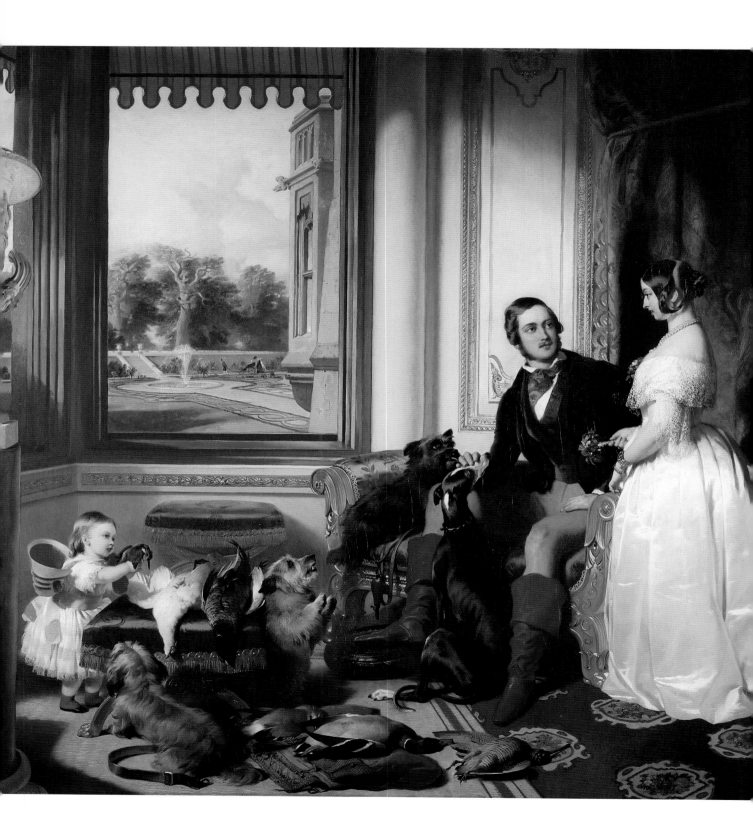

FIG. 127 Sir Edwin Landseer (1802–73), *Windsor Castle in Modern Times: Queen Victoria, Prince Albert and Victoria, Princess Royal*, c.1840–43. Oil on canvas, 113.4 x 144.3 cm. Royal Collection (RCIN 406903)

dead kingfisher in her hands, standing very close to the array of dead game laid out on the floor and stool like trophies. The dogs Dandie Dinmont, Cairnach, Islay and Eos excitedly interact with their owners, conveying the adrenaline of the kill.

Landseer seems to give the viewer a direct glimpse into the personal life of the royal family, echoing Zoffany's depiction of *Queen Charlotte with her two eldest sons* (fig. 84). The similarity of the two is particularly evident in the double openings on to the group, with a window looking out to the outside world, and the doorway leading into the rest of the private space at Windsor. The family appear as a contained unit, and Victoria and Albert are the model couple. Landseer experienced some difficulties in achieving the right tone and took three years to complete *Windsor Castle in Modern Times*. All the figures (including the dogs) had numerous individual sittings for their portraits.[105] Landseer carefully reworked the positioning of Victoria and Albert, altering their poses so that, rather than standing side by side with Albert towering over his wife, the Prince Consort was seated, enabling the monarch to have a commanding position over him, tempered by the deference in her attitude.[106]

Queen Victoria's preference for the informal was fully expressed in her passion for photography, through which fleeting moments could be captured. This new art-form seized her imagination, and she commissioned several thousand images of herself, her family, foreign royalty, her friends, her animals, and an exten-

sive collection of photographic records of the royal residences and her favourite works of art from the Royal Collection.[107] On an even greater scale than engravings, photography enabled the royal family to become accessible to the public, and Queen Victoria used this to her advantage. As a member of the Royal Household commented in 1898:

> It is quite a weakness of hers [Queen Victoria's] to be photographed in every possible condition of her daily life. Sitting in her donkey chair, dangling the latest baby, chatting in her private sitting room among her daughters, working at her writing-table, or breakfasting in the open air … the Queen's photographer is always to be sent for and ordered to 'fix the picture'.[108]

However, Queen Victoria could not control photographs to the same extent as painted portraits, and the photographer could not flatter and idealise to quite the same degree as an artist. The ability of a photographic image to represent the actual likeness of the sitters, as opposed to an idealised vision, must have been disconcerting at first. A daguerreotype (a process whereby the image was produced on a light-sensitive silver or silver-coated plate and developed in mercury vapour) of 17 January 1852 shows Queen Victoria with five of her children (fig. 128). Just as in an engraving or woodcut, the original design is the reverse of the final image when

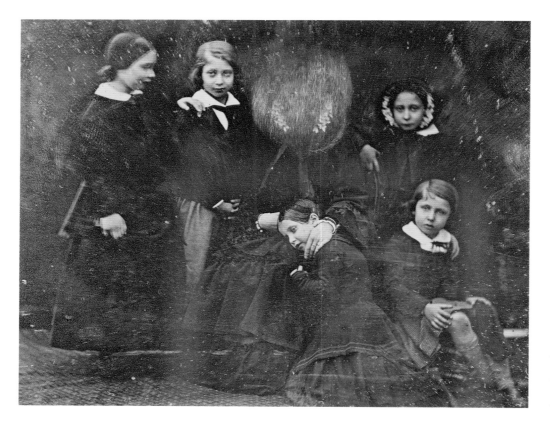

FIG. 128 William Edward Kilburn (1819–91), *Queen Victoria, Princess Royal, Princess Helena, Princess Alice and Prince Alfred, January 17th 1852*, 1852. Daguerreotype, 9.1 x 11.5 cm. Royal Collection (RCIN 2932491)

reproduced as a print. It seems that Queen Victoria erased the image of her own face, perhaps not liking how she appeared. This was possible in a daguerreotype, as the chemicals used give the surface a consistency which, when you remove the protective glass, may be smudged with a finger.[109] With a painting, Queen Victoria could demand that an artist rework any part that did not meet her approval, while photographs captured an actual moment with startling truthfulness. The carbon-copy print of the same image (fig. 129) shows that the Queen, unlike her children, had her eyes closed, and it was not a flattering image.

Despite the unprecedented number of images of Queen Victoria in her youth, the best-known representations of the monarch show her in middle to old age, following the prema-

ture death of Prince Albert in 1861. Convention stated that full mourning should be worn for twelve months after the death of a loved one; Queen Victoria wore it for the rest of her life. There are numerous depictions of the Queen in mourning dress on public monuments, most of which still remain *in situ* throughout Great Britain and Northern Ireland and the Commonwealth. An example is Sir Thomas Brock's *Queen Victoria* in Victoria Square, Birmingham, of 1901 (fig. 130). Brock's original marble statue was later replaced by a bronze cast. Queen Victoria's preferred sculptor was Sir Joseph Edgar Boehm, who became her 'Sculptor in Ordinary'. Like many of her favourite artists, he was not of British origin. He was born to a Hungarian family in Vienna, where he trained before travelling and studying in Europe and eventually settling

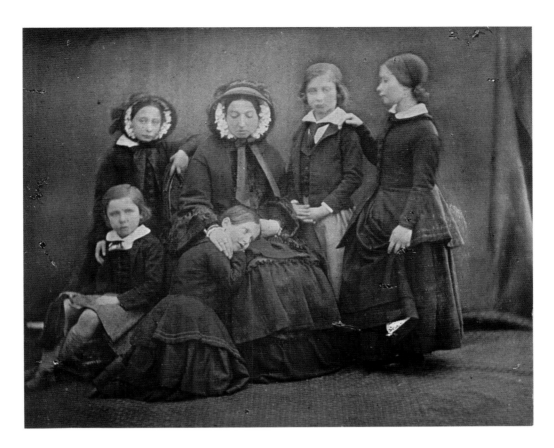

Fig. 129 William Edward Kilburn (1819–91), carbon print copy of fig. 128, 8.1 x 9.8 cm. Royal Collection (RCIN 2931319c)

in London and acquiring British nationality in 1865. A sculpture by Boehm of Queen Victoria stands in the Grand Vestibule at Windsor and, like the Chantrey sculpture of George IV (fig. 103), creates an imposing but welcoming presence at the entrance to the State Apartments at Windsor Castle (fig. 131). The image is dignified and combines a realistic, sympathetic portrayal of the woman with a symbolic representation of the Queen. The inclusion of the Queen's collie, Sharp, further emphasises this duality. Sharp gazes up at his mistress with a perfect mixture of affection and loyalty.

The last portrait of Queen Victoria before her death was painted by the Hungarian artist Heinrich von Angeli in 1899 (fig. 132). The Queen is depicted resting her head on her hand, leaning against a table on which are placed a group of roses and a fan. She appears as a personification of wisdom and old age. Queen Victoria had experienced much, and appears here as though in deep contemplation. In its melancholy, the painting calls to mind the enamel of George III in his final illness (fig. 92). Intriguingly, the painting is very close to a photograph of the Queen attributed to John Thompson, taken to mark the Golden Jubilee in 1887 (fig. 133). A comparison of the two emphasises the difference between the intense reality of an untouched photograph and the artifice of a painted portrait. The two images are so similar that it seems likely that Von Angeli was instructed to use the photograph as a model for his painting. This may explain Von Angeli's *pentimenti* (alterations) to the back of the chair, which he originally positioned much higher and

with a rounded top, probably in accordance with the photograph.

The main differences between the painting and the photograph may be seen in the more decorative elements in von Angeli's image: the table, roses, more elaborate chair, and in the position of the Queen's hands to emphasise her contemplative attitude. The roses were probably included for a specific reason. In her youth Queen Victoria was frequently referred to as a rose, the same symbolism that was used in the sixteenth-century depiction of Elizabeth I within a rose (fig. 46). A children's book published in 1899 (the same year as the painting), *Victoria's Golden Reign: A Record of Sixty Years as Maid, Mother, and Ruler*, written by a lady from the court, described Princess Victoria's upbringing as the ideal foundation to enable her to blossom into 'the fair white rose of perfect womanhood'.[110] This likening of Queen Victoria to a rose continued into her reign: for example an optical transformation image of 1838 changed, when backlit, from an image of a large rose into a portrait of the Queen enthroned, both images set against a depicted backdrop of Windsor Castle.[111] In von Angeli's portrayal, the 'rose' has grown, and Queen Victoria is presented by the artist in poetic contemplation of the passing of time. As Shakespeare's Viola commented wistfully in *Twelfth Night* in response to Count Orsino's observation that women are like roses which fade:

> And so they are: alas, that they are so;
> To die, even when they to perfection
> grow![112]

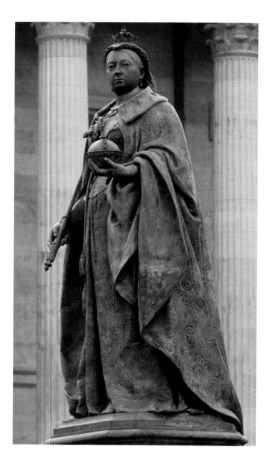

LEFT:
Fig. 130 Sir Thomas Brock (1847–1922), *Queen Victoria*, 1901. Bronze, Birmingham, Victoria Square

The royal portraiture of Queen Victoria was commissioned and constructed to present her as a role model for women, a strong matriarch who commanded the respect of her people. Because of technical advances the more intimate portrait types developed during the reign of George III and Queen Charlotte blossomed during Victoria's reign so that her imagery was available for public consumption. As the first truly visually accessible monarch, during her long reign she became an emblem of 'Britishness' and her sense of moral duty defined her age. Queen Victoria took pains to ensure that her portraits, along with her continual letter- and diary-writing, aided her intention to convey that she was constantly aiming to do what was 'right and fit' for her country.

Fig. 131 Sir Joseph Edgar Boehm (1834–90), *Queen Victoria*, c.1869–71. White marble, height 172.5 cm. Royal Collection (RCIN 35336)

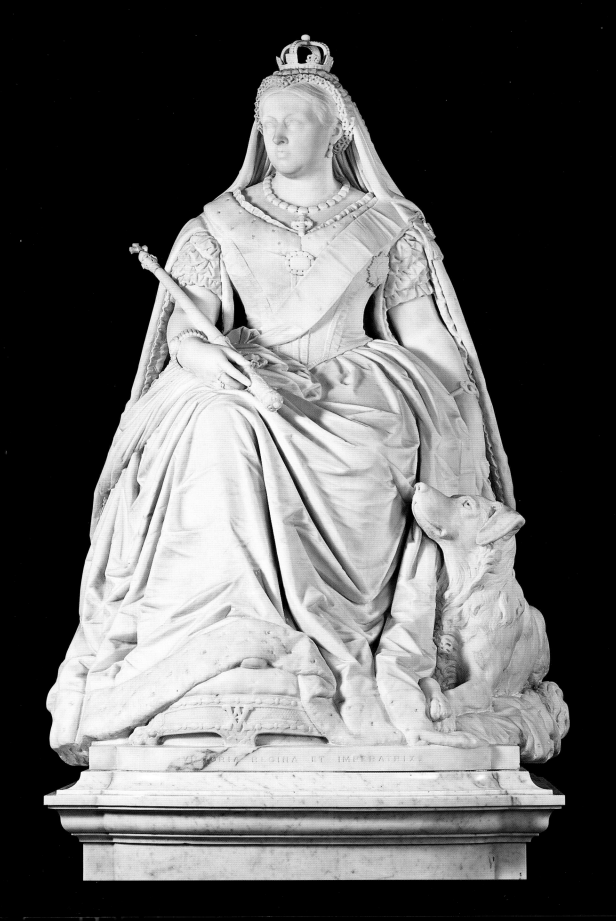

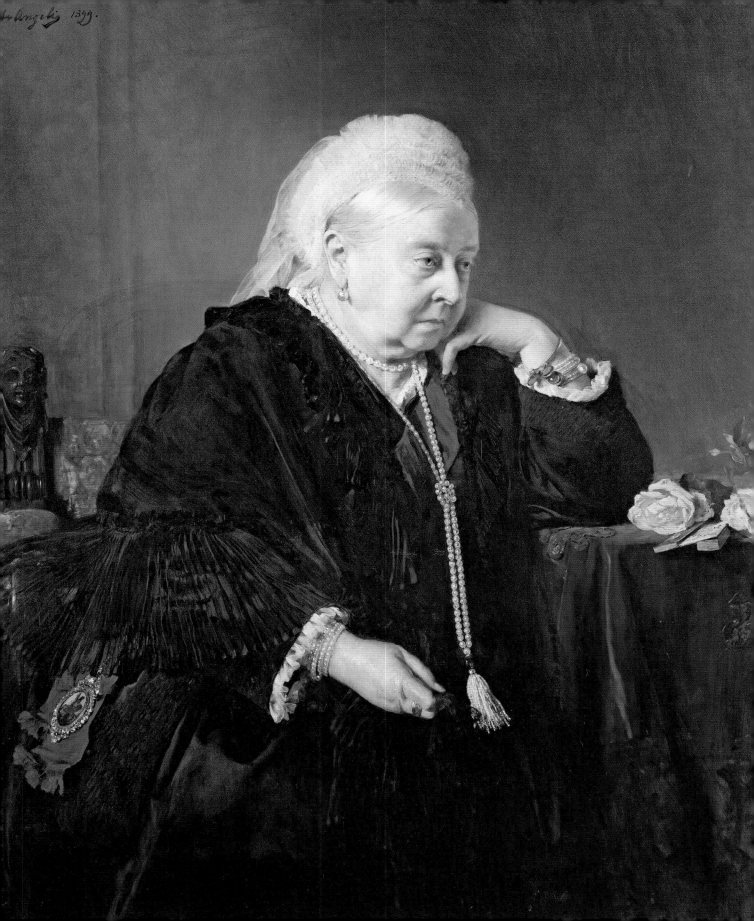

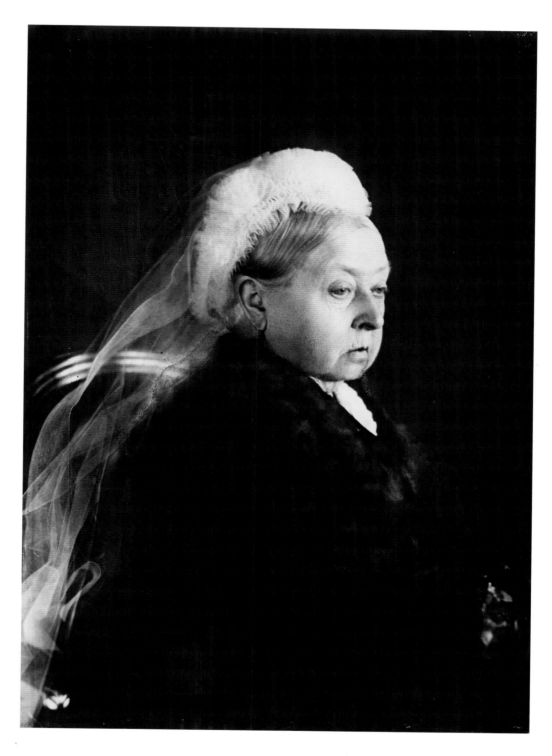

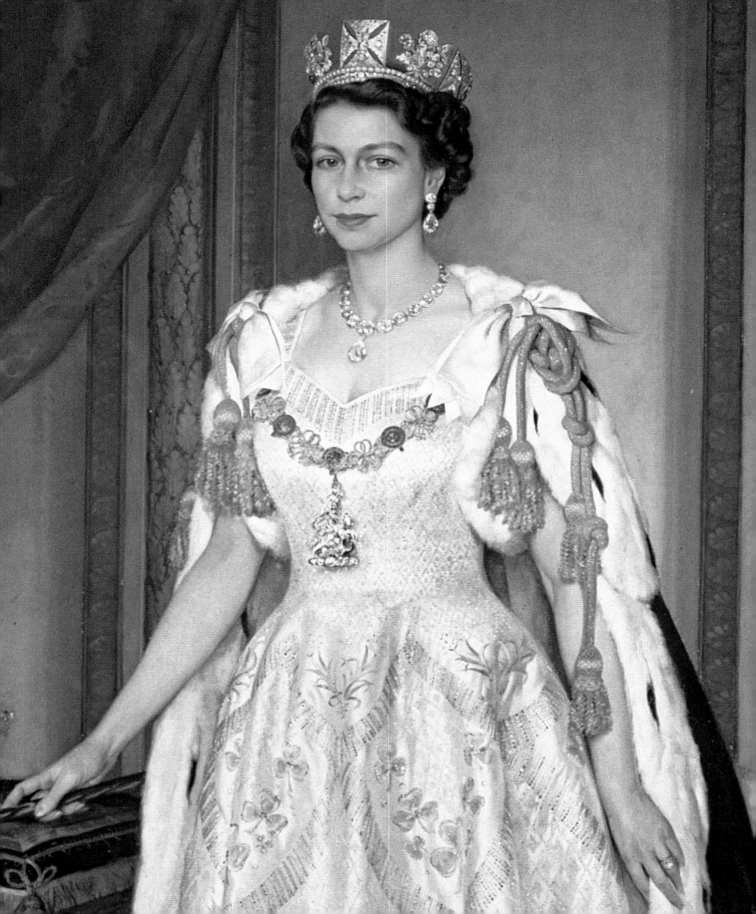

6

Queen Elizabeth II

*'We may ourselves be confronted by a bewildering array
of difficulties and challenges, but we must never cease to
work for a better future for ourselves and for others.'*

Her Majesty The Queen, Christmas Broadcast, 25 December 2009

THE REIGN OF QUEEN VICTORIA proved that the invention of photography did not undermine the royal portrait, but instead opened up new and exciting possibilities. This proved even more the case during the next century. In 1928 the 2-year-old Princess Elizabeth, niece to the Prince of Wales and not expected to reign, was photographed by Marcus Adams (fig. 134) looking distinctly angelic, in a pose not dissimilar to that of one of the cherubs from Raphael's *Sistine Madonna* (fig. 135). This is precisely what is expected of a royal princess, but the immediacy of the image and the comical seriousness of the pose render this an endearing photograph, with no particular reference in Adams's iconography to the child's royal status. A similarly charming painted portrait of Princess Elizabeth aged 5 by Edmond Brock presents the young Princess in a white dress with blue sash and matching ribbons, sitting with a white dog (fig. 136). Despite the Princess's tender years, Brock paints her with a calm, assured expression, an artistic technique similar to that employed by Van Dyck and Zoffany (figs 62 and 84) to show maturity and readiness for the responsibilities of the future.

Official state portraiture still had a significant place in twentieth-century royal imagery. At the turn of the century Sir Luke Fildes dominated royal portraiture, creating the state portraits of *King Edward VII* in 1902 and *King George V* in 1912 (figs 137 and 138). These two powerful images clearly derive from the imposing state portraits of George III and IV by Ramsay and Lawrence (figs 80 and 102), in which the crown is set on a stool to the side and the monarch is standing in the centre of the image wearing coronation robes, with a backdrop comprising a dramatic curtain and classical architecture. Intriguingly, Fildes employed these conventions to convey two different personalities. King Edward VII (1841–1910) is presented slightly from below, with the effect that he appears to fill the picture plane whilst obliging the viewer to look up at him in awe. In contrast, King George V (1865–1936) appears smaller and more reserved, the positioning of his sword on the ground imbuing him with a more tempered attitude, less flamboyant than that of his father.

In 1938 Sir Gerald Kelly was commissioned to create the state portraits of King George VI (1895–1952) and Queen Elizabeth (1900–2002; figs 139a and b). Kelly's use of a patterned floor with complicated perspective opens up the picture plane so that the portraits seem lighter than any previous depictions of monarchs in coronation robes. The architectural background was designed by Sir Edwin Lutyens (1869–1944), in

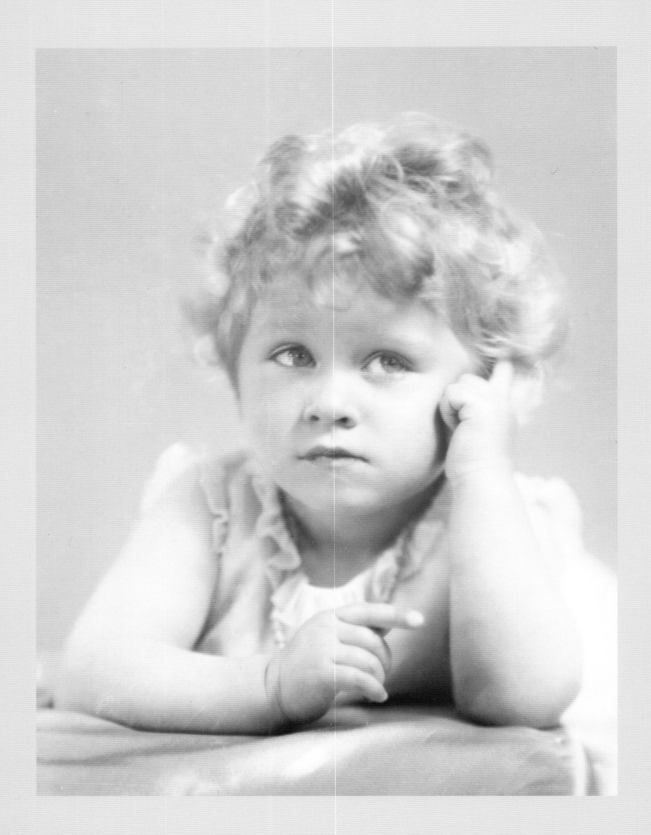

LEFT:
FIG. 134 Marcus Adams
(1875–1959), *Princess
Elizabeth*, 1928. Gelatin silver
print, 19.6 x 15.5 cm.
Royal Collection
(RCIN 2585297)

FIG. 135 Raphael (1483–1520),
The Sistine Madonna (detail
of cherubs), *c*.1512–13. Oil on
canvas, 269.5 x 201 cm.
Dresden, Gemäldegalerie
Alte Meister

the neoclassical style he used for the Viceroy's House in New Delhi. Despite reportedly feeling uncomfortable in his coronation robes, King George VI appears dignified and regal, and Queen Elizabeth is perfectly composed, glancing wistfully towards her husband. Kelly recorded his pleasure at painting the Queen, which is reflected in this elegant portrait: 'From wherever one looked at her, she looked nice: her face, her voice, her smile, her skin, her colouring – everything was right.'[115]

The official State Portrait *Queen Elizabeth II in Coronation robes* by Sir James Gunn seems to take the Kelly portraits of her parents as its main point of reference, so that it too is light and elegant (fig. 140). The Queen is presented wearing Coronation robes and diadem, with the Imperial State Crown and sceptre on a table alongside her. The Queen's face is painted with great clarity, revealing the influence of photography.[114] The light catches the diadem, diamond necklace and earrings and the Great George and collar of the Order of the Garter around her neck, creating an impression of great opulence and glamour, echoed by the richness of the Coronation dress, which had been designed by Sir Norman Hartnell (1901–79). Although neither controversial nor innovative, this paint-

FIG. 136 Charles Edmond
Brock (1870–1938), *Princess
Elizabeth of York, later HM
Queen Elizabeth II when a
child*, 1931. Oil on canvas,
116 x 90.7 cm.
Royal Collection
(RCIN 401030)

ing is exquisitely executed and fulfils the neces-
sary function of an official portrait to mark a new
reign.

Photographic portraits have been as numer-
ous as painted portraits during the current reign,
and photographers carefully selected to capture
the Royal Family. After photographic commis-
sions have been carried out, prints are sent to
Buckingham Palace for the Queen's approval. A
Family group by Anthony Armstrong-Jones
(later Lord Snowdon, following his marriage to
Princess Margaret in 1961) was commissioned
in 1957 for use in official gifts (fig. 141). This
image shows the Queen, the Duke of Edinburgh,
Prince Charles and Princess Anne with two cor-
gis in the gardens of Buckingham Palace. The
composition is notably similar to the outdoors
conversation-piece sketch of *George II and his
family* by Hogarth, particularly in the position-
ing of the monarch off-centre (fig. 76). The
Queen's Assistant Private Secretary corre-
sponded with Armstrong-Jones to ensure that
every detail of the final photograph was perfect.
In a letter of 16 September 1957 he remarked:
'something will have to be done about the halo
of leaves round the top of Prince Philip's head –
I have put a circle round the leaves I mean. I
would be glad if you would let me have a second
trial of this photograph as soon as possible.
I hope you can manage to take the leaves out.'[115]
Armstrong-Jones rectified the problem imme-
diately and sent a retouched print to the Palace.
This was approved, and on 20 September a
request was made for 200 prints to be mounted
in covers and sent to the Queen for official use.
This demonstrates the extent of personal

involvement that the Palace had in the images,
even in the case of an informal (although, just
like the Hogarth, staged) family-group compo-
sition. It is also apparent that the Queen took an
active interest in the 'out-takes'; in this particu-
lar instance she ordered copies of more relaxed
moments from the shoot for her own use.

In 1954 the Worshipful Company of Fish-
mongers commissioned the Italian artist Pietro
Annigoni to paint a full-length portrait of the
Queen (fig. 142). Annigoni went to Bucking-
ham Palace and painted the Queen in the
Yellow Drawing Room, which is often used for
portrait sittings because of the good light pro-
vided by the tall east-facing windows.[116] The
artist recorded how the presence of the Queen
filled him with a type of artist's block, until she
put him at his ease by chatting to him about
how she used to enjoy looking out of the win-
dows as a child and imagining what life was
like 'outside the palace'. By saying this she gave
him the idea for the composition:

> Her words were like a searchlight lighting
> my way. I saw her immediately as the
> Queen who, while dear to the hearts of
> millions of people whom she loved, was
> herself alone and far off. I knew then that
> was how I must show her. I asked her to
> look out of the great window once more
> and I watched her face light up with the
> ever-changing scene she surveyed.[117]

In the final composition Annigoni portrayed
the Queen in Garter robes as though seen from
a low viewpoint, towering over a sparse

Fig. 137 Sir Luke Fildes (1843–1927), *King Edward VII*, 1902. Oil on canvas, 265.7 x 170.1 cm. Royal Collection (RCIN 404553)

FIG. 138 Sir Luke Fildes
(1843–1927), *King George V*,
1912. Oil on canvas,
279.8 x 183.3 cm.
Royal Collection
(RCIN 402023)

THE ROYAL PORTRAIT

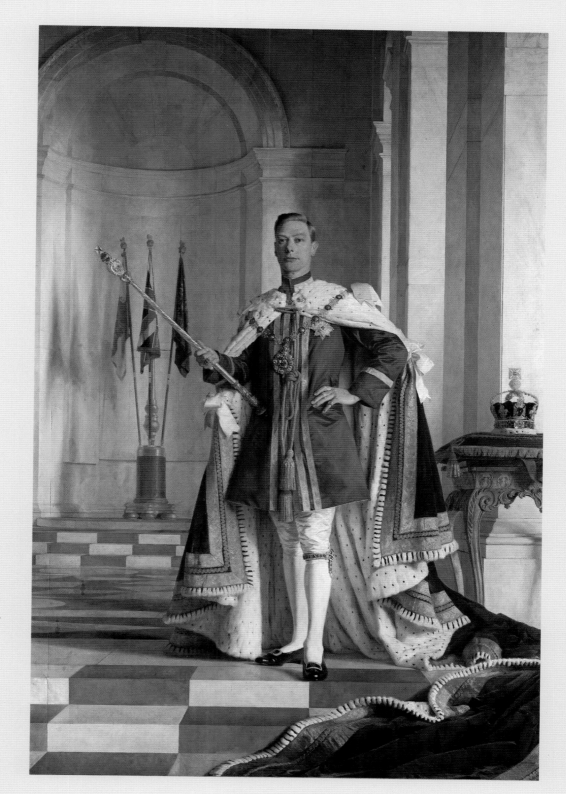

Fɪɢ. 139a Sir Gerald Kelly
(1879–1972),
*Queen Elizabeth, c.*1938–45.
Oil on canvas,
276 x 184.7 cm.
Royal Collection
(RCIN 403423)

Fɪɢ. 139b Sir Gerald Kelly,
*King George VI, c.*1938–45.
Oil on canvas,
273.8 x 182.9 cm.
Royal Collection
(RCIN 403422)

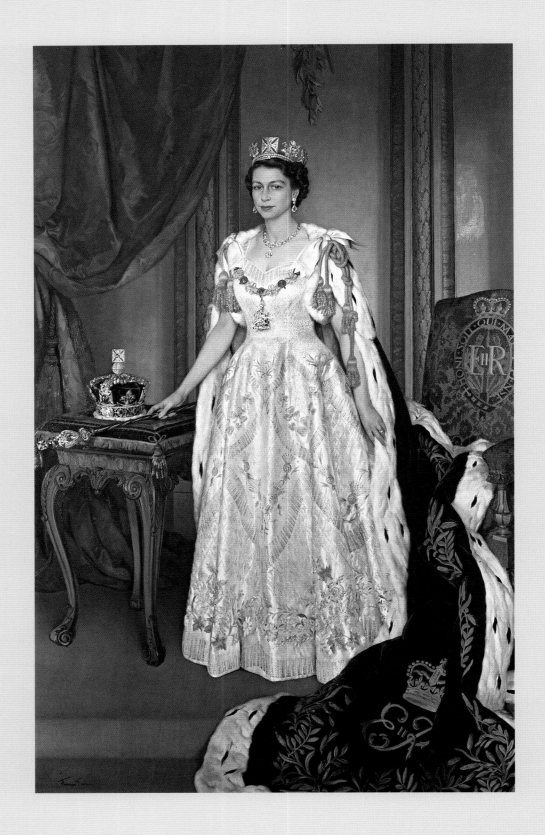

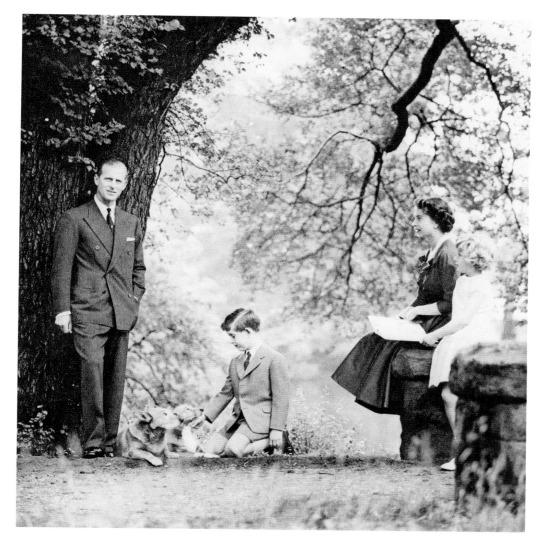

landscape and silhouetted against a clear sky. She appears glamorous and pensive. It is an innovative portrait, combining the grandeur of monarchy with the isolation of the role. The painting was shown at the Summer Exhibition of the Royal Academy in 1955, where it generated much interest, with visitor numbers during the fifteen-week exhibition totalling 300,000.[118]

The presentation of the Queen in this manner appears to have influenced the photographer Sir Cecil Beaton (1904–80), who, in 1968, took his definitive images of Her Majesty wearing a naval boat-cloak. The position of the head as well as the perspective (seen from below) derives directly from Annigoni's portrait and illustrates the interrelationship between photographic and painted portraiture. In a memorandum to the Queen of 10 October 1968, following a meeting with Beaton, the Assistant Private Secretary Martin Charteris noted: 'Cecil is anxious to do something different and wondered if Your Majesty would pose for him in a simple dress or the Boat Cloak?'[119] Beaton

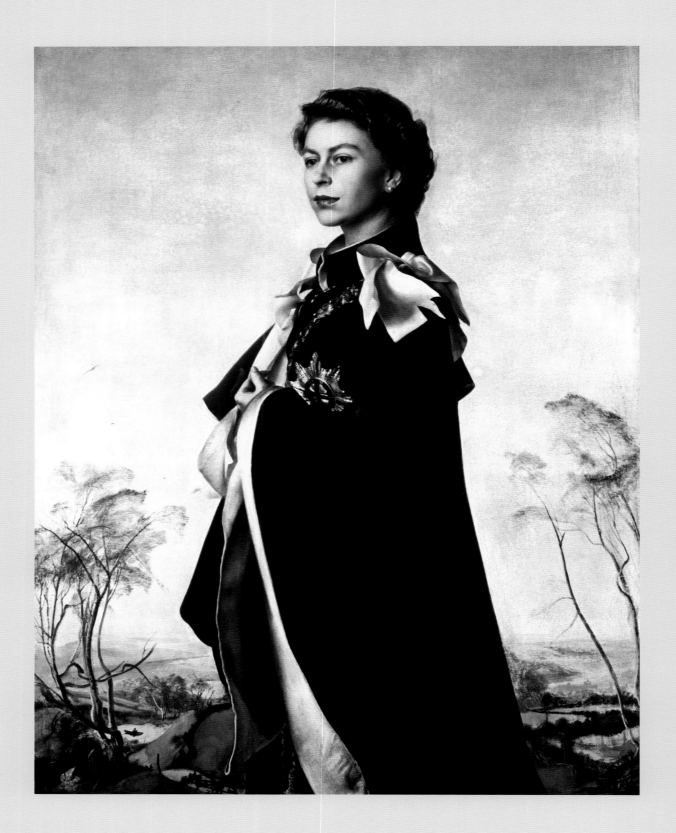

LEFT:
FIG. 142 Pietro Annigoni
(1910–88), *Queen Elizabeth II*,
1954. Oil on canvas,
150 x 99 cm.
London, The Worshipful
Company of Fishmongers

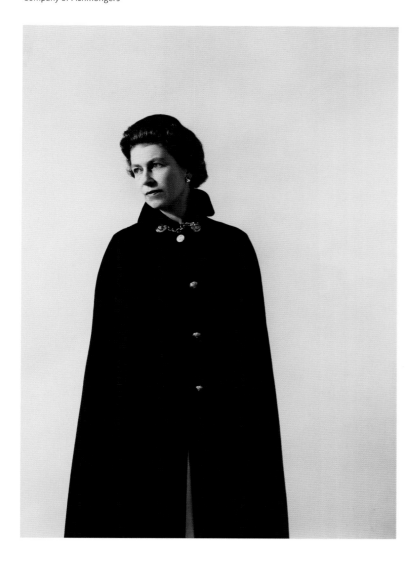

FIG. 143 Sir Cecil Beaton
(1904–80), *Queen Elizabeth II*,
1968. Gelatin silver print,
30.4 x 25.3 cm.
Royal Collection
(RCIN 2999826)

wanted to take these photographs in order to include them in his retrospective exhibition to be held at the National Portrait Gallery in 1968. Although derived from the Annigoni portrait, these finished full-length photographs of the Queen, silhouetted against a stark white background, have an austere power, rather different in character from Beaton's earlier royal portraits (fig. 143).

Cecil Beaton was a highly influential photographer who captured major events in the life of the Royal Family from 1930 until his death. His photographs gave a degree of public access to significant moments in the life of the Royal Family, as well as endowing them with an air of subtle glamour. Just like Queen Victoria's photographs, these images were carefully controlled and selectively released to the press. Some of the most intimate photographs that Beaton took were of the Queen with her children. He was the first official photographer to depict Prince Charles, and in 1964 he took the first images of Prince Edward, one of which was selected for publication in the morning newspapers on Saturday 13 June 1964 (fig. 144). This photograph shows the Queen standing with Prince Andrew (b.1960) at the crib of Prince Edward. The angle of the baby's head recalls that of the baby (Princess Helena) in Winterhalter's *The Royal Family* of over one hundred years earlier (see fig. 118). The photograph captures a moment of pure joy in the Queen's face, which her smile invites the viewer to share. In this way it is the perfect popular image: a portrayal of the monarch as an accessible and contented mother.

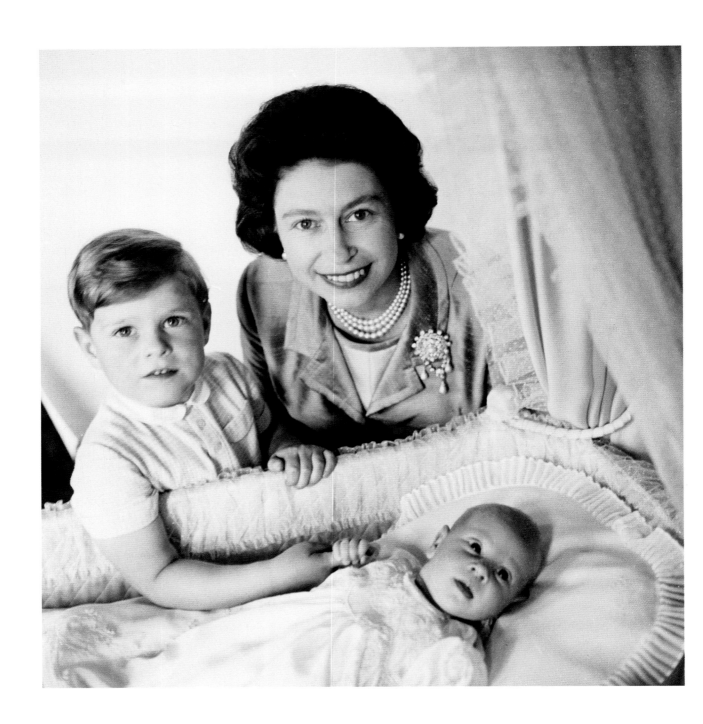

FIG. 144 Sir Cecil Beaton (1904–80), *Queen Elizabeth II, Prince Andrew and Prince Edward as a baby, in the Music Room at Buckingham Palace, 1964,* 1964. Gelatin silver print, 13 x 13 cm. Royal Collection (RCIN 2999987)

This interest in accessibility was extended in March 1968 when a decision was taken to record the day-to-day activities of the Royal Family in a documentary made by the BBC. For the first time, members of the Royal Family were filmed going about their daily lives. The techniques employed were of *cinéma-vérité*, with cameras gaining close access to the family and following them wherever they went. A photograph capturing the filming shows the Queen in conversation with President Julius Nyerere of Tanzania, the camera positioned close to the Queen's face (fig. 145). Intimate conversations, snowball fights, state occasions and days at the races were all captured, with the Queen, the Duke of Edinburgh and their children depicted chatting together and in formal interviews. Queen Charlotte in the eighteenth century and Queen Victoria in the nineteenth allowed the palace doors to open metaphorically to a small degree by means of the portraits that they commissioned. Allowing a film crew into your life is an entirely different matter. There was a feeling in the 1960s that the Royal Family needed to do something to keep up with changing times and to ensure that they did not become outdated. Martin Charteris later explained it candidly: 'as a deliberate policy we let the light in on the mystery with the film of the Royal Family … were we wrong to encourage the press to look inside the gilded cage? I don't think we had any choice. It was a sort of no-win situation.'[120] It could be argued that the filming led the Royal Family to be part of the culture of celebrity. Questions arose regarding the boundaries of privacy, and the subsequent rise of 'paparazzi' photography meant that the Royal Family could

no more control the way in which they were portrayed than George IV could silence the satirists.

On 29 July 1981 the Prince of Wales married Lady Diana Spencer. The ceremony was broadcast by the BBC and reached an estimated audience of 750 million people worldwide.[121] This was global fame on an unprecedented scale, and the 1980s and 1990s saw a continuing growth in popular interest in the Royal Family that led to the increasing use of invasive photography techniques. In the first decade of the twenty-first century it has been the younger members of the Royal Family, in particular Princes William (b.1982) and Henry (Harry; b.1984), who have been most targeted and whose photographs are regularly featured in tabloid newspapers and on gossip websites. This exposure contrasts dramatically with the controlled experiments into informal portraiture attempted in the eighteenth century (fig. 84), particularly as the demand for such photographs is high and they may have immense commercial value. A paparazzo portrayal of Prince William and Prince Harry off-duty, sitting together at a rugby match, may appear to show them as relaxed, but only because they are unaware that they are the subject of a photograph. The methods used to take such images are more opportunistic than artistic (fig. 146).

The rise of paparazzo photography has not diminished the role of official photography. To celebrate the Golden Jubilee of 2002 the Queen commissioned a select number of established photographers to capture her image. This project included Lord Snowdon, Patrick Lichfield, Bryan Adams, Rankin and Polly Borland.

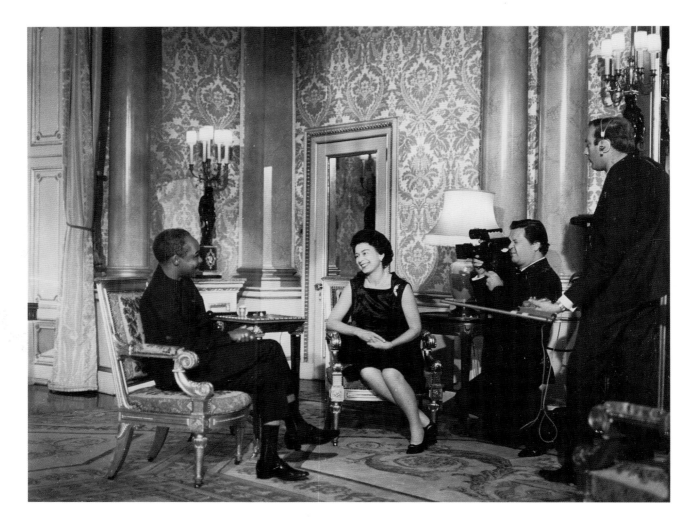

Borland presented the Queen in a head-and-shoulders view against a gold backdrop, to signify the Golden Jubilee (fig. 147). It is intriguing to compare this photograph with the full-length *Westminster Portrait* of Richard II (fig. 15). In the fourteenth century gold symbolically indicated a person of great importance (either a religious figure or a monarch), as well as creating an atmospheric effect when viewed by candlelight. Borland's gold background has a more speckled, and therefore contemporary, effect than the smooth application of gold leaf in the *Westminster Portrait*. To modern eyes it is a shock, a paradoxical pairing of medieval colour schemes and twenty-first-century style. The photograph by Rankin is equally arresting, presenting the Queen at close range in front of the throne canopy in the Ballroom at Buckingham Palace (fig. 148). It is taken at an awkward angle, portraying the Queen in spontaneous reportage-style photography, the palace setting acting as a frame. The Ballroom is the location for official investitures. Rankin's vision of the Queen's face with the canopy behind thereby mimics the manner in which she would appear if the viewer were kneeling before her to receive an honour such as a knighthood. Perhaps this close-up style is a commentary on the

FIG. 145 Joan Williams, *HM Queen Elizabeth II and President Nyerere of Tanzania* (1922–99) *during the BBC filming of* The Royal Family *documentary*, 1968–9. 20 x 24.5 cm. Royal Collection (RCIN 2591847)

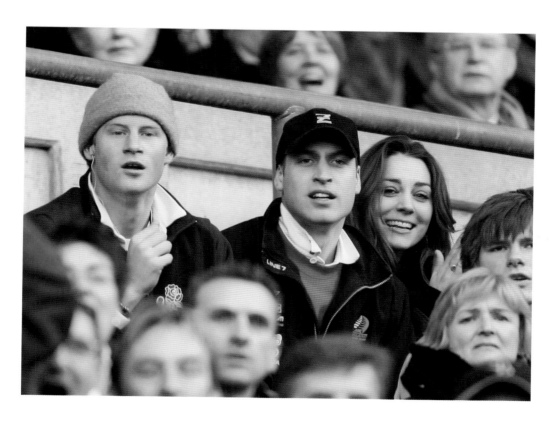

FIG. 146 Richard Heathcote, *Prince Harry and Prince William at the RBS Six Nations Championship match between England and Italy at Twickenham*, 10 February 2007

familiarity of the Queen's face and the ability of modern cameras to get near to her.

An interesting addition to the photographs taken in 2002 is a set of three portraits by Prince Andrew (fig. 149). In these images we see the Queen through the lens and, by extension, through the eyes of her son. These three moments capture developing stages of laughter. In the first photograph the Queen seems to be amused, in the second she is smiling and in the third she throws back her head in laughter with her hands on her hips. The photographs lead the viewer to imagine that they are privy to the private joke shared by the photographer and the sitter – the mother and the son. These photographs give a very human insight into the private life of the monarch, and they succeed in this far more than any paparazzo photograph because the sitter evidently had complete trust in her photographer. A similarly informal image of the Queen was painted in the 1960s by the Duke of Edinburgh (b.1921; fig. 150). The painting shows the Queen sitting at her breakfast table at Windsor Castle reading the morning papers. The painting has a still-life quality, so that it functions as an impressionistic study of the Private Dining Room – which just happens to contain a portrait of the Queen, the artist's wife.

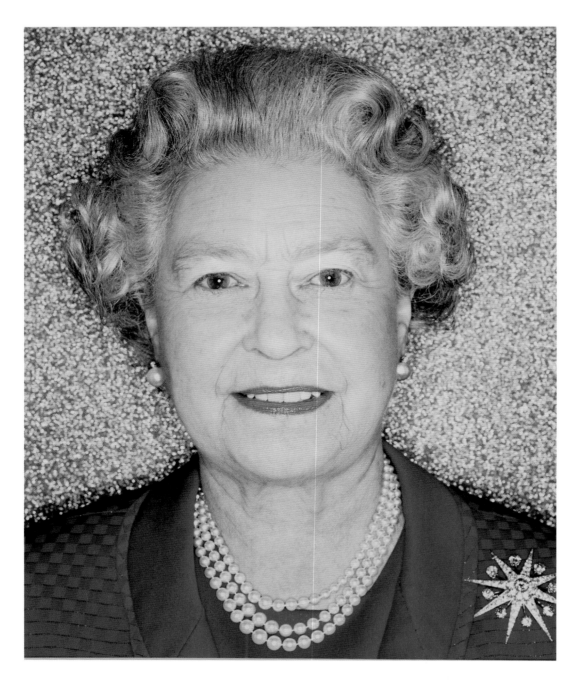

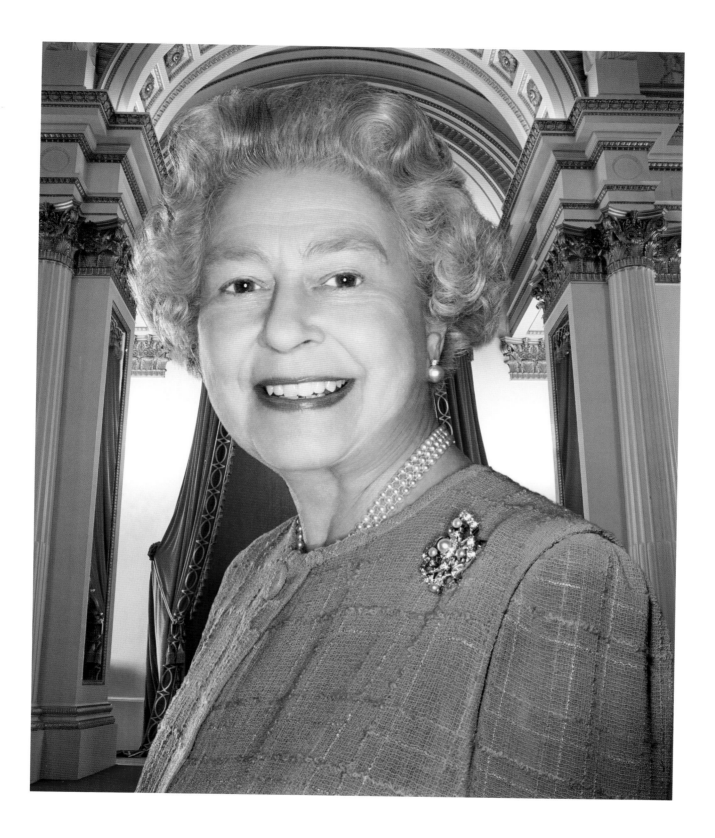

A similarly relaxed portrayal of the Queen was created by Susan Crawford in 1977 (fig. 151). This was commissioned by the Household Brigade as a gift to mark Her Majesty's Silver Jubilee in 1977. The painting shows the Queen riding Worcran – a horse that belonged to Queen Elizabeth The Queen Mother and was used by the Queen for hacking. The Queen 'sat' for this portrait in an unusual way: Crawford made sketches in the Home Park at Windsor while the Queen rode around her, making the artist 'dizzier and dizzier'.[122] This was followed by one further sitting of the Queen alone at Buckingham Palace. The composition of the painting cleverly combines the imagery of the Queen at leisure and within her role as sovereign, with the view sloping down towards Windsor Castle. The Queen gently smiles as she gazes away from the Castle, as though enjoying a brief respite from her work. The Queen's love of country life and riding is a well-known aspect of her personality and is understandingly portrayed here, in a carefully constructed portrait that gives the impression of having been painted outdoors. Crawford specialises in equestrian paintings and it is perhaps owing to her understanding of horses that her equestrian portraits are especially sensitive to the mounts and their relationship with the rider. This contrasts with the ways in which earlier royal portrait painters used horses as a tool to increase the visual impact of the monarch (see fig. 63).

In 2000–2001 the Queen was portrayed by one of the greatest contemporary artists, Lucian Freud (fig. 152). Previously Freud only painted people he knew well, so to portray the Queen clearly presented a challenge, especially as he chose to paint the portrait on an extremely small canvas. It brings to mind a postage stamp, which in itself reminds the viewer of the extent

FIG. 149 HRH The Duke of York, *Her Majesty The Queen*, 2002. C-type print, each image 14.4 x 10.2 cm. Royal Collection (RCIN 2935299)

FIG. 150 HRH The Duke of Edinburgh, *The Queen at Breakfast, Windsor Castle*, 1965. Oil on canvas, 40 x 50 cm. Private collection

of the familiarity of the sitter, whose face has adorned postage stamps and coins in Britain and the Commonwealth for over 50 years. The relative scale of the image is most evident in a photograph taken by David Dawson of the work in progress (fig. 153). The photograph emphasises the relatively small canvas size and the surprising bareness of the location for the sit-

tings. These took place at Friary Court Studio, a space usually reserved for the conservation of Royal Collection paintings. It is sometimes difficult to see anything new in the portrayal of a face that is ingrained in public consciousness. Freud ensured that this was not the case in his royal portrait by seizing the viewer's attention with dramatic brushwork and thickly applied

paint. He builds up the surface of skin with confident strokes, so that the familiar image of the Queen appears to emerge from the paint rather than being constructed out of it.

Freud is wary of people's insistence on portraits resembling the sitter. In an interview he remarked: 'Many people are inclined to look at portraits not for the art in them but to see how they resemble people. This seems to me a profound misunderstanding which is nevertheless very interesting.'[125] Queen Victoria's assessment of the success of portraits frequently grounded on the 'likeness' of the image: the words 'it was

very like' became almost a catchphrase in her diary. Freud strove to move away from this typically nineteenth-century idea, and instead sought to create great art that also incidentally functions as a portrait. His portrait of *Her Majesty The Queen* achieves just that. The painting places an intense focus on the Queen's face. Freud's interpretation of her features is cold; it is the paint handling that makes the image come alive, with the angles at which the artist applied the orange and white tones animating the Queen's face and encapsulating many fleeting expressions. This may indicate that Freud succeeded where other

Fig. 151 Susan Crawford (b.1941), *Her Majesty The Queen on Worcran*, 1977. Oil on panel, 71 x 91.5 cm. Royal Collection (RCIN 400709)

Fig. 152 Lucian Freud (b.1922), *Her Majesty The Queen*, 2000–2001. Oil on canvas, 23.5 x 15.2 cm. Royal Collection (RCIN 407895)

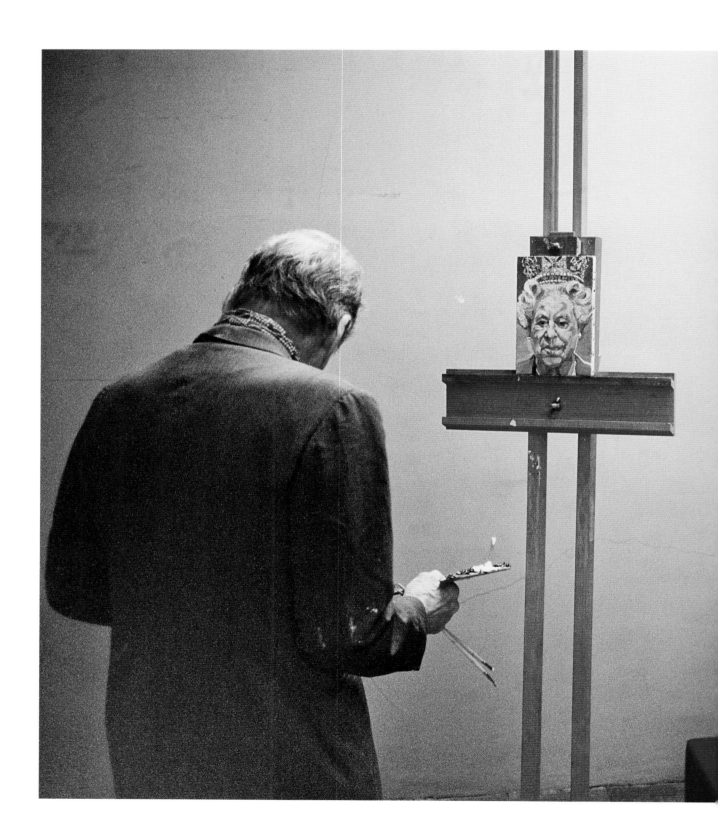

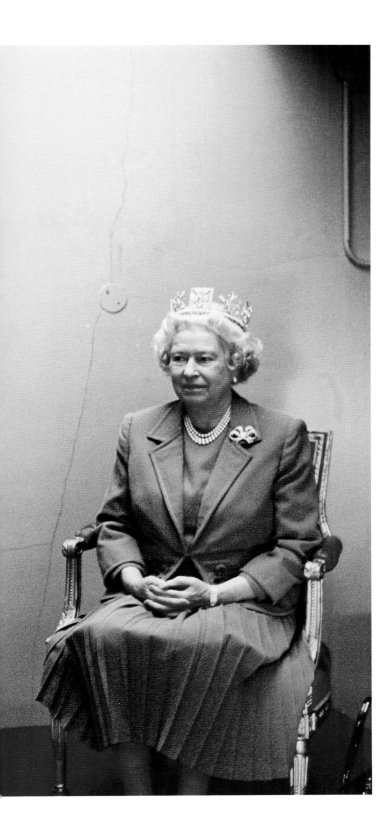

Fig. 153 David Dawson
(b.1960), *Freud at Work*, 2001.
C-type print, 39.7 x 59.9 cm.
Royal Collection
(RCIN 2584774)

portraitists had experienced difficulties. Annigoni had reported that the Queen's facial expressions were a challenge to capture because they were 'mercurial – smiling, thoughtful, determined, uncertain, relaxed, taut, in rapid succession'.[124] After looking at the Freud portrait for a while, the viewer gains the uncanny impression that the sitter is about to move. This is not a glamorous image but it feels real and earthy, almost as though Freud peeled away the layers of deportment that come so naturally to a monarch and painted the person underneath. Late on in the process the artist decided to include the diamond diadem (which he thought of as a 'crown'), and had to extend the canvas in order to fit it in. It is almost as if Freud painted the woman first, and the Queen as an afterthought.

A portrait sculpture by Angela Conner was commissioned to mark the Queen's eightieth birthday in 2006 (fig. 154). The sculpture, which is on permanent public display at St George's Chapel, Windsor, was commissioned by the Knights of the Garter, by whom it was presented to the Queen. The bronze bust was created using the traditional 'lost-wax' technique: the original model was made out of clay and subsequently covered with silicone to create a mould for the finished bronze sculpture. The artist carried out the clay modelling of the Queen's features during five 2-hour sittings at Buckingham Palace.[125] Like Freud's painted portrait, Conner's image seems to convey changing expressions in the Queen's face. When viewed from the front she is stoic with a firm jaw; when seen from the side her face seems lighter and more relaxed. This fluidity of mood is also conveyed in the rough-

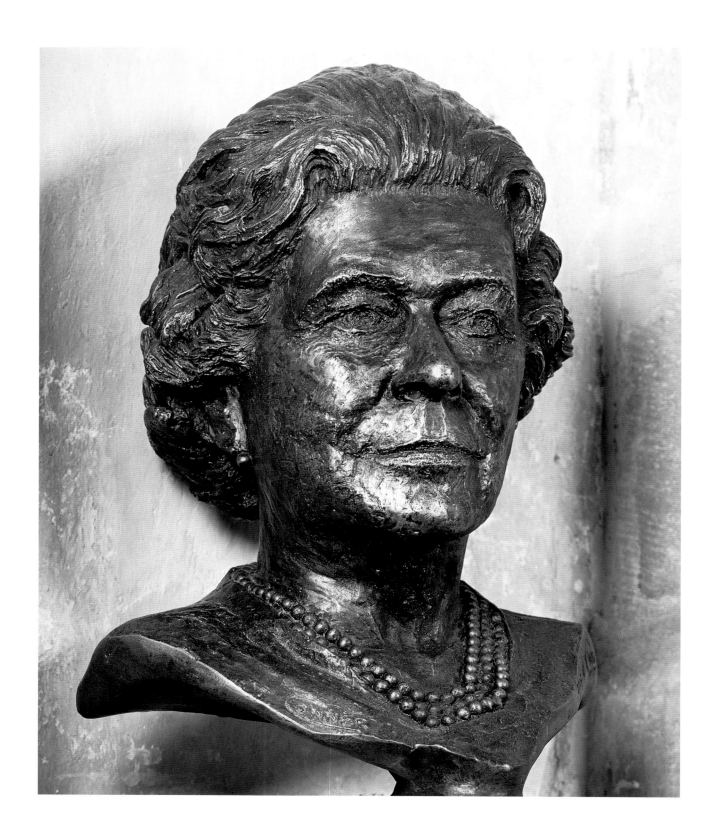

ness of the finish. The bronze image captures Conner's personal vision of the Queen, imbuing this public image with a unique perspective.

In 2007 the famous American photographer Annie Leibovitz photographed the Queen in a series of images to mark her State Visit to the United States. The photographs relate directly to iconic portraiture from the past. Of the four resulting official photographs, one in particular has a serene mood of quiet contemplation (fig. 157). Leibovitz portrayed the Queen sitting in the White Drawing Room at Buckingham Palace. The Queen gazes out of the window, seemingly unaware that her photograph is being taken. This photograph compares interestingly with *Windsor Castle in Modern Times* by Sir Edwin Landseer (fig. 127), where the monarch is presented against an open window leading into the garden beyond. The melancholic atmosphere of Leibovitz's photograph is heightened by the darkening skies outside, where rain clouds gather above two sparse trees. Like Freud, Leibovitz gives a sense of the Queen's dual role: the monarch sitting in an opulent room wearing state robes and diadem, and the woman who gazes out at the atmospheric landscape, perhaps wishing that she was walking her dogs in the garden.

In 2006 the Queen purchased the preparatory study (fig. 155) for Pietro Annigoni's second portrait of her, which had been commissioned by the National Portrait Gallery in 1969. With this second opportunity to paint the Queen, Annigoni encountered a monarch who had changed considerably in the 15 intervening years. Annigoni recorded in his autobiography

a conversation that he had with the Queen during which he outlined to her his vision for the portrait:

> I see Your Majesty as being condemned to solitude because of your position and I intend to let that be my inspiration. It goes without saying that, as a wife and mother you are entirely different, but I see you really alone as a Monarch and I want to represent you that way. If I succeed, the woman, the Queen and, for that matter, the solitude will emerge.[126]

Queen Elizabeth II conveys an air of responsibility and dignity in the pose and face of the sitter (fig. 156). The finished portrait presents the Queen full length, the shape of her robes (the red mantle of the Order of the British Empire) echoing Renaissance representations of the *Madonna of Mercy* in which the Virgin Mary shelters penitents underneath her cloak.[127] The austerity of the painting and the study is heightened by the lack of jewellery, a decision specified by the artist. The full-length portrait, set against a star-scattered night sky, seems to capture the 'Queen' and the 'solitude' that the artist strove for, but, with its focus solely on the head and shoulders, it is the study that appears to capture the 'woman' with astonishing directness. Annigoni succeeded in his aim and created an image that expresses the assured regal dignity of monarchy.

In the twenty-first century the boundaries between officially approved and invasively snatched images have been blurred to such an

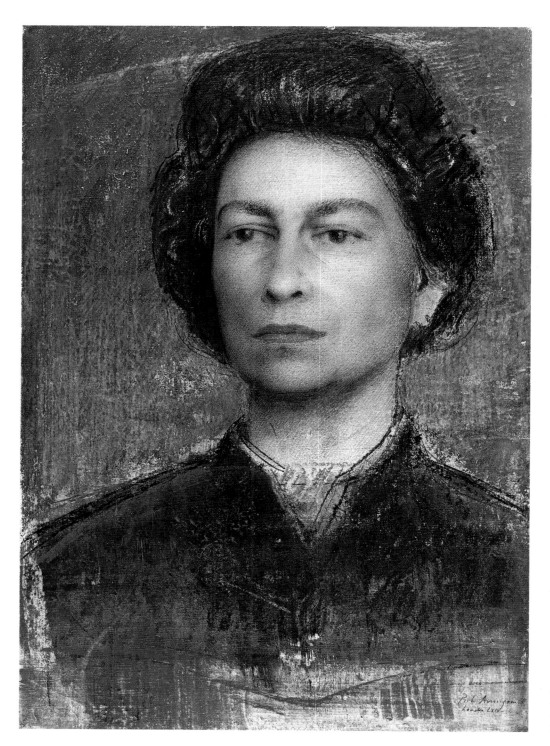

LEFT:

FIG. 155 Pietro Annigoni (1910–88), *Study for the portrait Queen Elizabeth II*, 1969. Oil distemper and pastel on pasteboard, 68.5 x 63.5 cm. Royal Collection (RCIN 453953)

FIG. 156 Pietro Annigoni (1910–88), *Queen Elizabeth II*, 1969. Oil on panel, 198.1 x 177.8 cm. London, National Portrait Gallery

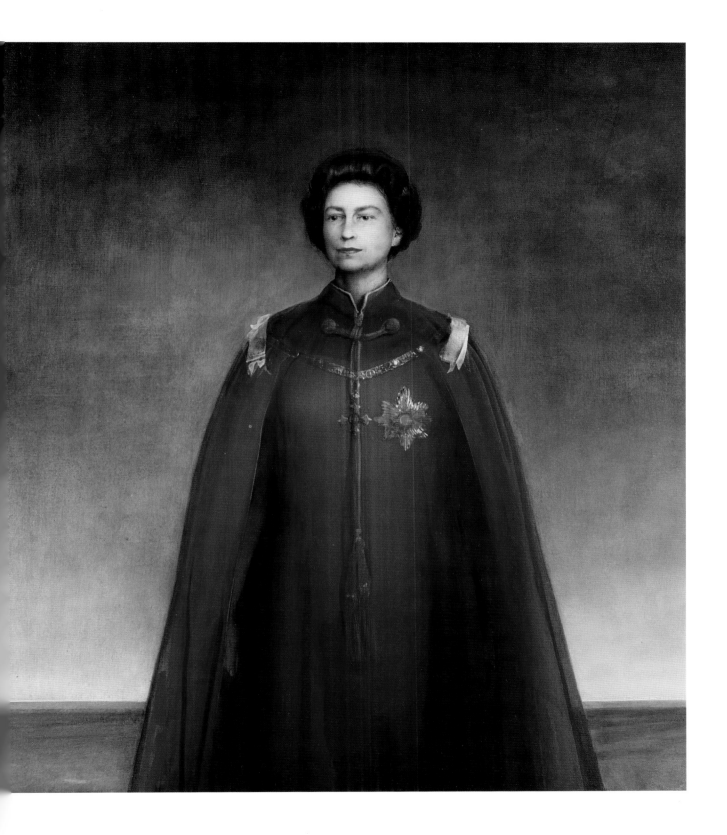

FIG. 157 Annie Leibovitz
(b.1949), *Her Majesty Queen
Elizabeth II*, 2007. C-type
print, 33.6 x 50.2 cm.
Royal Collection
(RCIN 2935744)

extent that the public is not always aware of the difference. The 2006 film *The Queen* deliberately explored this uncertainty. It is common practice for historical figures and events to be fictionalised on screen, with regular appearances of, for instance, Henry VIII, Charles I and Queen Victoria, but it is rare for a reigning monarch to be characterised in such terms. *The Queen* may be seen as unofficial royal portraiture of a sort which, although loosely based on factual events and at times sensitively done, was in fact imaginary. The film functions not as accurate representation but, like Mathias Kauage's *Missis Kwin* (fig. 1), as a subjective interpretation of the Queen that tells us more about its makers than it does about the person it describes.

After continual development and several metamorphoses, royal portraiture survives. The depictions of Queen Elizabeth II play an essential part in the canon of masterpieces outlined in this book and indicate the accumulative visual vocabulary of the genre. Having examined a selection of evidence from the reign of Richard II to the present day, we return to the question originally posed: what constitutes a royal portrait? To varying degrees, depending on the stipulations of the patron and the invention of the artist, the portraits illustrated here convey the status, patriotism, idealism, taste, religious beliefs, political self-fashioning, vanity, humility, insecurity, power and dignity of distinct key sovereigns. When considered in context, royal portraiture serves to illuminate both history and humanity.

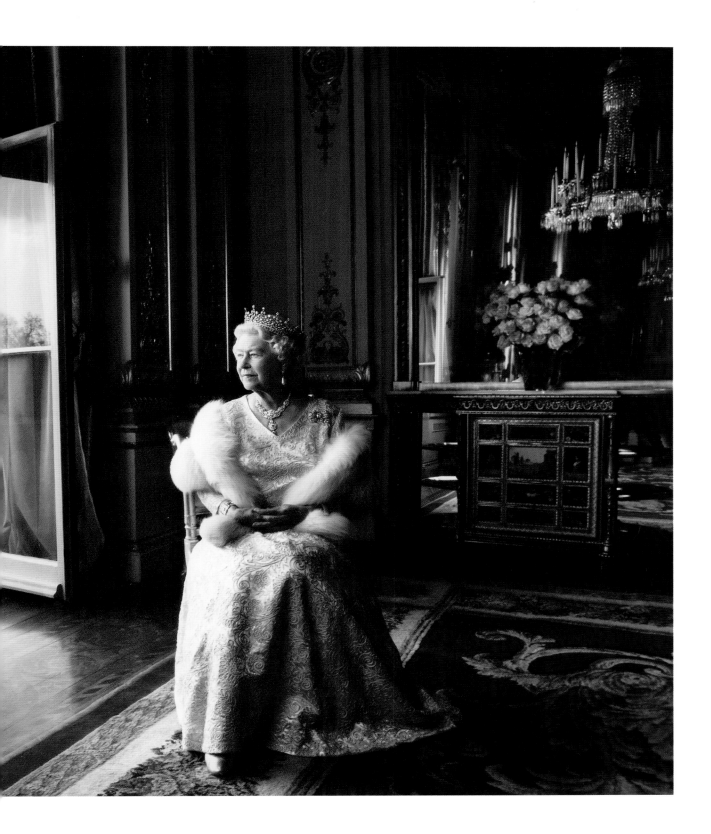

The Royal Line of Succession since Richard II

HOUSE OF
PLANTAGENET

RICHARD II
1377–1399

HOUSE OF
LANCASTER

HENRY IV
1399–1413

HENRY V
1413–1422

HENRY VI
1422–1461 and 1470–1471

HOUSE OF
YORK

EDWARD IV
1461–1470 and 1471–1483

EDWARD V
1483

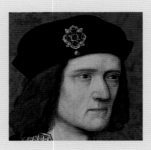

RICHARD III
1483–1485

HOUSE OF
TUDOR

HENRY VII
1485–1509

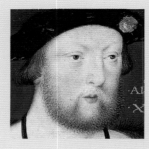

HENRY VIII
1509–1547

EDWARD VI
1547–1553

MARY I
1553–1558

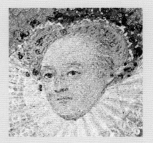

ELIZABETH I
1558–1603

HOUSE OF
STUART

JAMES I
1603–1625

CHARLES I
1625–1649

COMMONWEALTH
1649–1660

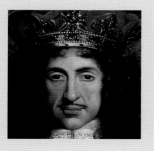

CHARLES II
1660–1685

JAMES II
1685–1689

WILLIAM III
& MARY II
1689–1702

ANNE
1702–1714

HOUSE OF
HANOVER

GEORGE I
1714–1727

GEORGE II
1727–1760

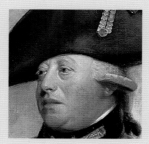

GEORGE III
1760–1820

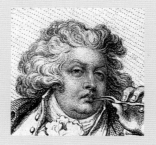

GEORGE IV
1820–1830

WILLIAM IV
1830–1837

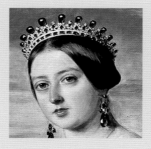

VICTORIA
1837–1901

HOUSE OF
SAXE-COBURG
& GOTHA

EDWARD VII
1901–1910

HOUSE OF
WINDSOR

GEORGE V
1910–1936

EDWARD VIII
1936

GEORGE VI
1936–1952

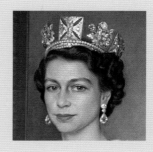

ELIZABETH II
1952–

NOTES

1 Cochrane 2007, p. 126.

2 Piper 1978, p. 198.

3 Millar 1963, p. 53.

4 Henry VII died at Richmond Palace in 1509. The palace was destroyed in the seventeenth century following the execution of Charles I in 1649.

5 Colvin 1982, pp. 225–7.

6 de Voragine 1993, p. 238.

7 Campbell 2007, p. 83.

8 Gordon 1993, p. 58.

9 Strong 2005, p. 94.

10 Chapman *et al*. 2004, p. 47.

11 Ettlinger 1983, pp. 25–9, and Haskell 1989, p. 216.

12 Hepburn 1986, p. 22, and Binski 1999, p. 91.

13 Hepburn 1986, p. 15.

14 Millar 1963, p. 51.

15 Hepburn 1986, p. 9. Hepburn dates these panels slightly later. Dendro-chronology carried out in the 1970s suggested a date around 1518–23, but these readings are now thought to be slightly unreliable. Until further dendrochronology is carried out, no dating of these panels can be certain.

16 Tudor-Craig 1973, p. 90.

17 The author is grateful to Frederick Hepburn for his advice on this matter. His insights will be published in a forthcoming article on the portraits of Richard III.

18 Sir Thomas More, *The History of King Richard III*, written *c*.1513. First published 1557.

19 Bentley-Cranch 2004, pp. 80–82.

20 Roberts 2002, p. 130.

21 Reynolds 1999, p. 48.

22 Quoted in Auerbach 1954, p. 4.

23 Lloyd and Thurley 1990, pp. 44–5.

24 William Shakespeare, *Henry VIII*, Act 1, Scene 1. First performed in 1613.

25 William Shakespeare, *Henry VIII*, Act 1, Scene 1.

26 Van Mander 1936, p. 86.

27 Van Mander 1936, p. 88.

28 Translated in Foister 2006, p. 94.

29 Millar 1963, p. 117.

30 Foister 2006, p. 136.

31 Translated in Roberts 1978, p. 130. The text comes from 2 Chronicles 9:7–8 and 1 Kings 10:9.

32 Millar 1963, p. 55 and p. 64.

33 Hearn 1995, p. 50.

34 Hearn 1995, p. 79.

35 Hearn 1995, p. 78.

36 Millar 1963, pp. 64–5.

37 Strong 1987, p. 14.

38 Walker 2004, p. 2.

39 Translated in Lloyd 1991, p. 62.

40 Strong 1987, p. 66.

41 Strong 1977, p. 111.

42 Quoted in Starkey 2006, p. 92.

43 Quoted in Strong 2005, p. 112.

44 The author is grateful to Richard Rutherford for providing this translation.

45 Millar 1963, p. 77.

46 Croft 2003, p. 12.

47 Whitehall Palace was destroyed by a fire of 1698; only the Banqueting House remained intact.

48 Millar 1963, p. 81.

49 It is thought that James I may have discussed the decoration of the ceiling with Sir Peter Paul Rubens shortly before the building was completed in early 1622.

50 Cust 2005, p. 11.

51 Donovan 2004, p. 117.

52 Donovan 2004, p. 115.

53 White 2007, p. 8.

54 This imagery derives from the written account of the life of St George in *The Golden Legend* written by Jacobus de Voragine *c*.1260.

55 Cust 2005, p. 161.

56 White 2007, p. 218.

57 Cust 2005, p. 77.

58 Millar 1963, p. 85.

59 Millar 1963, p. 93.

60 Roberts 1999, p. 36.

61 Bacchi *et al*. 2008, p. 245.

62 Millar 1963, p. 96.

63 The author is grateful to Bridget Wright for translating these inscriptions.

64 Daems and Nelson 2006, p. 14.

65 White 2007, pp. 127–9, and van Beneden and de Poorter 2006, p. 176.

66 Thackeray 1866, pp. 126–7.

67 Shawe-Taylor 2009, p. 80.

68 Millar 1963, p. 176.

69 Millar 1963, p. 175, and Shawe-Taylor 2009, p. 82.

70 Quoted in Lloyd 2004, p. 11.

71 Smart 1999, pp. 88–90 and 111–21.

72 Rosenblum 2007, p. 18.

73 Lloyd 2004, pp. 16–17.

74 Piper 1978, p. 154.

75 Lloyd 1994, p. 64.

76 Brooke 1972, p. 72.

77 William Shakespeare, *King Lear*, Act II, Scene IV.

78 Hill 1965, p. 120.

79 Walker 1992, p. 88.

80 Garlick 1989, p. 21.

81 Millar 1969, p. xxxvi.

82 Dunkerley 1995, p. 79.

83 Millar 1969, p. xxxvi.

84 Priestly 1969, p. 143.

85 Hibbert 1984, p. 1.

86 Vallone 2001, p. 162.

87 Plunkett 2003, p. 88.

88 Clubbe 2005, p. 131.

89 Millar 1969, p. 144.

90 Shawe-Taylor 2009, p. 163.

91 Millar 1969, p. xlii.

92 *Journal* entry, 8 May 1837. Quoted in Millar 1992, p. 96.

93 Millar 1992, p. xvii.

94 Quoted in Millar 1992, p. 105.

95 Hibbert 1984, p. 35.

96 Wood 1999, p. 14.

97 Millar 1969, p. 246.

98 Ormond and Blackett-Ord 1987, p. 40.

99 Millar 1992, p. 293.

100 Millar 1992, p. 294.

101 Homans 1998, pp. 29–33.

102 Millar 1992, pp. 83–4.

103 26 June 1875, letter to the Crown Princess of Prussia. Hibbert 1984, p. 239.

104 Millar 1992, p. 136.

105 Millar 1992, p. 140.

106 Homans 1998, p. 28.

107 Dimond and Taylor 1987, p. 26.

108 Quoted in Green-Lewis 1996, p. 1.

109 The author is grateful to Sophie Gordon, Curator of the Royal Photograph Collection, for explaining this process.

110 Quoted in Vallone 2001, p. 168.

111 Illustrated in Homans 1998, p. 12.

112 William Shakespeare, *Twelfth Night*, Act II, Scene IV.

113 Quoted in Hudson 1975, p. 61.

114 Lloyd 2003, pp. 277–8.

115 Archive material held in the Royal Photograph Collection, Windsor Castle.

116 Rogers 1986, p. 10.

117 Annigoni 1977, pp. 82–3.

118 Annigoni 1977, p. 86.

119 Archive material from the Royal Photograph Collection, Windsor Castle.

120 Quoted in 'Obituary of Lord Charteris of Amisfield', *Independent*, 27 December 1999.

121 www.bbc.co.uk 'On this day, 29 July 1981'.

122 Letter from the artist to the Surveyor of the Queen's Pictures, 5 November 1981 (held in the Picture Files, York House, St James's Palace).

123 Smee 2006, p. 32.

124 Annigoni 1977, p. 172.

125 Spanier 2006, pp. 22–3.

126 Annigoni 1977, p. 176.

127 Rogers 1986, p. 12.

BIBLIOGRAPHY

Annigoni, P., 1977. *Pietro Annigoni An Artist's Life: An Autobiography, as told to Robert Wraight*, London

Auerbach, E., 1954. *Tudor Artists: A Study of Painters in the Royal Service and of Portraiture on Illuminated Documents from the Accession of Henry VIII to the Death of Elizabeth I*, London

Bacchi, A., *et al.* (eds), 2008. *Bernini and the Birth of Baroque Portrait Sculpture*, Los Angeles CA

Bentley-Cranch, D., 2004. *The Renaissance Portrait in France and England*, Paris

Binski, P., 1999. 'Hierarchies and Orders in English Royal Images of Power' in Denton, J. (ed.), *Orders and Hierarchies in Late Medieval and Renaissance Europe*, Basingstoke and London, pp. 74–91

Brooke, J., 1972. *King George III*, London

Campbell, T.P., 2007. *Henry VIII and the Art of Majesty: Tapestries at the Tudor Court*, New Haven CT and London

Chapman, H., *et al.*, 2004. *Raphael: From Urbino to Rome*, London

Clubbe, J., 2005. *Byron, Sully and the Power of Portraiture*, Aldershot

Cochrane, S., 2007. *Art and Life in Melanesia*, Newcastle

Colvin, H.M. (ed.), 1982. *The History of the King's Works Volume IV, 1485–1660, Part II*, London

Croft, P., 2003. *King James*, New York

Cust, R., 2005. *Charles I, A Political Life*, Edinburgh

Daems, J., and H.F. Nelson, 2006. *Eikon Basilike: The Portraiture of His Sacred Majesty in his Solitudes and Sufferings*, Peterborough ONT and Plymouth

de Voragine, J., 1993. *The Golden Legend: Readings on the Saints* (2 vols), trans. W.G. Ryan, Princeton NJ

Dimond, F., and R. Taylor, 1987. *Crown and Camera: The Royal Family and Photography 1842–1910*, Frome and London

Donovan, F., 2004. *Rubens and England*, New Haven CT and London

Dunkerley, S., 1995. *Francis Chantrey: Sculptor from Norton to Knighthood*, Sheffield

Ettlinger, H.S., 1983. 'The Question of St George's Garter', *Burlington Magazine*, CXXV, No. 958, January, pp. 25–9

Foister, S., 2006. *Holbein in England*, London

Garlick, K., 1989. *Sir Thomas Lawrence: A Complete Catalogue of the Oil Paintings*, Oxford

Gordon, D., 1993. *Making and Meaning: The Wilton Diptych*, London

Green-Lewis, J., 1996. *Framing the Victorians: Photography and the Culture of Realism*, Ithaca NY and London

Haskell, F., 1989. 'Charles I's Collection of Pictures' in Macgregor, A. (ed.), *The Late King's Goods. Collections, Possessions and Patronage of Charles I in the Light of the Commonwealth Sale Inventories*, London and Oxford, pp. 203–31

Hearn, K. (ed.), 1995. *Dynasties: Painting in Tudor and Jacobean England 1530–1630*, London

Hepburn, F., 1986. *Portraits of the Later Plantagenets*, Suffolk

Hibbert, C., 1984. *Queen Victoria in her Letters and Journals*, London

Hill, D., 1965. *Mr Gillray the Caricaturist*, London

Homans, M., 1998. *Royal Representations: Queen Victoria and Visual Culture 1837–1876*, Chicago IL and London

Hudson, D., 1975. *For Love of Painting: The Life of Sir Gerald Kelly, KCVO, PRA*, London

Lloyd, C., 1991. *The Queen's Pictures: Royal Collectors through the Ages*, London

Lloyd, C., 1994. *Gainsborough and Reynolds: Contrasts in Royal Patronage*, London

Lloyd, C., 2003. *The Paintings in the Royal Collection: A Thematic Exploration*, London

Lloyd, C., 2004. 'King, Queen and Family' in Roberts, J. (ed.), *George III and Queen Charlotte: Patronage, Collecting and Court Taste*, London, pp. 10–21

Lloyd, C., and S. Thurley, 1990. *Henry VIII: Images of a Tudor King*, Oxford

Millar, O., 1963. *The Tudor, Stuart and Early Georgian Pictures in the Collection of Her Majesty The Queen*, London

Millar, O., 1969. *The Later Georgian Pictures in the Collection of Her Majesty The Queen*, London

Millar, O., 1992. *The Victorian Pictures in the Collection of Her Majesty The Queen*, Cambridge

Ormond, R., and C. Blackett-Ord, 1987. *Franz Xaver Winterhalter and the Courts of Europe 1830–70*, London

Piper, D., 1978. *The English Face*, London

Plunkett, J., 2003. *Queen Victoria, First Media Monarch*, Oxford

Priestly, J.B., 1969. *The Prince of Pleasure and his Regency*, London

Reynolds, G., 1999. *The Sixteenth and Seventeenth-Century Miniatures in the Collection of Her Majesty The Queen*, London

Roberts, J., 1978. *Holbein and the Court of Henry VIII*, London

Roberts, J. 1999. *The King's Head. Charles I: King and Martyr*, London

Roberts, J. (ed.), 2002. *Royal Treasures: A Golden Jubilee Celebration*, London

Rogers, M., 1986. *Elizabeth II: Portraits of Sixty Years*, London

Rosenblum, R., 2007. 'Portraiture: Facts versus Fiction' in Rosenblum, R., *et al.*, *Citizens and Kings: Portraits in the Age of Revolution, 1750–1830*, London, pp. 14–25

Shawe-Taylor, D., 2009. *The Conversation Piece: Scenes of Fashionable Life*, London

Smart, A., 1999. *Allan Ramsay: A Complete Catalogue of his Paintings*, New Haven CT and London

Smee, S., 2006. *Freud at Work*, London

Spanier, S., 2006. 'London News: Samson Spanier meets Angela Conner, Sculptor of a New Bust of the Queen', *Apollo*, June, pp. 22–4

Starkey, D., 2006. *Monarchy: From the Middle Ages to Modernity*, London

Strong, R., 1977. *The Cult of Elizabeth: Elizabethan Portraiture and Pageantry*, New Haven CT and London

Strong, R., 1987. *Gloriana: The Portraits of Queen Elizabeth I*, New Haven CT and London

Strong, R., 2005. *Coronation: from the 8th to the 21st Century*, London

Thackeray, W.M., 1866. *The Four Georges*, London

Tudor-Craig, P., 1973. *Richard III*, London

Vallone, L., 2001. *Becoming Victoria*, New Haven CT and London

van Beneden, B., and N. de Poorter, 2006. *Royalist Refugees: William and Margaret Cavendish in the Rubens House 1648–1660*, Leuven

Van Mander, C., 1936. *Dutch and Flemish Painters, Translation from the Schilderboeck*, trans. C. Van de Wall, New York

Walker, J.M., 2004. *The Elizabethan Icon: 1603–2003*, New York

Walker, R., 1992. *Miniatures in the Collection of Her Majesty The Queen: The Eighteenth and Early Nineteenth Centuries*, Cambridge

White, C., 2007. *The Later Flemish Paintings in the Collection of Her Majesty The Queen*, London

Wood, C., 1999. *Victorian Painting*, London

INDEX

ACKNOWLEDGEMENTS

The Royal Portrait: Image and Impact would not have been possible without the encouragement and assistance of numerous people.

I am immensely grateful to Her Majesty The Queen for granting me privileged access to the Royal Collection and the Royal Archives. Their Royal Highnesses The Duke of Edinburgh and The Duke of York kindly gave permission for the reproduction of personal portraits by them of The Queen.

I am particularly indebted to Jacky Colliss Harvey for her support and commitment in managing this project, to Desmond Shawe-Taylor and Sir Hugh Roberts for editing the manuscript and making invaluable suggestions, and to the designer, Nigel Soper, for his skill and vision. Sabrina Mackenzie and Nina Chang worked tirelessly on all aspects of the book, including tracking down images and obtaining copyright, and cannot be thanked enough. I would like to thank Debbie Wayment, Jenny Knight, Alison Thomas, Debbie Bogard and Kate Owen. I am also grateful for the help of the Royal Collection photographic services department – Katie Holyoak, Daniel Partridge, Karen Lawson, Louise Oliver, Dominic Brown, Stephen Chapman, Eva Zielinska-Millar and Shruti Patel.

I have benefited from the expertise and support of Royal Collection colleagues past and present, especially The Hon. Lady Roberts, Jonathan Marsden, Sophie Gordon, Lisa Heighway, Alessandro Nasini, Bridget Wright, Joanna Langston, Kate Heard, Lauren Porter, Allan Chinn, Christopher Lloyd, Lucy Whitaker, Rupert Featherstone, Nicola Christie, Tabitha Teuma, Nicola Swash Hardie, Kathryn Jones, Caroline de Guitaut, David Oakey, Frances Dunkels, Rachel Woollen, Nathanael Moyers, Emma Shaw, Susanna Mann, Anna Bowdler, Michael Field, Stephanie Carlton, Chris Stevens, Vanessa Remington, Alex Buck, Anna Reynolds, Leonora Martin, Janice Sacher, Melanie Edwards, Deborah Clarke, Alison Campbell, Amy Watsham, Karly Allen, Stephen Patterson, Charlotte Bolland, Simon Metcalf and Allison Derrett. My thanks are also due to Christine Taylor, John Phillips, Alison O'Neill, Clare Barnes, Emma Featherstone and the patient team of wardens at Windsor Castle who allowed me to try out ideas on them.

No book on royal portraiture is complete without mention of Sir Roy Strong whose publications on the subject act as a touchstone. I am grateful for the scholarship of Sir Oliver Millar, Lorne Campbell, Sir Christopher White, Graham Reynolds and Richard Walker. I would also like to thank Tess Cavendish, Charlotte Manley, Richard Wragg, Dame Anne Griffiths, Katharine Stevenson, Frederick Hepburn, John Goodall, Edward Town, Brett Dolman, Joanna Marschner, Jane Richardson, Michael Scott, Eirlys Scott and Stephen Johnson.